FINE VIEWS OF KYOTO

Tadashi Shirafuji
2-6 Wakunami 2 chome
Kanazawa, ISHIKAWA
920, JAPAN.

Kyoko Watari
1-6-3 Nakano
Nakano-ku, Tokyo
164 JAPAN

THIS WAY PLEASE ☞

Johan Chiaramonte & Camille Mathieu

THE MUSEUM OF
WES ANDERSON

His Movies and the Works
That Inspired Them

PRESTEL

MUNICH · LONDON · NEW YORK

The Imaginary Museum	DATE	MANUSCRIPT
WES ANDERSON	**1975**	EXHIBITION CATALOGUE
PART ONE/ONE · W/S		
WSB32100080-350 · 1001		

TABLE OF CONTENTS

Curated by

CAMILLE MATHIEU & JOHAN CHIARAMONTE

PLAN OF THE MUSEUM

THE KITCHENS

THE CLOAKROOM

THE LIBRARY

THE MAIN ENTRANCE

Entrance

THE PORTRAIT GALLERY

THE SECRET ROOM

THE AUDITORIUM

THE PROJECTION ROOM

THE CABINET OF TRAVEL SOUVENIRS

Exit

THE MUSEUM SHOP

I

THE MAIN ENTRANCE

1975. The Imaginary Museum is both delighted and proud to host a great exhibition devoted to the American movie director Wes Anderson. Like many other movie enthusiasts, you too may have dreamed of entering the mind of one of your favorite filmmakers. Better still, to discover its secret nooks and crannies, to lose yourself in its corridors, to unearth the treasure trunks, to wander around and visit it like a stroller visiting a museum… With its abundance of details, its rich universe and its evocative power, Wes Anderson's films are more inviting than any other to this phantasmagorical stroll.

The Imaginary Museum is both delighted and proud to host a great exhibition devoted to the American movie director Wes Anderson. Like many other movie enthusiasts, you too may have dreamed of entering the mind of one of your favorite filmmakers. Better still, to discover its secret nooks and crannies, to lose yourself in its corridors, to unearth the treasure trunks, to wander around and visit it like a stroller visiting a museum… With its abundance of details, its rich universe and its evocative power, Wes Anderson's films are more inviting than any other to this phantasmagorical stroll.

Throughout this exhibition, which is not comprehensive, our museum will attempt to draw the contours of a body of work which, despite its detractors, has never ceased to evolve, to mutate and to transform. Much has been said about the undeniable formal qualities of Anderson's cinematographic works: a whimsical, old-fashioned aesthetic, instantly recognizable among thousands, infinite attention devoted to every shot, films reminiscent of picture books, overflowing with trinkets and small objects. Anderson's cinema is indeed art that teems with details, a swarm of features,

4

an accumulation of meticulously distilled references and of elements arranged with maniacal rigor. This is Anderson's gentle madness, entirely contained within this rigorously organized disorder, where nothing is ever left to chance.

We too sought to forsake the wide-angle lens, and instead, focus on the details, the accessories, the references and the characters that populate his world. In the guise of humble archivists, we will seek to dust them off, to list them and to catalogue them, so that we can better arrange them within the walls of a genuine "imaginary museum."

The book that you are holding in your hands is the catalogue of this fantasized exhibition. From this guided tour will emerge a vast cartography of the Texan filmmaker's imagination. Here, you are free to wander throughout a museum devoid of any real boundaries, whose shape-shifting architecture will gladly adapt to your pleasure. Don't be afraid to act as the passer-through-walls: in this place, nothing is set in stone. In this book, you will read about Indian cinema, French pop music, speeding trains, jaguar sharks, pancakes, fur hats, flashing and buzzing electronic machines, picturesque Italian villages and mysterious islands.

We wanted this meander to be a reflection of Anderson's cinematographic approach: playful and containing a wealth of details; some real, others made up, springing from a universe that one can imagine to be vast, infinite even. Because reality and fiction are constantly intertwined throughout the filmmaker's entire body of work, we too felt that it was necessary to build a bridge between the world of reality and the imaginary, between what is and what could be. Finally, to those of you who find it preposterous, absurd, impossible even, that this exhibition was held in 1975, we ask: when did Wes Anderson and his characters ever allow themselves to be hindered by such practical considerations? The laws of time and physics do not apply here.

Let us now undertake a journey from the priceless captain Zissou to the underwater adventures of Captain Cousteau, from the Grand Budapest cake hotel to Stefan Zweig's World of Yesterday, from the pages of The New Yorker to the columns of the French Dispatch, from the roadrunner's cartoonish deserts to the Technicolor horizons of Asteroid City. Let us sail upon the seas of a movie director that one would be misled to perceive only as a precious stylist, and let us scrape off a little of the varnish from The Darjeeling Limited's sleeper cars and attempt to enter the secrets of Anderson's (occasionally) aquatic world.

Welcome to the Museum of Wes Anderson!

PLEASE FOLLOW THE GUIDE…

II

THE CLOAKROOM

Once your entry ticket has been punched by our friendly ticket seller, it's time for you to remove your overcoat, your bags and your hat and to leave them in the care of your hosts. Be warned, however: the cloakroom in our Imaginary Museum is no ordinary cloakroom. In this room, silky fur coats hang beside terrycloth tennis headbands. Impeccably folded scout outfits, covered with patches, hang beside the purple liveries of the bellhops. Everything holds its rightful place, and everyone wears the uniform given to them. Indeed, in Wes Anderson's movies, there is no room for happenstance; every item in this cloakroom carries its own story, its own intimate meaning, its own share of fantasies, of hopes—and, of course, of intense neuroses. Whether they delineate the contours of a family, a clan or a vocation, Wes Anderson's costumes can never be ignored. While it is true that our clothes do reveal a part of ourselves, this rule could bot be any truer than in the filmmaker's works. In Wes Anderson's world, you are always what you wear; so it is wise indeed to trust appearances. Hence, a red cap that never leaves your head might well make you a worthy heir to Captain Cousteau. To begin the tour, let us explore a few emblematic pieces from this great Andersonian cloakroom. Don your finest suits—preferably Italian— and step out onto the thick carpet of our imaginary cloakroom.

Rushmore's Uniform
The Hallmark of Excellence

A pair of tortoiseshell glasses, a sensible blue Oxford shirt, a neatly knotted striped tie, a navy blue blazer adorned with two honorary pins boasting some unspectacular accomplishments. Only the bright red beret pressed deeply onto the young Max Fischer's skull might provide any indication of the storm that rages within the confines of his well-shaped head. Overly proud to be a member of the eminent Rushmore Academy, Max always looks sharp indeed, in his preppy uniform. On the private school campus, he dreams of being an exemplary student, solving impossible equations, earning unanimous praise from his teachers, and even the affection of the highly respected dean. And yet, while he certainly attempts to compensate by looking like the best student in the classroom, Max Fischer is far from achieving academic miracles. On the contrary, his school years prove to be rather haphazard, and instead, he accumulates extracurricular activities in the hope of concealing mediocre, if not downright poor results.

However, if Max Fischer wears the school uniform with such aplomb, it is foremost because he feels that he belongs, body and soul, to Rushmore's noble institution. His uniform is filled with symbolism, as is often the case in Anderson's world; indeed, this working-class child was granted access to Rushmore's prestigious benches after being awarded a scholarship thanks to one of his many extracurricular talents: playwriting. While his comrades seem to belong to Rushmore by privilege and birth, Max Fischer constantly needs to prove that he indeed deserves to be here. In the absence of an impeccable educational record, it is important, if not absolutely essential, for him to "keep up appearances" by donning an impeccably ironed shirt, while

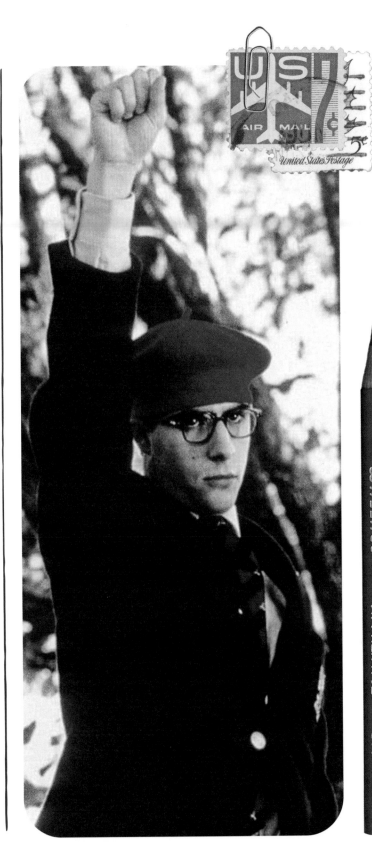

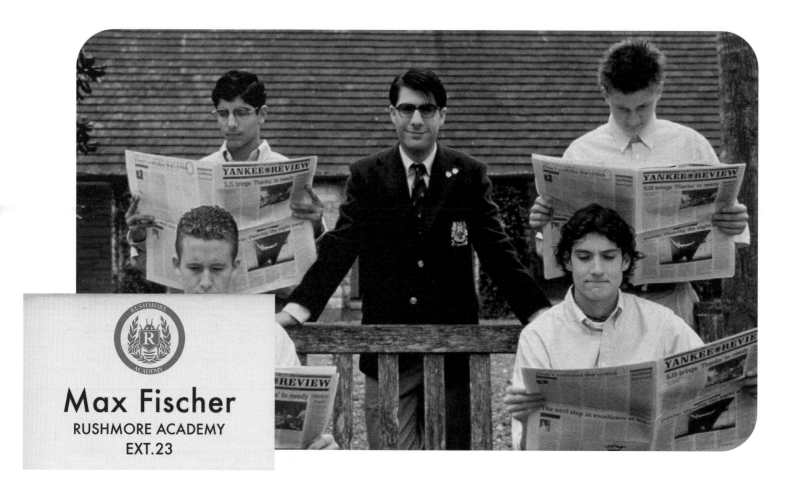

also lying about his modest social background. However, far from blending in with the rest of the student body, this overdressed suit actually sets him apart from the rest of the students, for the simple reason that he is the only one among them who wears it. Through this chosen, rather than imposed, uniform, Max Fischer dons the outfit of the young man that he projects himself to be, rather than the young man who he really is.

Beneath the surface, the evolution of Max Fisher's outfit symbolizes a quest for identity, an extensive initiatory journey. So when the Rushmore academy dismisses him out of hand, Max's destiny is shaken to the core. For the young man who must now remove Rushmore's noble uniform and return to the benches of the public school, it is the beginning of a genuine identity crisis that manifests through sartorial symptoms.

Max soon seeks refuge with his father, a humble hairdresser, by adopting his vocation… and also his outfit. Embracing a true social legacy and a family heirloom, Max immediately dons an outfit consisting of a fur

hat, a thick brown coat and a trusty Thermos, identical to that worn by his "old man." The young Max Fischer no longer dresses as the person he hopes to become, but as the person that he resigns himself to being.

A movie that narrates the tumultuous transition into adulthood, the difficulty of becoming "one's own" in a society that is obsessed with superficial social success, Rushmore leads us along the initiatory and bumpy pathway of adolescence. When at last, in a final burst of emancipation, Max Fischer decides to embrace his individuality, he finally liberates himself from social uniforms. This liberation is expressed through a new selection of clothing: a forest green velvet suit accompanied by a pale pink bow tie—an outfit that reminds us somewhat of the movie director's own choice of clothing. For Wes Anderson, as for Max Fischer, it is much easier to truly be oneself. ⚷

J.L.W.'s Suitcases
Coming With Baggage

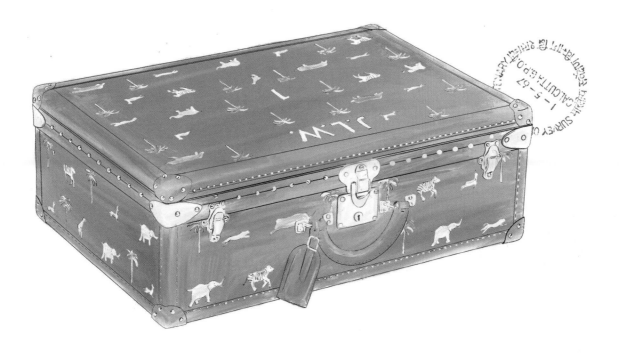

In French, the expression "*plier bagage*" means "to leave, to flee, to scram," "to pack up and leave, to take off, to take to one's heels"—or, when used in a more colloquial context, "to die." It is this last meaning that applies to the enigmatic character J.L.W., whose initials adorn the trunks, bags and suitcases making up this extraordinary assortment of baggage. This one-of-a-kind collection, with its carefully numbered items, is a creation of the very chic François Voltaire, if one should believe the closing credits of the short film *Hotel Chevalier*. In fact, designed by Marc Jacobs for Louis Vuitton, these baggage items are remarkable, owing to their curious motifs. Instead of the expected monogram, they feature an eye-catching "wildlife" print, created by illustrator Eric Chase Anderson, the director's brother.

On the camel leather, cheetahs, elephants, zebras and other wild creatures are extending their limbs, seemingly caught in the heat of the moment, running an immobile race—mindlessly forging ahead. From this impressive accumulation of paraphernalia emerges a portrait of the Whitman patriarch, whose real name remains unknown, summarized here only by three initials: *J.L.W.* This portrait *in absentia* is drawn up, throughout the movie, through the belongings of the missing father: a razor, some sunglasses customized to his eyesight, the keys to a sports car, and finally, this exceptional collection of baggage, which was split among the three sons that he left behind. These objects, which Francis, Peter and Jack are fighting over, follow them everywhere, like talismans. However, in the context of this journey, embodied by a spiritual

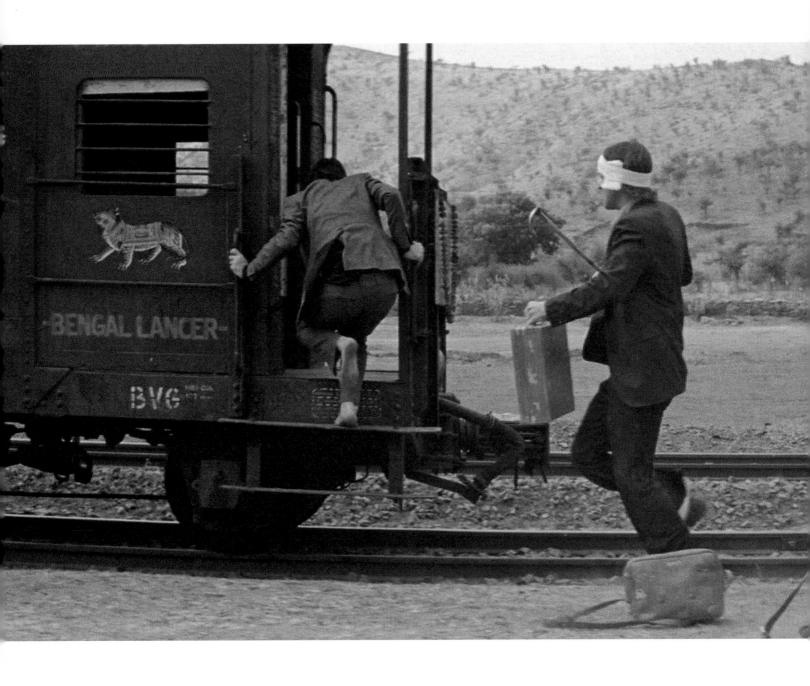

ambush (Francis failed to mention all the details regarding the reasons for the trip), one can legitimately ponder upon the need to carry such a cascade of baggage. The imposing suitcases provide an incongruous contrast with the narrowness of *The Darjeeling Limited*'s carriages, unquestionably encumbering our characters—especially when they will need to drag these suitcases through the Bengalese wilderness.

Behind the sons' unwavering determination to haul this heavy equipment, one perceives the baggage's symbolic charge. For Francis, Peter and Jack Whitman, who seem to have carefully avoided each other since their father's funeral, the journey is above all a mourning process. "*I guess I still got some more healing to do,*" Francis admits as he contemplates at his wounds, reluctantly acknowledging that the pain of losing his beloved father is still with him. For these brothers, who are literally haunted by absence, the imposing set of baggage is a metaphor for the weight of the grief that they are unable to overcome. Considerably weighed down by this burden, they are attempting to move forward, however, in vain. The expression "*To come with baggage*" precisely refers to the emotional

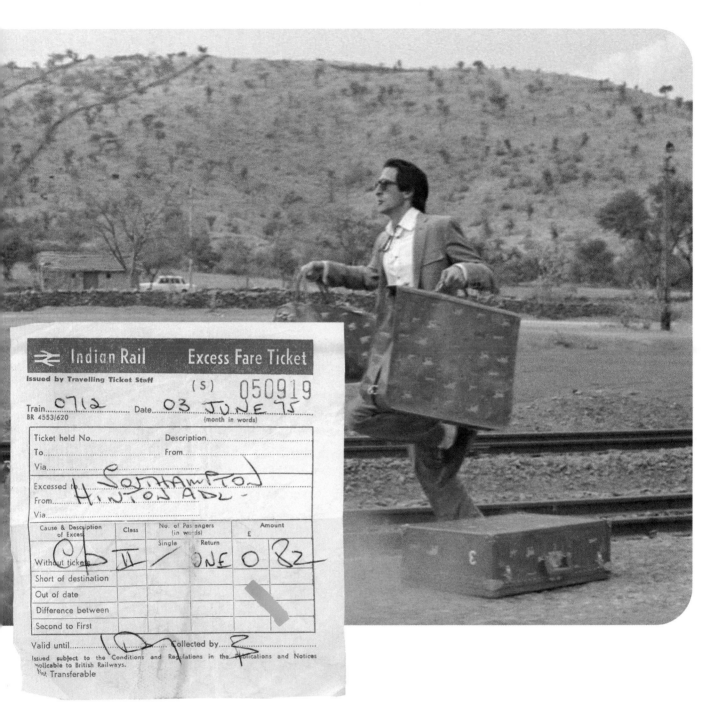

baggage that we all carry with us, filled with unresolved traumas and unfortunate experiences. This metaphor has never been more appropriate than in the case of the Whitman brothers. Here, it is taken literally—and, apart from the baggage's symbolic value, one has no indication whatsoever of what the precious shipment contains. It is only at the very end of this journey of reconciliation and acceptance, rife with adventures, that the three brothers finally relinquish their baggage. In a last-ditch effort to board the return train, the *Bengal Lancer*, the Whitman brothers set off

in a frantic pursuit, dropping their suitcases and bags on the platform. An insane race, filmed in slow motion, where the characters no doubt remind us of wild animals, they are in turn caught mid-stride, in the heat of the instant. Fortunately, for our three wildcats, it is no longer a matter of running away, but instead, returning home. ⚷

The Lobby Boy's Uniform
Dressed Up to the Nines

1932. In the interwar period, overlooking the snowy landscapes of the Zubrowka Alps, the splendid Grand Budapest Hotel is living out its last days of glory. A veritable institution for the declining aristocracy of the Old Continent, the Grand Budapest is a beehive, teeming with a humble staff that busy themselves, buzzing about like bees. Sauntering down corridors covered with thick, purple carpeting, hastily lunching in the hotel's kitchens or secretly sneaking into the rooms of lonely wealthy widows, the staff of the Grand Budapest Hotel are recognizable by their good manners and their impeccable violet suits. Whether elevator attendants or concierges, waiters or bellboys, all, without exception, proudly wear the colors of the Grand Budapest Hotel. Among them, the young and ambitious Zero Moustafa

dons his uniform with formidable seriousness: a floor attendant's outfit with an officer collar, edged with red trim, carefully buttoned up, topped with a cap adorned with the following inscription, in large gold embroidered letters: "LOBBY BOY". In this hotel world, where the clothes always make the man, every protagonist zealously plays the role assigned to them. And, far from concealing employees from the prying eyes of the clientele, as is customary in such establishments, their gleaming uniforms stand out starkly against the pale pink decor, always captivating the viewer's attention. Indeed, there is no doubt for spectators that the staff of the Grand Budapest are the beating heart of this noble institution, the last guardians and protectors of a world doomed to disappear.

In his *lobby boy* costume, awkwardly drawing a thin Errol Flynn moustache—the hallmark of sophistication—on his upper lip, Zero has found more than a mere livelihood in this adopted country: he has become part of a surrogate family, brought together by the strength of its vocation. *"Why do you want to be a lobby boy?"* M. Gustave enquires. *"Well, who wouldn't?"* replies Zero Moustafa candidly. M. Gustave's presumably modest origins and Zero Moustafa's not entirely compliant legal papers are of little importance; once they don the uniform of the Grand Budapest Hotel, with its flamboyant colors, they become members of a society apart, a world that exists under a dome, governed by rules from another time, sheltered from the outside world… or almost. On spotting the soldiers posted on the railways leading to Lutz, the carefree M. Gustave sniffs with disdain, appalled by the blandness of their uniforms.

While totalitarianism lurks outside, in its morose gray uniform, the dazzling concierge fervently maintains the hotel's standing; elegance becomes a last bulwark against barbarism, and poetry, as a means to combat the horrors of war. It's a losing battle for both the idealist M. Gustave and for the eminent Grand Budapest Hotel, both caught up by the tides of history. Many years later, in the grounds of the aging hotel, Zero Moustafa remembers his comrade in arms: "*To be frank, I think his world had vanished long before he ever entered it—but, I will say: he certainly sustained the illusion with a marvelous grace!*" In memory of his lost love, of his friend M. Gustave and of the fallen glory of the hotel, Zero Moustafa, now in the twilight years of his life, recounts the incredible adventure of the Grand Budapest Hotel. He is dressed in a velvet jacket in deep shades of purple, the color of days gone by. 🔑

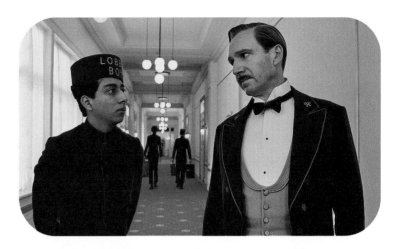

Margot's Fur Coat
The Tenenbaum Mystery

"**S**he was wearing a sheared-raccoon coat, and Lane, walking toward her quickly but with a slow face, reasoned to himself, with suppressed excitement, that he was the only one on the platform who really knew Franny's coat. He remembered that once, in a borrowed car, after kissing Franny for a half hour or so, he had kissed her coat lapel, as though it were a perfectly desirable, organic extension of the person herself."[1] This is how the character of Franny is depicted in J.D. Salinger's work *Franny and Zooey*, all dressed in fur, stepping off the train, while Lane, seeing her coming, fails to repress a gesture that betrays his emotion. Franny Glass and Margot Tenenbaum might well be distant cousins. The two New Yorkers certainly have a lot in common: their love of books and theater, their feverish chain-smoking habit (even though Margot smokes

cigarettes of the imaginary brand "Sweet Afton"), a certain affinity for kissing in cars, and finally, their iconic fur coat. In fact, Franny's "entrance" could just as easily describe Margot's arrival as, wrapped up in her long coat, she steps off a Green Line bus to meet her adopted brother, in a slow-motion sequence that speaks volumes about the latter's feelings toward her.

One might point out that Margot's fur coat, too, appears to be "*an organic extension*" of her person. Like all Tenenbaum children, Margot is bound to wear what resembles a uniform, which she only removes on the rarest of occasions. The brief glimpse the film allows us to take into her closet indeed reveals a room invariably filled with silky fur coats. In Anderson's movies, every character wears an outfit of their own: the

1. J.D. Salinger, *Franny and Zooey*, Back Bay Books, January 30, 2001.

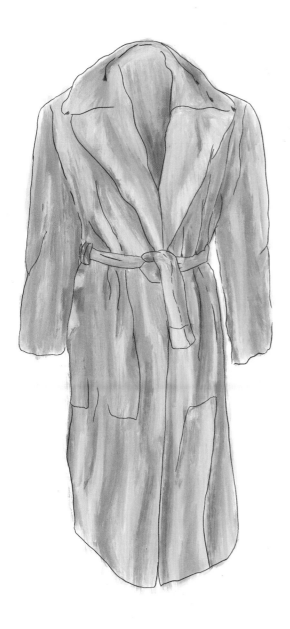

elevator attendants don the purple suits worn by modest bellboys, while the Tenenbaums wear the Tenenbaum uniform. This strange attire, which remains unchanged throughout the years, reveals an insight into the young woman's troubled psyche. *"In The Royal Tenenbaums, the 'uniform' also helps to reinforce the idea that the Tenenbaum children peaked in childhood. We see these people at age 10, and then suddenly at age 30. And part of the story is how they're connected to the way they were then,"*[2] explains the filmmaker. During our guided tour, we will return to take a closer look at this strange *Andersonian* disorder that sees adults and children swap roles, as if in a game of mirrors. As a result, the precocious siblings soon grow into barely functional adults, entangled in the memory of a certain golden age of the Tenenbaums.

In this respect, the only Tenenbaum daughter's outfit constantly blurs boundaries, revealing to what extent Margot is at odds with the world that surrounds her. As a child, this thick fur coat—a symbol of femininity, charged with a whole imaginary world of luxury, even sensuality—appears to weigh heavily on the little girl's frail shoulders. In adulthood, on the other hand, while the luxurious fur coat no longer appears incongruous, Margot's entire outfit suddenly seems inordinately childish. Margot still wears the moccasins that she wore throughout her youth; her never-changing Lacoste dress, decorated with colorful stripes, has become too short, a symbol revealing the secret influence of her feelings for Richie, a tennis player himself. When one gazes upon Margot's impassive face, one notices the same features: her large, light-colored eyes are heavily rimmed with black, while her smooth, blond hair is held back in a sensible parting by a little girl's red plastic clip. Looking terribly sophisticated in her caramel-colored fur coat, carrying a timeless *Birkin* bag designed by Hermès on her arm, Margot nevertheless looks like a child dressing up in her mother's clothes. Beneath her elegant coat,

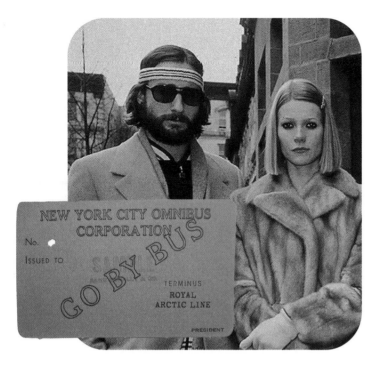

stage in the role of a wounded zebra, draped in a striped fur costume. This totem animal, to call it that way, even appears on the crimson tapestry of her childhood bedroom, on the third floor of the family home. Attentive viewers will recognize many of the animal prints, zebras and leopards, among the furs hanging in the closet. Beneath the young woman's apathetic appearance, the fur coat may indeed betray a dormant wild nature. Silent and distant, cultivating the utmost secrecy about all details of her life, Margot remains an elusive character. And since it is never a good idea to ask too many questions about mysteries, perhaps at the risk of giving them away, Margot's outfit with all its superb contradictions, ensures that the aura surrounding the young woman is never dissipated. On the contrary, the heavy, coppery fur coat further adds to the mystery embodied by Margot Tenenbaum. ⚷

her rebellious soul shines through, manifesting in her smoky make-up, her nasty habit of smoking on the sly, her repeated attempts at running away and her secret adventures. The mysterious Margot is reminiscent of a number of glamorous and marginal idols, among which the singer Nico, whose deep, unyielding voice resonates when Margot makes her first appearance, to the track *These Days*.

Here, the movie director's love of props and costumes truly shines through; during the preparation of the film, he imposed a significant restriction: no item should be purchased, everything should be made.[3] Created by Fendi from sketches and notes by Anderson and his costume designer, Karen Patch, this uniform, like many others envisioned by the filmmaker, becomes a narrative element in its own right. The siblings wear their neuroses on their sleeves, like Richie, who never leaves his Björn Borg-style tennis headband, the vestige of a broken career, and Chas, whose family uniform reveals the extent of his trauma: since the death of his wife, Chas has imposed it on all in his clan, as if to better bring his shattered family together, fearing that it would otherwise disintegrate before his eyes. Margot's uniform, however, is even more remarkable. From the age of eleven, the little girl took to the

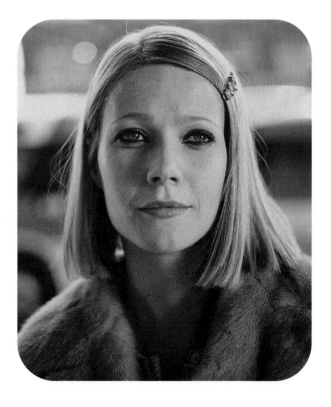

3. Mary Sollosi, "*The Royal Tenenbaums costume designer looks back on dressing 'a family in decline'*", *Entertainment Weekly*, 18 October 2021.

The Yellow Jumpsuits From *Bottle Rocket*

Amateur Bank Robbers

Dignan's choice of outfit for a heist is indeed a curious one. Dressed in bright yellow jumpsuits, Dignan and his gang storm a refrigerated warehouse, where they rob a safe. A first "big score" for these weekend criminals, who are a little more accustomed to robbing local bookstores, or even their own parents. Of course, these canary-yellow jumpsuits have one definite disadvantage: they are rather flashy. However, they also offer the not inconsiderable benefit of boosting team cohesion—and this feature, both for Dignan and for Wes Anderson, is by means no means unimportant. Here is a point that Anderson feels particularly strongly about, and which he already openly expresses in *Bottle Rocket*: the need to belong to a family, in the broadest sense of the term—families bound by blood, like the Tenenbaums,

but also other kinds of families, brought together by the strength of a calling, such as a strange brotherhood of butlers, by their sense of adventure, such as a tribe of little scouts in khaki outfits, or around a charismatic, but misguided leader, such as a crew of oceanographers aboard a rickety submarine… When the whole world turns its back on Andersonian characters, they turn toward their own small, offbeat, marginal communities, for good. Dignan is therefore the founder of the first "battalion" in Wes Anderson's cinematographic works, and his need to belong—a slightly more obsessive pursuit—already foreshadows the obsession that will run throughout the director's filmography. Yellow is hardly a discreet color, that much is true. However, Dignan is not one to let himself be concerned about such minor details—which is a pity, we shall

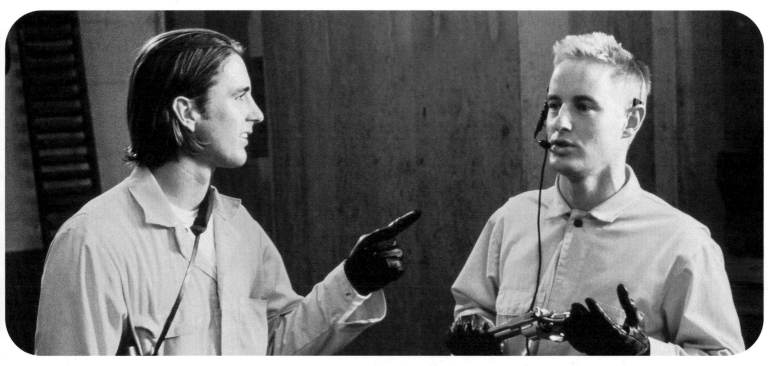

agree, because he is indeed the brains behind the operation. No doubt inspired by gangster movies, the young man turns out to be a dangerously incompetent strategist, obsessed with lists, notes, plans, inventories and anything that might procure him the illusion of mastering, to a modest extent, the chaos that surrounds him.

It's hardly surprising, then, that Dignan, too focused on the importance

of dressing his sidekicks in bank robber outfits, somewhat neglects the "practical" aspect of this camouflage. His inextinguishable thirst for adventure is never hindered by reality, even when reality hits him head-on. It soon becomes very clear indeed that while *Bottle Rocket* may be a gangster movie, it also depicts the most inoffensive and ineffectual succession of heists in the genre. Instead, *Bottle Rocket* reveals itself to be a thrilling comedy about failure and disorganization. The inexhaustible Dignan, brimming with energy that he doesn't quite know how to expend,

decides to orchestrate an outlaw life for himself and his friend Anthony. Their first misdeeds—the escape from the wide-open hospital, the parents' burglary, the safe robbery—are merely the initial stages of a twenty-five-year plan that will turn them into genuine godfathers.

And it would indeed require all that devastating energy to drag along a depressed Anthony, who was all too aware of the plan's catastrophic potential, but who frankly didn't have the heart to stand up to his friend. As a matter of fact, the robbery's success matters less than the feeling of camaraderie and the enthusiasm generated by the operation. In the absence of their respective families (their parents are nowhere to be found), the promise of a surrogate family brings our amateur criminals together under the tutelary shadow of the mysterious Mr. Henry. In this respect, the appearance of the yellow jumpsuits, in the last stretch of the movie, embodies as a genuine

achievement for the gang. "*You like it?*" Dignan asks Anthony hopefully, presenting him with the uniform. "*I ordered a dozen of them.*" With his crew cut and his protective goggles, perched on his backfiring motorbike, Dignan rides into the subdivision, where he is greeted with nothing but mockery from neighbors. It is to protect him from this newest humiliation that Anthony decides to don the very becoming yellow jumpsuit. Dignan, a character who is a little too intense for his own good, wears his jumpsuit buttoned all the way up to the collar, while the other members of his gang wear theirs with the carelessness typically displayed by those who are a little less convinced of what they are doing. When finally, the plan goes awry (how could it not have failed?), Dignan shows his colors and acts a true team leader, not hesitating to turn back to save one of his gang—even if for him, it means going to jail. Far from dampening the young man's wonderful enthusiasm,

this arrest almost turns the movie's final chapter into a happy ending. When they visit their friend at Wasco Penitentiary, Anthony and Bob find him wearing a white inmate's jumpsuit—an exact replica of the famous yellow jumpsuit used for the robbery, which Dignan is thrilled to wear among his fellow prisoners. "*We did it, though, didn't we?*" he says, not hiding his pride. The would-be criminal has somehow become a real criminal—at least, in the eyes of the law. Filmed in slow motion, his exit, handcuffed and parading as a resplendent outlaw, is an ironic consecration, but a consecration nonetheless. "*Yeah,*" Anthony replies, "*we did it, all right.*" ⚷

The Raccoon Hat
A Sense of Adventure

There are clothes and accessories that are so evocative that they carry with them a whole imaginary world, have the power to revive a childhood memory, or are able to trace the outline of a character in the blink of an eye. The famous raccoon fur hat, adorned with a long, bushy tail, is unquestionably one of these magical accessories. This striking hat immediately conjures up the figure of one Davy Crockett. Long considered one of the most popular figures in North American mythology, the historical figure soon gave rise to the legend, extricating himself from history books and venturing into folklore. However, it was unquestionably the television show produced by the studios with the big ears, broadcast in the mid-fifties on ABC, that rekindled the flame. A Davy Crockett fever spread like wildfire all across the United States—attractions, comic books, spin-off products… Disney, acknowledging the success of its TV show, proceeded to wring out the myth for all it was worth. In 1960, for his first stint behind the camera, John Wayne chose to play the American hero himself, heading off for his last battle in *The Alamo*. Driven by the vastly romantic imagery of the Wild West, Davy Crockett's character became the seminal figure of the American adventurer. It therefore comes as no surprise that a few years later, in the late summer of 1965, on a small island off the coast of New England, a very young boy by the name of Sam Shakusky has fun going on an adventure. Wearing his irreplaceable trapper's hat, Sam imagines himself as the heir to the American pioneer.

In Wes Anderson's movies, indeed, the clothes do indeed make the man: when

20

the young boy dons his raccoon hat, he instantly turns into a perfect adventurer. And while many children play "as if," they are no match for the intensity of Anderson's young heroes, who, when they play pretend, really aren't pretending at all. Let us mention here the epic assault scene in which the scouts rush onto the battlefield, like a scaled down and not entirely reliable reinterpretation of the great battle of Fort Alamo, where Davy Crockett lost his life. Right from childhood, when he was directing short plays, Wes Anderson put himself in the shoes of the American hero: *"We did a play, The Alamo, that was just like a big war scene. […] When I look back, it seems kind of static, because everybody was just sitting in these cars. I always cast myself as the hero. Maybe that was the reason I wanted to do them,"*[1] he recalls. For the filmmaker, it is certainly an opportunity to get to grips with this piece of Texas history, where he was born. Of course, the confrontation in *Moonrise Kingdom* ultimately boils down to a wild race across the fields, filmed as a wide shot, which looks somewhat less like a battle and rather more like an orienteering race. It reaches its climax when our young hero utters this impassioned cry for peace,

1. Phillip Zabriskie, *"Who's Laughing Now?", Icon Thoughtstyle*, September 1998.

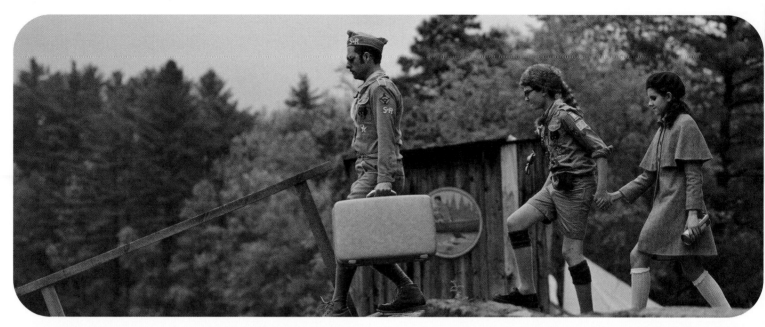

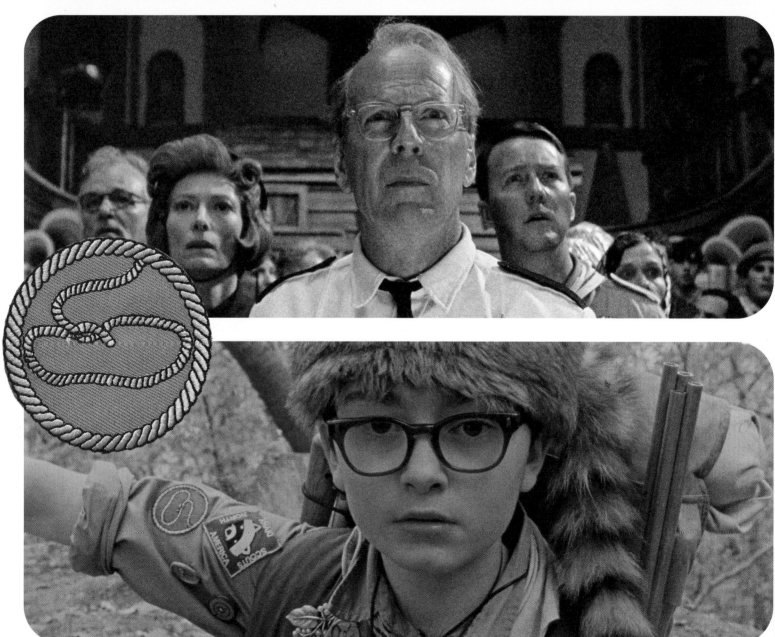

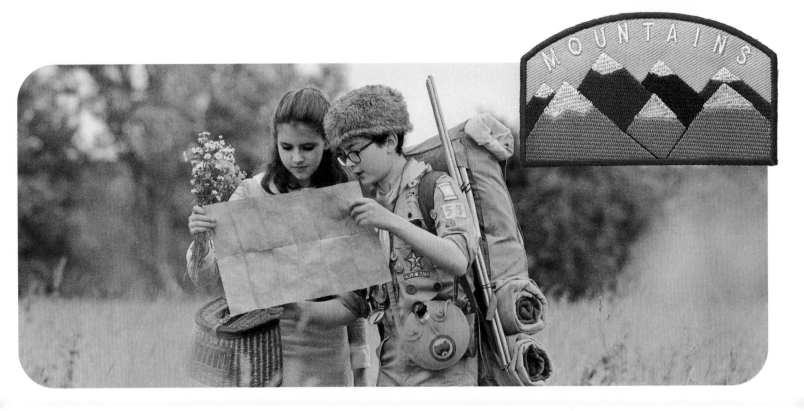

borrowed from a famous tribal chief: "*On this spot I will fight no more, forever!*" Abandoning the historical legacy, Anderson rather focuses on what really interests Sam's character and his gaggle of scouts: a sense of adventure. While Sam shares this penchant with many other characters in Wes Anderson's universe, he does embody it with great ado, and in this regard, the director himself is not one to be outdone. For example, let us remember that his great-grandfather is none other than the American writer Edgar Rice Burroughs, father of another iconic character in popular culture: Tarzan. In this tale, references to adventure literature abound, from Davy Crockett to Ivanhoe and Peter Pan. Indeed, what are these young scouts if not lost boys?

And yet, in the midst of this little society of scouts, straight out of a Norman Rockwell painting, something is brewing. Sam and Suzy leave nothing to chance when they decide to flee, and when they retrace the migratory trail of the Chickchaw Indians, it is to better pursue this fantasy of a world that has now disappeared, of wild and yet untouched territories, far from human society, where one might perhaps be able to live in absolute innocence.

Indeed, because a sense of impending doom hangs heavily over the movie, like a stormy sky. This isn't about the storm that the narrator benevolently keeps harping on about throughout the movie—no, this storm would be rather harmless. Instead, *Moonrise Kingdom* is pervaded by a feeling of overpowering catastrophe, the loss of a certain innocence—Sam's and Suzy's, as they come to terms with the disorders of adulthood, and that of the United States which, two years after the assassination of President Kennedy, hear the distant drums of war beating in Vietnam. In this context, the harmless "militarization" of the little scouts has a strange ring to it, given that a far less fake war awaits them on the threshold of adulthood. In the face of very real danger, Davy Crockett's tall, trapper-like figure more than ever evokes the innocence of childhood, a blessed time rife with adventure, when war was nothing more than a game played by children in the shade of forests on an island lost in the middle of the Atlantic, as summer slowly draws to an end. ⚷

The Hotel Chevalier Bathrobe
The Town That Dreaded Discomfort

Guests yearn to don it the moment they walk through the door to their room; some even call reception to complain about its absence—a technique that enables them to have staff provide them a second bathrobe, so that they can secretly take it with them when they leave. Its terrycloth fabric is unquestionably the ideal material when stepping out of a bath. It is worn in the evening, after a hard day's work, or on weekends, as a way of celebrating the time for rest. It is enjoyed for its thickness, its softness and its warmth; it is best worn slightly oversized, like a large blanket. One sometimes sleeps with it, wrapping oneself in it as if it were a second skin. This item is the bathrobe. And if there is a "bathrobe moment" in Wes Anderson's filmography, it is unquestionably in the short movie that precedes his movie *The Darjeeling Limited: Hotel Chevalier.*

Shot in Paris, in a real hotel, the Hôtel Raphaël, everything about *Hotel Chevalier* exudes French–Parisian, even–fantasy. In the background, the

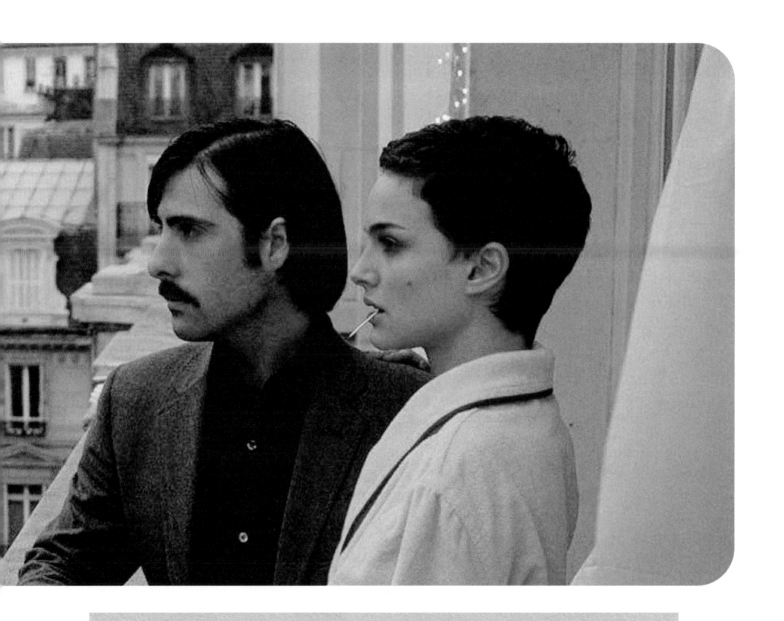

JACK WHITMAN

■ ■ Hotel Chevalier
Guest in Residence

Luftwaffe Automotive

He had been killed suddenly,struck buy a
cab while crossing the street. A service was
scheduled for the following week and family
members flew or drove into town.I was in a
rented funeral car with my brothers and

song "*Where Do You Go To (My Lovely)?*"
by Peter Sarstedt depicts this fantasy
à la française, invoking many symbols,
from the Sorbonne to the Grand
Boulevards, from Zizi Jeanmaire to
Sacha Distel. A luxurious room, albeit
a little old-fashioned, provides the
backdrop for the play that follows: a
couple on the verge of a breakup meet,
perhaps for the very last time… As
Jack Whitman bears the crushing weight
of his unhappiness in his untidy
yellow bedroom, unshaved and wrapped
up in his bathrobe, lying down and
watching an old movie by Billy Wilder
(*Stalag 17*), the telephone rings.
His girlfriend turns up unannounced.
Jack barely has time shake himself
up before she knocks on the door and
bursts into the room, as if entering
familiar territory, exploring Jack's
belongings, borrowing his toothbrush
without asking for permission,
slipping a mysterious item into his
half-open suitcase. The seemingly
polite chatter becomes increasingly

mysterious, laden with innuendo,
revealing a complicated story of which
the viewers know almost nothing. This
dialogue, which bears the hallmark
of *French movies*, is interrupted by
room service bringing in Jack's lunch
tray—chocolate milk and a cheese
sandwich; indeed, when Jack placed his
regressive order, he had no idea that
his pretty girlfriend was on her way
to see him). Soon, the two lovers slip
under the covers together. The couple
waste no time, obviously wanting to
give each other tit for tat, to put
things chastely. The bruises on the
young woman's body further muddy
the waters, hinting at her painful
past. An elegant tracking shot then
reveals Jack Whitman's seductive
girlfriend, played by Natalie Portman;
looking slightly tomboyish, with her
short hair, she towers over him, and
dressed only in white socks. There
she stands, leaning against a piece
of furniture, akin to a statue placed
in the middle of a shot where the

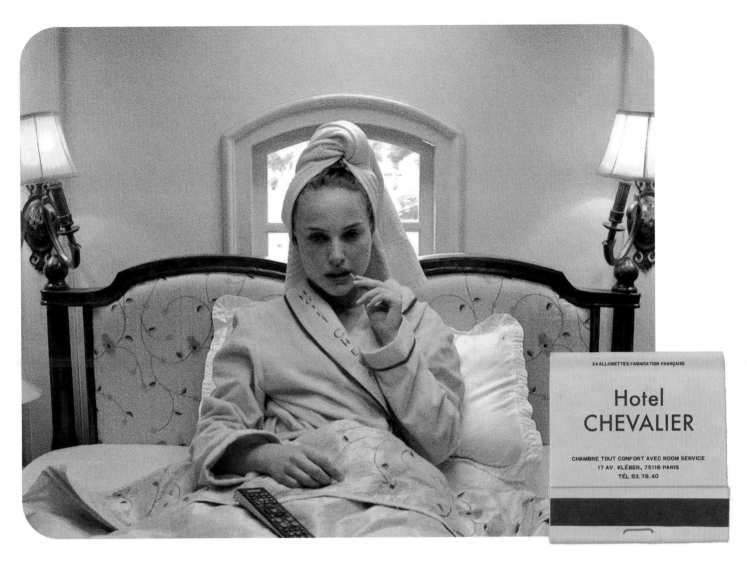

only for her. Jack approaches her in slow motion, and, with one gentle movement, covers the young woman's naked body with a yellow bathrobe bearing the seal of the Hotel Chevalier.

In Wes Anderson's mind, this brief poetic short movie, which runs for only thirteen minutes, soon merges with the movie *The Darjeeling Limited* providing a poignant prologue, shedding a little light on Jack's melancholy. Above all, this concise scene sheds new light on the beginning of the short story written by the character at the end of the movie, as if to exorcise his difficult breakup. ⚷

Björn Borg's Outfit
Most Elegant (Terrycloth) Ensemble

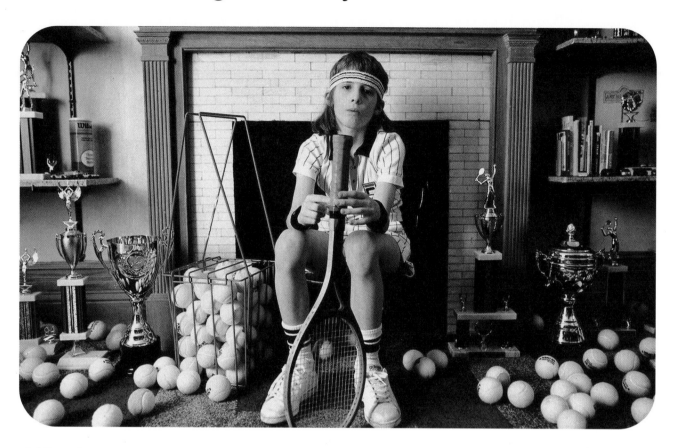

"*I*n the Tenenbaum family, I choose Richie.*" A prodigal son and an extraordinary tennis champion, from an early age on (until his collapse on live television, which we will mention in further detail later on), groomed to the very tips of his long hair, Richie Tenenbaum is to his family what Björn Borg was to the world of tennis: the embodiment of elegance. What could be more obvious in the world of a movie director who cares for nothing more than chic and refinement, and wears a skillfully tailored suit on every occasion!

Björn Borg, whose heart beat only forty-five times a minute, ruthlessly dominated world tennis with a class and a weightlessness that would once only ever grace the ATP rankings. A quintessential star of the seventies and early eighties, the tennis player won every tournament, writing his name into the legend of the sport and pop culture, reaching far beyond the lines of tennis courts. Impassive on courts worldwide, his phlegmatic attitude contrasted radically with that displayed by his most famous opponents of the time, such as John McEnroe, Jimmy Connors or Ilie Nastase, all of whom were known for their Homeric tantrums, both on and off the courts. This sphinxlike attitude earned him the nickname "Iceborg", fitting indeed for a player hailing from the Nordic country of Sweden. Sporting a long, honey-colored mane, Borg's figure slender, lanky figure seemed to have been honed to soar above the courts, as he swooped down on his opponents with the speed of a bird of prey. In 1976, he even outran French runner Guy Drut, a gold medalist in the 110-meter hurdles race, during a 600-meter steeplechase. Borg played with a grace that was approached only by Roger Federer during his fantastic career. But beyond his highly recognizable physique, Björn Borg had that little something extra that the others lacked—a characteristic outfit.

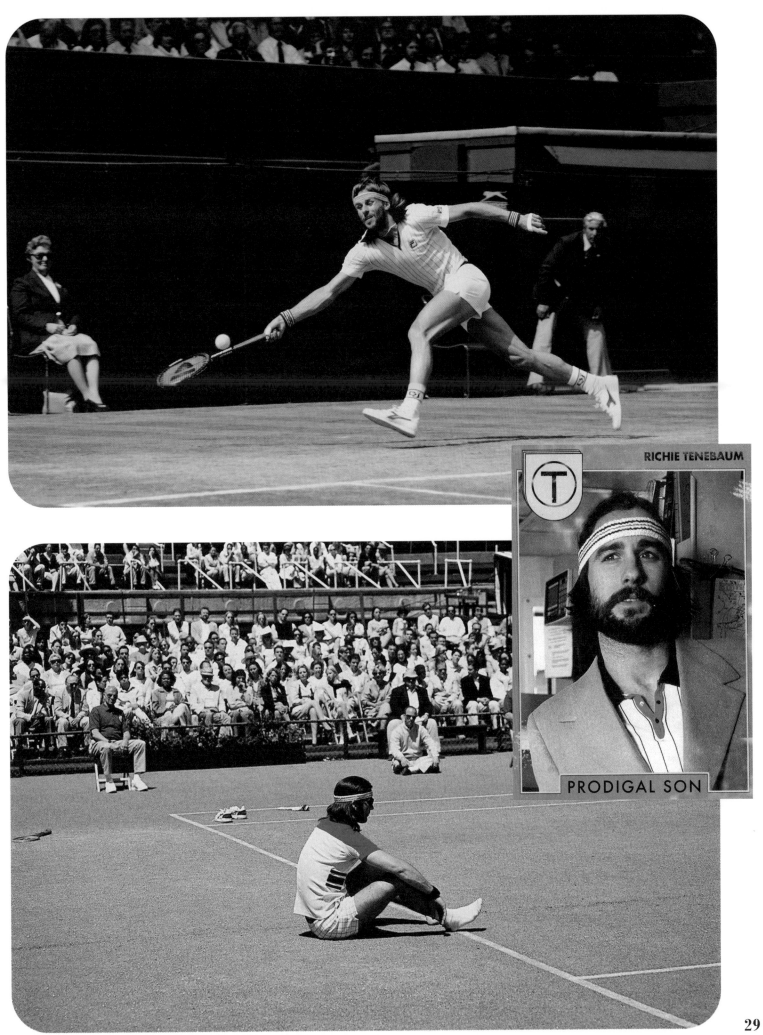

RICHIE TENEBAUM

PRODIGAL SON

A Donnay wooden racket, white sneakers and matching socks, equally immaculate shorts, an impeccable white polo shirt adorned with black pinstripes, featuring an open V-neck edged in black, generously emblazoned with the logo of the Italian brand Fila. When *GQ* magazine asked him about this preferred outfit of his, Björn Borg replied that he had become very superstitious: "*The clothes I wore when I won became my lucky clothes. I had a lot of success on court in those pinstripes, and so many great memories…*"[1] However, the features that made him instantly recognizable were his two wristbands and the terrycloth headband holding back his abundant hair, ensuring that always retained his incomparable elegance, even when he moved to play close to the net. It was in 1975 that the player donned his famous headband for the first time, at the Roland Garros tournament, which he won. Of course, he would never again part with it. This iconic headband would disappear from the tennis courts when Björn Borg retired, as if he were the only one worthy of wearing this terrycloth item…

It didn't take much for Wes Anderson to draw inspiration from this "larger than life" character–a graceful and distinguished sportsman, who was almost aristocratic in his attitude, and an unrivaled champion to boot. Borg became the main reference point for Anderson's character Richie Tenenbaum, played by Luke Wilson, both openly depressed and also unfailingly elegant. In *The Royal Tenenbaums*, Richie, nicknamed "The Baumer", is also a former high-profile tennis champion. Akin to all Tenenbaum children, his glory days are long gone, but that doesn't stop him from sporting his unchanging tennis kit, complete with the pinstriped polo shirt and the terrycloth headband, under an elegant fawn-colored city suit. Richie Tenenbaum is unable to shake the memory of days gone by, and his strange uniform is tinged with an even more depressive hue—like a fallen alter ego of the famous sportsman, he obscures his facial features with a long, unkempt beard and thick sunglasses, holding a Bloody Mary in his hand. While on his boat, the *Côte d'Ivoire*, sailing across oceans with no real purpose, he receives a message that moves him, with his falcon Mordecai (another bird of prey), to return to the fold.

Richie Tenenbaum's career came to a screeching halt during a decisive match, on 15 July 1994. "*Meltdown! Tenenbaum suffers mid-match nervous collapse in the semis at Windswept Fields*," reads the headline of *Sporting Press Magazine*. Seeing his adopted sister, Margot, the day after her marriage to Raleigh St. Clair, twenty years his senior, Richie collapses in front of the cameras, removes his shoes and socks and bursts into tears, as viewers around the world look on in bewilderment. "The Baumer" would never recover from this failure, lugging his grief across oceans worldwide, sailing toward a future that he struggles to define. Indeed, Richie's existential tragedy is not the abrupt end of his career, but the love that he has for Margot. The mysterious Margot, moving through life amid clouds of cigarette smoke, free and unbound by any real ties. Upon hearing of Margot's amorous and sexual relations and learning that she has cuckolded her husband Raleigh St. Clair, played by Bill Murray, displaying the discomfited look that he is known for, the crestfallen Richie even attempts to take his own life. Margot eventually confesses her love for him, even though the semi-incestuous nature of their

1. Stuart Brumfitt, "*Bjorn Borg on being a tennis style icon*", GQ, July 2022.

relationship will never enable them to officially disclose their feelings for each other.

While Björn Borg never removed his socks off on the court in the middle of a semi-final match, he shocked crowds worldwide by announcing his early retirement at the age of just twenty-six years, exhausted by the pressure and the unrelenting media coverage; and like Richie, Björn Borg was still very young when his career began. It was certainly no coincidence when Wes Anderson chose the lawn of an imaginary Wimbledon to bring the sporting adventures of Richie Tenenbaum to an end. Indeed, it was on this same central London court that the unsinkable Björn Borg won the tournament against John McEnroe on 5 July 1980, in a match that is still considered one of the most legendary in the sport's history. As if in a parallel universe, Wes Anderson, however, decided to defeat his character. A cruel twist of fate, concluding the game, set and match. 🔑

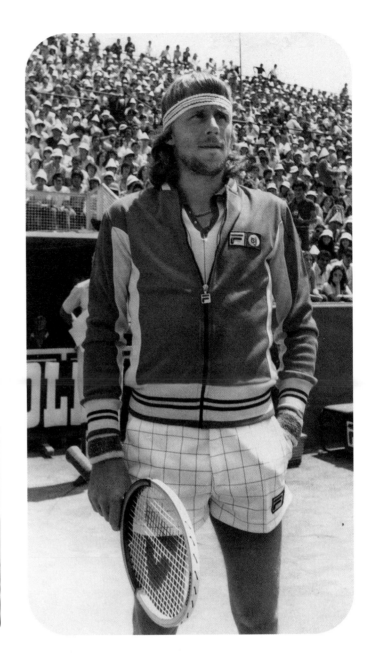

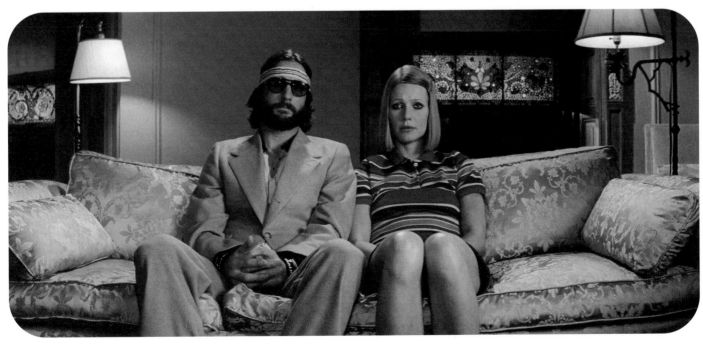

Montana's Blue Jeans
The Last American

They embody the American uniform *par excellence*, worn by the legendary John Wayne, movie after movie, the cowboy's unfailing best friend, along with his gun, hat and horse. "They" are denim jeans, named after the geographical origin of the cloth used to make them, "*de Nîmes*"—a fabric that, when produced with care, is practically indestructible, available in infinite shades of blue. Worn like a second skin by Montana, the soft-eyed rancher from *Asteroid City*, blue denim jeans become a real eye-catching feature.

Indeed, our cowboy boldly dons a blue denim outfit from head to toe. He wears denim jeans and a deep blue denim jacket, contrasting starkly with his light-colored hat, which he promptly removes in the presence of ladies. This outfit, which is uncharitably nicknamed "Canadian tuxedo," is a bold, slightly old-fashioned statement that is rarely seen in the modern world. In Montana's eyes, however, it is the only outfit worth wearing, and one can hardly imagine his character, whether by day or by night, parting ways with his timeless American uniform. A cigarette in his mouth, a campfire crackling at his feet, with a handful of chance companions strumming the strings of a well-tuned guitar: this is how one pictures Montana's character, long after the screen has gone dark. This lonesome *cowboy*, straight out of American myth, would ride off into the distance, with one steely blue eye turned toward the horizon. There is so much land to explore in the vast expanses of the Wild West. Indeed, in the blink of an eye, Wes Anderson sketches out his character and sets him in one of the great traditions of American cinema. From James Dean, the rebellious teenager in *Rebel Without a Cause*, to Marlon Brando in *The Wild*

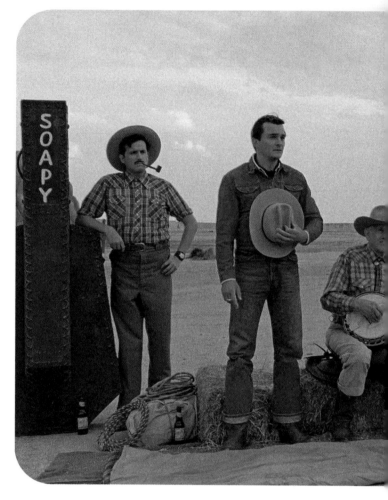

One, not forgetting Marilyn Monroe in *The Misfits*, blue jeans conjure up a powerful symbolism, inhabited by a fiercely free youth and characters living on the fringes of the world.

Montana is unquestionably a cousin of John Wayne and a brother in arms to the singing cowboys, archetypal heroes who ensured the incredible success of the musical western genre—icons that invoke, in this light-eyed cowboy and musician's character, memories reminiscent of Elvis Presley's crooning in *Love Me Tender*. One finds oneself dreaming of donning these denim jeans amidst the vast expanses of the American plains, of getting them dirty, of wearing them down to their

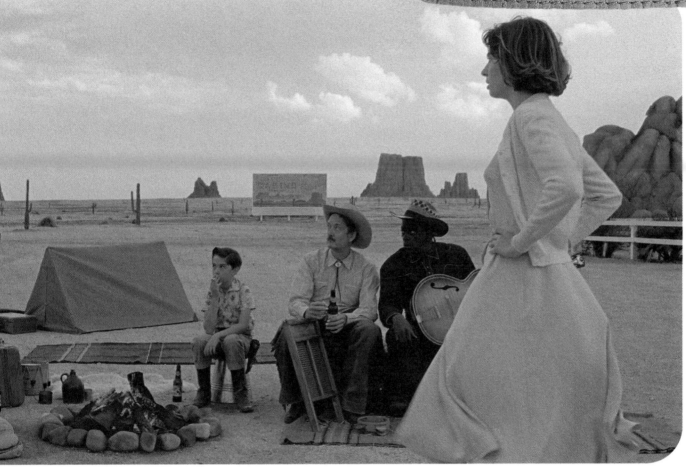

bare threads. Indeed, denim jeans are foremost clothes designed for hard toil, worn by cowboys and workers, like the famous overalls worn by Henry Fonda in John Ford's *The Grapes of Wrath*. They are a garment of recognition, like a casual wave that two people would exchange: "*Hey, buddy! How's life treating you? Still a way to go, huh?*"

Wes Anderson has no equal when it comes to luring us into all the commonplaces and archetypes that he mischievously reappropriates and redistributes. Blue jeans tell all these tales, and many more. At the end of the day, distinguish legend from reality is altogether unimportant, as both form an inalienable whole in Wes Anderson's world. What is important here are the stories that are conveyed through sets and costumes, and even the smallest details of a consistently meaningful stage direction. This is what Montana, in his blue jeans with wide hems, his leather boots planted in the earthy ground and his hat firmly placed on his head, seems to be saying to us, as he stares us straight in the eyes: "*I am the last American, and this is my uniform.*" A uniform steeped in history, the history of the Wild West and a certain vision of the United States. ⚷

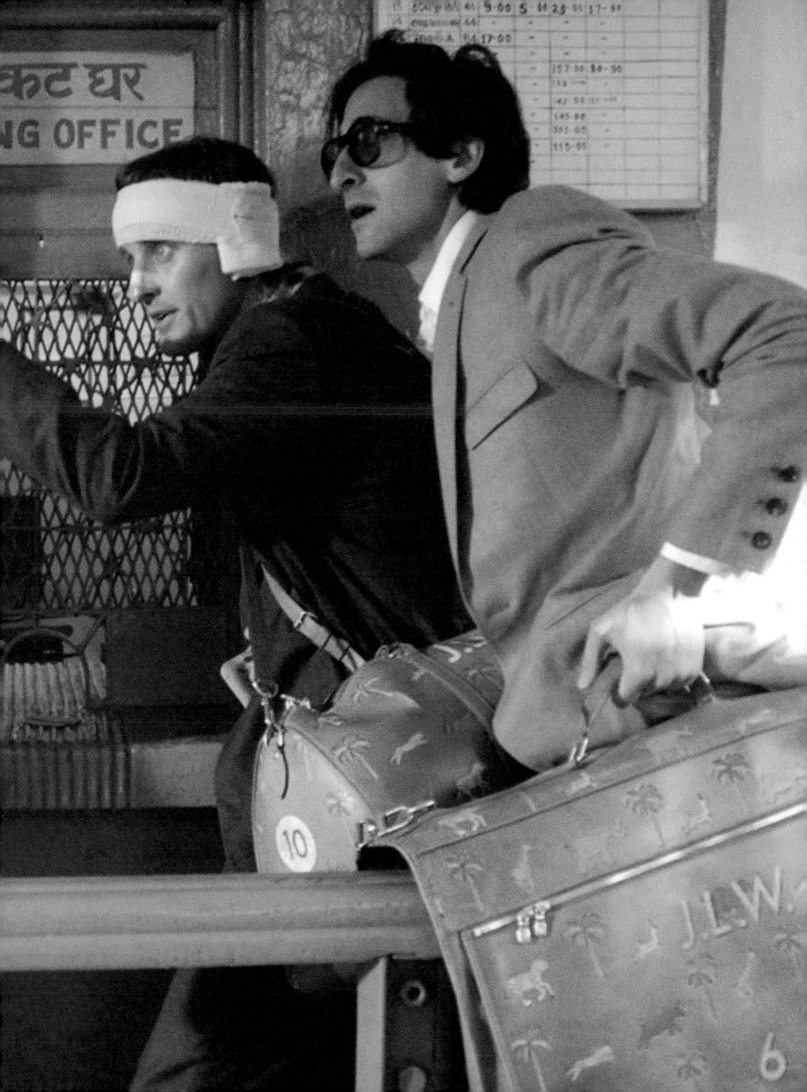

III

THE LIBRARY

Whether playwrights, columnists, poets, revolutionaries, journalists, editors or novelists, Wes Anderson's world is inhabited by talented writers, tapping away at their typewriters, filling their notebooks with black ink, reworking reality, reviving lost memories through the sheer force of their writing. There is little amusement to be had, however, in watching a man type, no matter how talented he is. So, as the narrator of Asteroid City suggests, it's better to *"Skip ahead, then, past the lonely, agonized months of composing, revising, polishing, editing, rewriting, cutting, pasting, pacing, doodling, and solitary drinking"* and get squarely to the point. Books, magazines and plays occupy a prominent place in Wes Anderson's world, and one can also easily picture him as an avid reader. His movies themselves seldom shy from taking on the guise of novelistic or theatrical essays, in an eternal game of *mise en abyme*. Even our well-stocked bookshelves would not suffice to accommodate the profusion of literary references that dwell within the Texas director's works. On this library's shelves, real-life works rub shoulders with purely fictional creations, born straight from the filmmaker's inexhaustible imagination. Political manifestos, memoirs, legendary magazines, high school plays and literary classics are collected in this section of the museum, listed in the most alphabetical order possible. We will leave it to readers to rummage through this imaginary library and delve a little deeper into the director's universe, rich with annotations and handwritten notes. So, open the doors to this library, remove your shoes and slip into your most comfortable slippers. Please be so kind as to whisper and respect the silence of this place; now is the time for some calm and reading. Bookmarks are available; however, house rules indeed allow you to bend page corners. We wish you a pleasant journey, without forsaking the comfort of your slippers.

Stefan Zweig
Remembering the Things We Lost

All the way down, on the very last tiers of this imaginary library's shelves, and with all due respect to the most fundamental rules of the Dewey Decimal Classification, one finds the letter *Z*. Carefully browsing the contents filed under the letter *Z* will inevitably lead us to the works of Stefan Zweig, to whom Wes Anderson pays a mischievous tribute in one of the masterpieces of his filmography, *The Grand Budapest Hotel*. While this movie is not a direct adaptation of one of the writer's works, it is certainly an adaptation in spirit. Indeed, Zweig's shadow haunts every corner of the noble institution that is the Grand Budapest. Color and nostalgia, the merciless struggle playing out between barbarism and civilization, between brutality and elegance, between worlds old and new: everything here speaks Zweig's language.

Born in 1881 in the former Austro-Hungarian Empire, Stefan Zweig was heir to the Europe that he called his *"spiritual homeland,"* where Vienna embodied the fascinating crossroads to which all of the old continent's artists and intellectuals were drawn. Graced with incredible culture, fluent in several languages, disarmingly polite and refined, the writer shared some personality traits with the obliging M. Gustave, who could well be his whimsical double. However, Stefan Zweig's Europe was not the one depicted on maps featuring neatly drawn borders; a citizen of the world, first and foremost, he identified with a European ideal that stood on the brink of collapse. In *The World of Yesterday*, in 1941, he chronicled the decline of this civilization until the

Second World War broke out, forcing him into exile and further tormenting his mind.

Akin to M. Gustave, who chose to overlook the announcement of war (even though it was printed in capital letters in the *Trans-Alpine Yodel*), Stefan Zweig initially underestimated the consequences of the rise of the Nazi Party. Then, like the young character Zero Moustafa, forced to flee his country, the Jewish writer would experience the anguish of exile. "*I grew up in Vienna, the two-thousand-year-old super-national metropolis, and was forced to leave it like a criminal… And so I belong nowhere,*"[1] he lamented in *The World of Yesterday*. Like the bellhop, an illegal refugee, Stefan Zweig would remain haunted by the cruel memory of clandestine life. "*For all that I had been training my heart for almost half a century to beat as that of a citoyen du monde, it was useless,*" he recounted. "*On the day I lost my passport, I discovered, at the age of fifty-eight, that losing one's native land implies more than parting with a circumscribed area of soil.*" After the painful episode of losing his passport, Zweig also recalled the words printed on the British document that was finally issued to him: "*ENEMY ALIEN.*"

These memories, recorded in his testimonial autobiography, are all echoed in Wes Anderson's work. In *The Royal Game*, a short novel published posthumously, Stefan Zweig mentioned an institution that could be the twin of the Grand Budapest—the Grand Hotel Metropole in Vienna, a luxurious Haussmann building that was confiscated by the Gestapo in March 1938. Transformed into a headquarters on Heydrich's orders, the hotel became a hive of activity, where civil servants and officers went about their sinister business. In the Republic of Zubrowka, the same fate would befall the Grand Budapest when it was taken over by the Zig-Zag brigade, who would hang on the walls its heavy black banners, adorned with two large *Zs*. In addition to their affection for things of the past and their fallen grace, the director and the writer share a certain taste for the art of narratives intertwined with

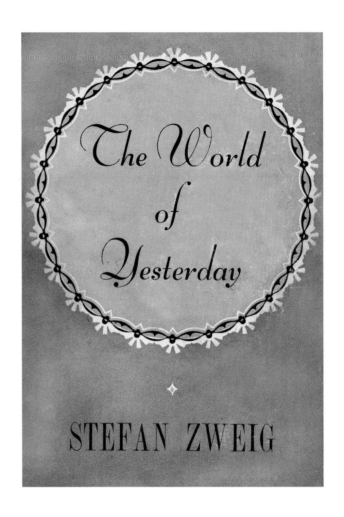

1- Stefan Zweig, *The World of Yesterday, Memoirs of a European*, Viking Press, April 1943.

intertwined with other narratives. This, indeed, is one of Stefan Zweig's great specialties: the narrator encounters a mysterious character, who tells him his story. In this way, *The Grand Budapest Hotel* is a vast game of narrative folding: the story of the hotel in its heyday is recounted by Zero Moustafa, many years later, in the establishment's dilapidated dining room; the story itself is transcribed by the Zubrowkan writer in the pages of his book, and the book itself is read by a young reader, who has come to pay her respects at a statue of the author. At the end of the movie, the filmmaker naturally lays out his work, through the ages and the voices that have carried this story. Like Stefan Zweig before him, Wes Anderson does not hesitate to disrupt his storyline, switching from one narrator to another, to better observe Zero Moustafa's emotion; this enables him to anchor the tale within the tale, reminding us of the power of his testimony. For the filmmaker, as for the writer, occurrences and events only take shape when they are finally recounted. These intimate stories, caught here in the vise of history, exist only because they are finally told, heard and passed on.

Indeed, beyond a laugh-out-loud adaptation of Stefan Zweig's story, *The Grand Budapest Hotel* is ultimately a tale about the power of recollection and the necessity to bring to life, through memories, stories that were once lived. Zero Moustafa preserves the ancient hotel to keep Agatha's memory alive: "*We were happy here. For a little while.*" It was perhaps to keep alive the happy memories of his old continent that, in the last years of his life, Stefan Zweig devoted himself to writing his memoirs. "*Against my will, I have witnessed the most terrible defeat of reason and the wildest triumph of brutality in the chronicle of the ages,*" he wrote. Too deeply affected, Zweig ended his life on 22 February 1942 in the Brazilian city of Petrópolis.

In a farewell message to his family and friends, he wrote: "*I salute all my friends! May it be granted them yet

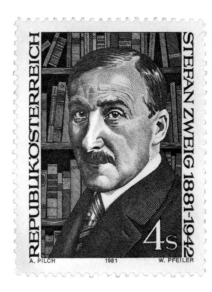

to see the dawn after the long night! I, all too impatient, go on before.*" These glimmers of dawn, which Zweig would never see, remind us of the words that Zero Moustafa utters about his old friend, M. Gustave: "*There are still faint glimmers of civilization left in this barbaric slaughterhouse that was once known as humanity. […] He was one of them. What more is there to say?*"

Before closing Stefan Zweig's work and placing it back in our imaginary library, let us linger over the last page of his memoirs, which, in remembrance of that dear old world, ended as follows: "*The sun shone full and strong. Homeward bound, I suddenly noticed before me my own shadow as I had seen the shadow of the other war behind the actual one. During all this time it has never budged from me, that irremovable shadow, it hovers over every thought of mine by day and by night; […] But, after all, shadows themselves are born of light. And only he who has experienced dawn and dusk, war and peace, ascent and decline, only he has truly lived.*"

Asahi Shimbun

Paper Kaiju

It is a monster weighing several thousands of tons, a gargantuan devourer of information, a *Kaiju*—an ancestral Japanese mythological creature. "It" is the *Asahi Shimbun*, the world's largest newspaper in terms of the amount of paper printed per day. Let us consider these figures: two daily editions, more than four million issues printed every day, tens of millions of readers, billions of characters and just as many tons of paper distributed to news agents. At the peak of its existence, the Japanese newspaper was unrivaled; it marched across Japan like a paper Godzilla, raining information down on a population that always hungered for more. It therefore comes as no great surprise that the *Asahi Shimbun* is the benchmark for daily newspapers in Wes Anderson's only movie set in Japan (let us hope that there will be more).

The director needed an invincible figure to embody the news organ of an imaginary town such as Megasaki—a monster of a city itself, sprawling and terrifying, like a wildly aggressive version of Tokyo, gray and roaring. Clad in metal, with its tall buildings of glass and steel, this Japanese megalopolis reminds us of Godzilla's mechanical enemy, Mechagodzilla—a giant robot of the kind that only the Japanese imagination could produce, that faced the king of monsters in an epic battle. In this quasi-Tokyo, tinged with unquestionably worrying futurism, it doesn't take long to reflect on the analogy: the city and its mayor versus the independent newspaper and the information published in the *Daily Manifesto*. While Mayor Kobayashi manipulates the masses, a group of young reporters organize themselves to voice dissenting opinions and, perhaps, expose a terrible conspiracy.

In its heyday, the *Asahi Shimbun* was considered to be a fairly left-leaning and relatively progressive publication in an ultra-conservative country. In the city of Megasaki, which lives under the yoke of its openly dictatorial mayor, the *Daily Manifesto* is an outpost of the resistance. This political evolution follows the logical curve of a filmography that

began to show a different face in *The Grand Budapest Hotel*, pulling the rug out from under the feet of those who thought Wes Anderson's cinema to be trivial and insubstantial, inward-looking or apolitical. And while the press holds a place of honor in Wes Anderson's universes, from the *Trans-Alpine Yodel* in *The Grand Budapest Hotel* to *The French Dispatch* and even Mr. Fox's diary, the greatest investigative newspapers have nothing on the *Daily Manifesto*. At a time when the media has become home to all manner of political propaganda, the *Daily Manifesto's* editorial staff is Megasaki's last hope for democracy, and the ultimate bulwark against the rampant corruption that devours the city. This hope is borne by a new generation, the symbol of a brighter future, ready to bring the truth to light from all their presses. ⚷

Roald Dahl

Fantastic Mr. Dahl

Who is this fantastic storyteller, whose books adorned with colorful covers fill children's bookcases all around the world? We will categorically forgo any attempt to retrace Roald Dahl's exhilarating life in these pages, as this could never do him justice. Indeed, the Norwegian-born Welsh writer Roald Dahl was quite a character. Born in 1916, he spent his childhood between well-mannered boarding schools and summer holidays in Norway, where he went on adventures, exploring fjords and landing on wild islets during expeditions that were every bit as thrilling as the robinsonades experienced by the young heroes of *Moonrise Kingdom*. Growing up as an adult—a very tall adult, for that matter, standing some 6'5" tall—, Roald Dahl would, in turn, become a skilled fighter pilot, a spy for British intelligence services, a screenwriter, an inventor in the medical field, and, of course, a wonderful writer for children of all ages. His real-life adventures were every bit as entertaining as those of his countless paper heroes.

For adult audiences, Roald Dahl wrote extremely funny and wildly inappropriate stories: he was an often macabre, caustic short story writer, who entertained no great illusions about human nature. Some of his short stories were played on television, in *Alfred Hitchcock Presents*, while others were adapted for his own series, *Tales of the Unexpected*, which Dahl presented from the comfort of a fireside. From the 1960s onwards, Roald Dahl turned his attention to children's literature, and would devote his career to delighting his young readers until the end of his life, in 1990. And when he spoke to children, the writer's sense of humor was every bit as formidable. Roald Dahl was not one of those self-indulgent storytellers who lulled their young audiences into complacency. On the contrary, he

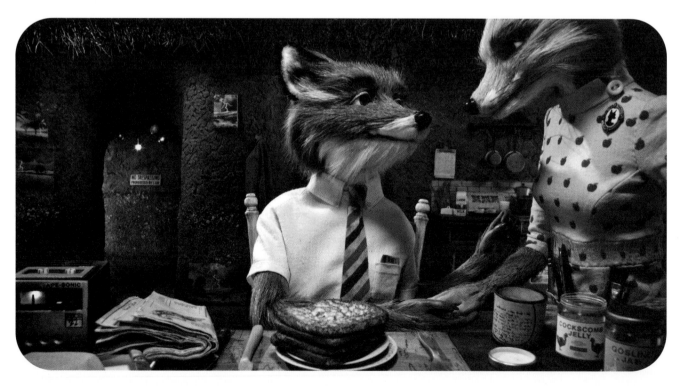

rather preferred to alert his youthful readers to the cruelty and the stupidity of the world that awaited them. In his rough and bizarre works, he willingly entrusted the villains' part to adults, to the great delight of children. Whether disgraceful parents, a tyrannical headmistress or unpleasant farmers, these were villains suited to children, yet portrayed with a wild sense of exaggeration that was unique to Roald Dahl. His young heroes had no choice but to resort to cunning and malice to get themselves out of trouble, and sometimes even, to exact revenge. One is, of course, reminded of Matilda, an extraordinarily gifted little girl, who would not be out of place among the Tenenbaum tribe, and who set out on a punitive expedition against her parents. Illustrator Quentin Blake, who lent to Roald Dahl's books his light, energetic style, as dynamic as the writer's fast-paced stories, stated: "*His idea of childhood wasn't simple, I think. On the one hand, he unambiguously sided with the children, and that is where the strength of his books lies. He was on their team, against adults who are oppressive giants. But at the same time, he had no illusions about children, who can also be mean.*"[1] In Roald Dahl's works, the mechanics of laughter are akin to the young heroes who populate his stories, and who, even in their innocence, can prove to be absolutely ruthless.

James and his giant peach, Charlie and his chocolate factory, little Sophie, kidnapped by a gentle giant, or Matilda and her telekinetic powers… Like Wes Anderson, Roald Dahl is a lover of characters, and his affection, his sense of truculent detail and comic exaggeration, can be found throughout this little gallery of heroes and villains. His first drafts of *Charlie and the Chocolate Factory* contained so many characters based on horrid children that the writer admitted that he became very confused indeed, but was unable to choose between these insufferable brats. "*To tell you the truth, I laughed so hard about these kids that I couldn't stop inventing new ones,*"[2] he recalls. He invented his many stories and their many, many characters from the comfort of the writer's armchair that he never left, in the solitude of a small cabin with a canary-yellow door. This little hut stood in a peaceful garden, at the back of his beautiful white home, Gipsy House. This lovely white house on Whitefield Lane was located in the picturesque village of Great Missenden, nestled between the hills of Buckinghamshire, northeast of London. Let's not move any further back, however; indeed, it is in this English county, in this picturesque

1. Quentin Blake, *Toute une vie*, France Culture, 27 December 2014.
2. Roald Dahl, *Spotty Powder and Other Splendiferous Secrets*.

village, in the peaceful garden adjacent to the pretty white house, in the cabin with the yellow door, and even in the writer's armchair that Wes Anderson would draw the inspiration for his movie, *Fantastic Mr. Fox*. This inspiration would lead him even further, as the filmmaker once again delved into Roald Dahl's works in 2023, with an adaptation of *The Wonderful Story of Henry Sugar*.

In the company of his screenwriter, Noah Baumbach, Wes Anderson visited the writer's home and explored his beloved English countryside, to better immerse himself in his new project. For ten years, Anderson had been planning to make a stop-motion movie; and, along the way, the filmmaker was apparently overcome by a longing for fur. Speaking to *Fresh Air*, he recalled his encounter with Roald Dahl's novel *Fantastic Mr. Fox*: "*Well, it was the first Roald Dahl book that I ever read as a child, and I became a huge fan of Dahl, and he was a big part of my childhood. For some reason, this book was the one I always kept with me. Wherever I lived, when I went to college, I always had this book on my shelves. It's not a very—it's a slim book, and it's really kind of… I think it's for young children, but something about it always stuck with me. And I think the character of Mr. Fox is a very Dahl kind of figure.*"[3] Wes Anderson made Roald Dahl's novel his own, seizing the opportunity to delve into some major issues that he felt concerned with: the animals, wild as they may be, are prey to genuine existential crises, constantly having to choose between their savage instincts and their civilized ambitions. In this movie, they appear fully clothed, with Latin names and always faithful to the author's spirit, Wes Anderson and Noah Baumbach took great delight in personalizing certain details of the novel, such as Master Fox's severed tail: "*Dahl had [Mr. Fox's] tail get shot off. We made it into a necktie. That might basically describe the collaboration,*"[4] the filmmaker comments with a mischievous air. This dashing incarnation of Maître Renard, a genuine dandy in his velvet suit, is

nothing less than a projection of the writer. And in fact, the co-writers gave "Mrs. Fox" the name Felicity, a tribute to Roald Dahl's widow. "*I think that part of the way we tried to remain true to Dahl was deciding that Mr. Fox was, in a sense, Dahl himself,*" Anderson explained. He then continued, asking this essential question: "*What would Roald Dahl be doing if he wasn't writing this story, but rather stealing chickens?*"[5] Beyond any doubt, Roald Dahl is a mischievous and incorrigible character, and he would most certainly take sides with the foxes, magnificent tricksters who resort to cunning to defeat the hunters of this world. ⚷

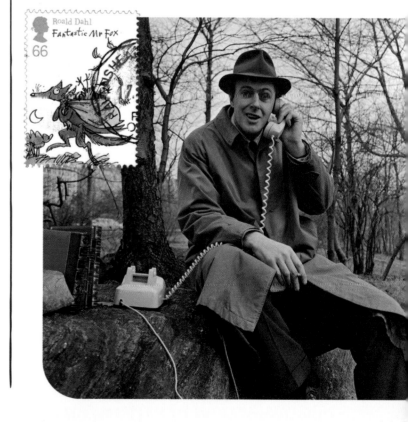

3. Terry Gross, "For Wes Anderson, A 'Fantastic' Animated Adventure" *Fresh Air*, 23 November 2009.
4. Matt Zoller Seitz, The Wes Anderson Collection, Abrams, 2013. • 5. Ibid.

J. D. Salinger

In Search of Salinger

Very little is known about J. D. Salinger, except for what the American author was kind enough to publish on the back of his books. So, dear visitor, let us skip the biography of this mystery of a writer who once told his hero, Holden Caulfield, that biographies "*and all that David Copperfield kind of crap*" meant nothing worthwhile to him anyway. As early as 1948, J. D. Salinger wrote a handful of short stories for the famous newspaper *The New Yorker*; however, it was the publication of *The Catcher in the Rye* in 1951 that marked the turning point of his work, if not of his life. His novel's ruthless success came with a notoriety that the writer did not want. J. D. Salinger withdrew from public life, and took refuge in Cornish, New Hampshire, where he demanded absolute tranquility. In 1974, after twenty years of stubborn silence, he consented to a brief interview with the *New York Times*, in which he protested against the unauthorized publication of his work. "*There is a marvelous peace in not publishing. It's peaceful. Still. Publishing is a terrible invasion of my privacy. I like to write. I love to write. But I write just for myself and my own pleasure,*"[1] he stated. His last works were written under the seal of secrecy, in the privacy of his Cornish home, further adding to the Salinger mystery.

"*If there's one thing I hate, it's the movies. Don't even mention them to me,*" Caulfield states in the very beginning of *Catcher in the Rye*. Did J. D. Salinger share his hero's aversion? Despite repeated assaults from Hollywood, *Catcher in the Rye* was never made into a movie; Salinger made sure of it. The writer jealously retained the rights to his novel, which he considered to be impossible to adapt. *Catcher in the Rye* is not, strictly speaking, a "story"; it is above all a gaze, a tone, a perspective on the adult world, a long interior monologue interspersed with digressive thoughts. *Catcher in the Rye* is also spoken in brusque tones, full of repetitions, tics, imbalances and dissonances, interspersed with absurd images. In this respect, J. D. Salinger was undoubtedly right to consider that his novel could not be adapted, as it was too closely tied to its narrative form to be easily carried to the silver screen. It is fair to say, however, that J.

1. Fosburgh, "*J. D. Salinger Speaks About His Silence*", *New York Times*, 3 November 1974.

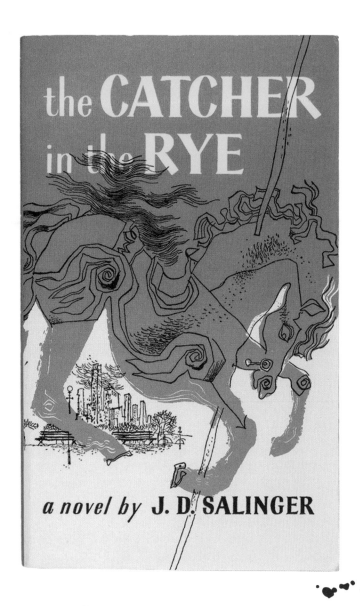

the CATCHER in the RYE

a novel by J. D. SALINGER

York family of young prodigies in crisis: the Glass family. Akin to the Tenenbaums, the Glasses are a sibling group of gifted, high-profile children. *The Royal Tenenbaums* brims with references to the adventures of the Glass family. Richie's attempted suicide is reminiscent of Seymour's sudden and unexpected disappearance in the short story *A Perfect Day for Bananafish*. When Margot first appears on the bus station's platform, wrapped up in her fur coat, she is emulating Franny's entrance, while the scene in which Etheline Tenenbaum finds her daughter cloistered inside her bathroom recalls a very similar moment in *Franny and Zooey*. As for the name Tenenbaum, it echoes the surname Tannenbaum, taken on by Boo Boo after her marriage. Beyond these few converging features, J. D. Salinger's shadow even hangs over the movie's screenplay. While his characters are indeed far less talkative, Anderson displays his penchant for evasive dialogue, slips of the tongue, absurd statements and gentle irony. "*I'm not in love with you anymore,*" Eli tells Margot. "*I didn't know you ever were,*" she replies impassively. "*Let's not make this any more difficult than it already is,*" Eli concludes, without listening to her. Anderson's works, *The Royal Tenenbaums* more than any other, are imbued with Salinger's presence.

Wes Anderson's movies, with their fundamentally maladjusted characters—all displaying the same impassivity, the same out-of-touch attitude to the world—, owe something to *Catcher in the Rye*'s adolescent hero. In this respect, *Rushmore,* set in a *prep school* for privileged children, is often reminiscent of J. D. Salinger's cult novel. Excluded from their schools, Max and Holden appear to us as distant cousins, two lost souls on the threshold of adulthood, haunted by the loss of a loved one. Both wear unique headgear that sets them apart from the crowd of their peers: a red hunting cap for Holden, and a red beret for Max. Both authors thus share what Matt Zoller Seitz calls a "*material*

D. Salinger's hero has long since crossed the threshold of the seventh art form; indeed, tributes to Holden Caulfield appeared in a large share of teen movies that were released throughout the years. So, one of Anderson's greatest references is not cinematographic, but rather literary. In his interviews, the director would never deny J. D. Salinger's decisive influence on his work. In return, complying with the author's vow never to see his writings made into a movie, Wes Anderson offered perhaps the most faithful non-adaptations of Salinger's works.

Of all his movies, *The Royal Tenenbaums* is, of course, the most "Salingeresque." Worthy heirs to the pages of *The New Yorker*, the Tenenbaums are descended from prestigious bloodlines, the most obvious of which is another New

synecdoche,"[2] a way of characterizing, through a specific object, their heroes' entire personality. This principle is remarkably intense in Anderson's movies, where characters are always what they wear. However, the connection with *Catcher in the Rye* may already have been apparent in *Bottle Rocket*. Like Holden, Anthony is a floating character, searching to give meaning to the chaos that pervades his existence and has to be institutionalized after "*falling ill*." When asked about the reasons for his depression, he gives this answer, which fiercely reminds us of Holden Caulfield: "*One morning, over at Elizabeth's beach house, she asked me if I'd rather go water-skiing or lay out. And I realized that not only did I not want to answer THAT question, but I never wanted to answer another water-sports question, or see any of these people again for the rest of my life.*"

It is impossible to sum up the fascination that J.D. Salinger's novel exerted on young people. Since it was first published in 1951, Holden Caulfield's voice has never ceased to strike a chord with readers, to the point of madness, even, as some claimed to have been under his influence when they committed reprehensible acts, such as the murder of John Lennon. In *Catcher in the Rye*, Salinger focused on this tipping point between two ages, while Holden, akin to the stricken horse on the cover of the novel, stubbornly refused the obstacle. This is another of Wes Anderson's favorite themes: disenchantment, the cruel transition into adulthood and the impermanence of all things. "*Anderson's films are light in much the same way as Salinger's fiction—which is to say, they're not,*"[3], wrote Matt Zoller Seitz. For readers all over the world caught in this tender, vulnerable interstice that is adolescence, reading *Catcher in the Rye* is a moment of grace, and Holden Caulfield, a brother in solitude.

The day after J. D. Salinger's death, in 2010, Wes Anderson wrote a few words to *The New Yorker*, an excerpt from a story by F. Scott Fitzgerald, *The Freshest Boy*: "*He had contributed to the events by which another boy was saved from the army of the bitter, the selfish, the neurasthenic and the unhappy. It isn't given to us to know those rare moments when people are wide open and the lightest touch can wither or heal. A moment too late and we can never reach them any more in this world.*" The director added: "*And it occurred to me that more than everything else, more than all the things in his stories that I have been inspired by and imitated and stolen to the best of my abilities, this describes my experience of the works of J. D. Salinger.*"[4] 🔑

2. Matt Zoller Seitz, "*The Substance of Style, Pt 4*," *Moving Image Source*, April 2009.
3. *Ibid.* • 4. Richard Brody, "*Wes Anderson on Salinger*", *The New Yorker*, 29 January 2010.

The Plays
Time for a New Play!

In one of the corners of the museum's library, you'll find the section devoted to the art of theater, where renowned playwrights casually rub shoulders with plays born of Wes Anderson's fertile imagination. Because Wes Anderson's loneliest characters tend to take refuge in writing, his world is populated by novelists, journalists, short story writers—and, of course, budding playwrights such as Margot Tenenbaum and Max Fischer. With Wes Anderson, however, biographical features are never buried very deep beneath the surface. They can be found scattered throughout his works, from one film to the next, reminding us of this anecdote that the filmmaker confided in Terry Gross in 2012: "*And the other thing I remember from that age is that our—is my fourth-grade teacher [...] I must've been some kind of troublemaker, because she made this arrangement with me that each week that I did not get in a certain amount of trouble she was giving me some points. And when I added up enough points, she let me put on a play in our school because she knew I'd written this one little short play that we had done in our class and she let me kind of become a little theater person at that age. And I did many of these five-minute plays over, you know, over that year. And I feel like in a way what I do now is vaguely, you know, continuing something from then that she kind of got me going on.*"[1] So, to better reward her pupil, who was obviously inattentive, the teacher would add little stars to his binders, before writing this magic formula in black and white: "*Time for a new play!*" This distant memory of a childhood spent channeling his energy into theatrical productions that brought him great success with his peers is undoubtedly where the roots of Max Fischer's character are found. At the

very beginning of the film, when Max is confronted with his unsatisfactory results at school, he stands up to the Rushmore Academy dean with great aplomb: "*Do you remember how I got into this school? – Yeah, I do. You wrote a play,*" the headmaster replies. "*Second grade. A little one act about Watergate. And my mother read it and felt I should go to Rushmore. And you read it, and you gave me a scholarship, didn't you?*" Max instantly joins this future tradition of young adults—children who, scattered throughout Wes Anderson's filmography, take on the postures and concerns of grown-ups. A tradition that undoubtedly began with Max and blossomed in the first part of *The Royal Tenenbaums*, before coming to full fruition in *Moonrise Kingdom*. While for Max, a mediocre student with dreams of greatness, theater is indeed a gateway, Margot is also remarkable in this regard. Right at the beginning of the movie, between reading Anton

1. Terry Gross, "*Wes Anderson, Creating A Singular Kingdom*", Fresh Air, 29 May 2012.

Chekhov and Eugene O'Neill, the young girl is introduced to us, sitting in front of a well-stocked "theater library" in her child's bedroom, its walls lined with prints of zebras. A young prodigy, as is customary in the Tenenbaum brood, she first cuts her teeth as a drama playwright, winning a modest $50,000 prize in the ninth grade. Between two books, Margot keeps her model sets, akin to miniature theaters. For the filmmaker, the opportunity to interweave worlds within worlds, like a *mise en abyme* of a scene within a scene, was too tempting to forgo.

In *Rushmore*, the movie's structure is based on a month-by-month breakdown, punctuated by the opening of velvet curtains, like acts. Nothing could seem more natural, when one considers Max Fischer's extreme ability to stage his own existence, according to the same principles and rules that govern theatrical staging. So, to quote Max, "*Every line matters*," and he cares for the "dialogues" in his life with the same diligence. In Max's mouth, every sentence sounds like something straight out of a movie or one of his plays. This theatrical *mise en abyme* is most directly observable in *Rushmore*; indeed, while most of the novels, short stories and imaginary plays that populate Wes Anderson's universe remain off-screen (the short story based on Jack Whitman's character, *Hotel Chevalier*, is a slight exception to this rule), *Rushmore* allows us to become live spectators to a few selected pieces— the staging of *Serpico*, a homage to the Sidney Lumet classic, features a whimsical performance, rife with children wearing fake beards or dressed up as nuns, gunshots and model trains. In the middle of the audience, a shot featuring a gaggle of perplexed children is enough to make us fully aware of the incongruity of the situation. Backstage, excitement culminates, to the point of where protagonists actually come to blows over a line about *cannoli*, paying homage to another famous film line. Let us remember that Francis Ford Coppola, director of *The Godfather*, is none other than the uncle of Max's character, Jason Schwartzman. Max

«HEAVEN AND HELL»
a new play by Max fischer
revised draft
Dramatists Guild registered

receives a standing ovation from the audience, but as he likes to say, "*sic transit gloria*"—glory is fleeting, and he soon realizes that, despite his "*hit play*," he has not won the heart of Miss Cross, who appears at the arm of a man of slightly more appropriate age. As always, Max's drama lies in the gap between the staging and reality, in the frustration of things not unfolding according to script, as they do in the theater.

In Margot's world too, nothing seems to go according to plan. On her eleventh birthday, she invites her father to her first performance, exposing herself to cruel disappointment. The Tenenbaum patriarch, not mincing words, tears the play down. Therefore, it's hardly surprising that, now an adult, Margot endlessly struggles with writer's block. What remains of her career as a playwright is no longer presented to us on stage, but only through posters featuring with eloquent titles: *Erotic Transference*, *Static Electricity*, *Nakedness Tonight*, a mysterious body of work that, one suspects, is cerebral and intimate, very representative of New York and

THREE PLAYS

by MARGOT TENENBAUM

EROTIC TRANSFER-ENCE

NAKEDNESS TONIGHT

STATIC ELECTRICITY

NISWANDER

highly erotic. It is not until her latest play, *The Levinsons in the Trees*, that Margot finally returns to the theater. What one sees of the play is reminiscent of *The Swiss Family Robinson* and its family of castaways living in a tree house. It is a metaphor that fits the Tenenbaums like a glove, and this is quite fitting, since *The Levinsons in the Trees* turns out to be highly autobiographical. The play is a public and critical failure, but that is of little importance; here, indeed, theater possesses a cathartic value. By finally confronting her old demons, Margot takes her first step out of depression and finds her way back onto the stage.

Finally, if there is one play that stands out, it is unquestionably *Heaven And Hell*, the grand finale of *Rushmore*, a kind of miniature rendition of *Apocalypse Now*, where Max casts himself in the best role, that of an aspiring Tom Cruise (the resemblance is indeed striking), displaying exacerbated virility. A rather disturbing announcement rings out in the school gymnasium: "*Also, you'll find a pair of safety glasses and some earplugs underneath your seats. Please feel free to use them. Thank you very much.*" On a stage cleverly transformed into a misty jungle, between a helicopter and two unlikely pyrotechnic effects (a small child brandishes a flamethrower), Max appears in all his glory, featured in a play that is violent, political and highly unlikely for a high school show. This doesn't matter, however, because *Heaven And Hell* marks the victory of fiction over reality, perhaps symbolizing the power of theater and cinema, for those willing to suspend their disbelief. "*Maybe we'll meet again someday… when the fighting stops,*" Max declaims on stage. With this last line, the tearful face of Herman Blume appears—a character on the brink of apathy who, beholding this grand finale, at last seems able to release his pent-up emotions.

For Max Fischer, Margot Tenenbaum, Wes Anderson and the others, when the three bells ring out on the theater floor, it's time to leave reality behind for a little while. Maybe it will be different when we return. ⚷

Peter Pan

Sam, Suzy and the Lost Boys

A great movie about childhood, its fleeting nature, and yet, the indelible mark that it leaves on each of us, *Moonrise Kingdom* certainly reminds us of one of the masterpieces of children's literature: *Peter Pan*. In his play, and then in the novel of the same name, the Scottish writer J. M. Barrie recounts the adventures of the little boy who would never grow up, the living embodiment of eternal childhood. Despite being over a hundred years old, Peter Pan has not aged a day. How could he, when he leads a fascinating life of endless adventure and play? "*All children, except one, grow up,*" J. M. Barrie wrote in the introduction to his novel. This first sentence, as melancholic as it is marvelous, seems to open a fault, the possibility of an escape in the face of death. *Peter Pan* offers another way, in the form of an escape to Neverland, and even tells us how to travel there: "*Second star to the right and straight on 'til morning.*" Featuring heroes on the threshold of adulthood, whose imagination becomes childhood's last refuge, *Moonrise Kingdom* shares some essential themes with J. M. Barrie's myth.

First, there is the island of New Penzance, an imaginary location that unfolds its maps like an adventure novel treasure island would. When adults, these administrative figures (lawyers, policemen, social services and others), bogged down in their own boredom and grief, set off in search of Sam and Suzy, they remain impervious to the enchanted nature of the island. The divide between the young and the grown-ups has never been so clear in Wes Anderson's works, and the adults appear to have forever lost their sense of adventure in the mists of their worried minds. Sam and Suzy, however, don't yet suffer from this chronic lack of imagination, and in their eyes, the wild, unexplored stretches of the island are just as many magical and dangerous places. In J. M. Barrie's tale, Peter Pan and his gang fly over lagoons teeming with mermaids and flamingos, Indian camps

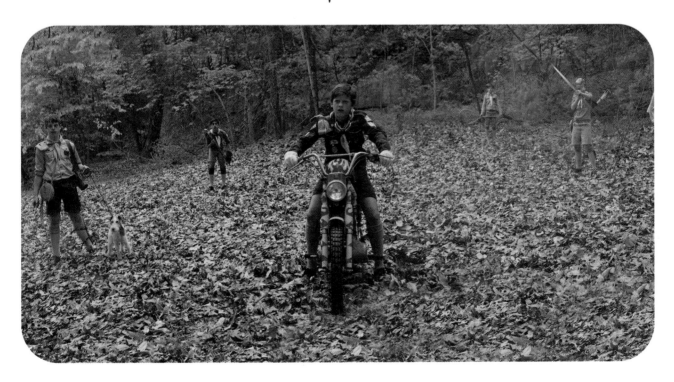

and pirate ships. Together, they live in a house under the ground, carved out of a tree trunk that serves as an elevator. This last idea resonates perfectly with Wes Anderson's universe, and one can't help but think of Mr. Fox's wonderful burrow, dug under a one-hundred-year-old tree. For the filmmaker with a penchant for all things handmade, there's nothing quite like jerry-rigged devices, huts of all kinds and other ingenious DIY projects where the lost boys turn into true experts, and which obviously remind us of the resourcefulness of the khaki scouts.

If the narrative of Peter Pan is to be believed, the lost boys are orphans who, after falling out of their baby carriages, have not been claimed by their unscrupulous parents. Peter himself was abandoned, as was little Sam. Stranded in Neverland, they form a makeshift family, united by chance and adventure. This curious little crew, of which Peter insists that he is the "captain," naturally echoes the surrogate families that populate Wes Anderson's filmography, and of which the khaki scouts are unquestionably a part. To complete their makeshift family, the lost boys set out in search of a "mother." In *Peter Pan*, it is Wendy who is tasked with telling stories to the lost boys; the young girl indeed soon becomes their "mother", and therefore, their official storyteller. Here, a scene from *Moonrise Kingdom* resonates with Wendy's story. At nightfall, under the tents, the impetuous Suzy takes her turn reading to the quieted boys who, hanging on to her every word, urge her to continue her story.

One can say that our boisterous scouts wouldn't look out of place among the lost boys, and that they are sometimes just as heavily armed and ready for a fight. In *Peter Pan* as in *Moonrise Kingdom*, childhood is innocent, but never harmless. When it comes to counting the lost boys, J. M. Barrie observes that the number of children varies according to those who have been killed fighting, or whom Peter Pan himself has killed because they have grown up a little too much. When

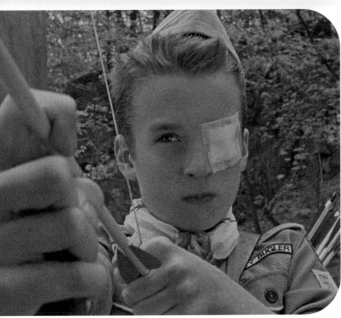

the verge of drowning, Peter Pan smiles strangely: "*To die will be an awfully big adventure.*" This is one of the most ambiguous aspects of J. M. Barrie's hero: Peter is condemned to eternal childhood in his "Neverland"; a sort of in-between world, a limbo where neither death, nor life, nor time have any real meaning. At the end of the novel, the immortal Peter is nothing more than a "*tragic little boy*" whose friends grew up without him, and who returns to Wendy's window to discover, to his horror, that she has become a grown-up. Moved, the young woman lets her daughter, Jane, fly off with the young boy to Neverland.

With *Moonrise Kingdom*, these diffuse memories from when we were twelve are what Wes Anderson seeks to wrap in cotton wool, as if to preserve the candor, the clumsiness and the emotions that already heralded the coming of adolescence. Akin to *Peter Pan*, *Moonrise Kingdom* is a work that acknowledges that Neverland is not a good place to linger, but nonetheless encourages us to retain a vivid memory of that blessed era and an adventurous spirit. In the epilogue to J. M. Barrie's novel, the years have passed, and sweet Wendy is long since gone. Her daughter, Jane, has now become an adult, and Wendy's granddaughter, Margaret, is now the one climbing through the bedroom window to join Peter Pan. Then, when Margaret grows up, she too will have a daughter, who will in turn fly off into the London night, toward the second star on the right, and straight on 'til morning. "*And thus it will go on, so long as children are gay and innocent and heartless,*" wrote J. M. Barrie. 🔑

they return to their wild, childish instincts, the scouts of *Moonrise Kingdom* sometimes show a face that is just as cruel, and the brave dog Snoopy will be the first victim of their blind excesses. For the thrill of adventure to become real, danger must be every bit as real. In J. M. Barrie's novel, Peter Pan embodies the vital force of childhood: overflowing and heroic, characterized by excess, both in terms of courage and barbarity, and by a ferocious refusal to bend to the demands of adult life. For the boy, every event becomes a game, an adventure—and naturally, death should be the craziest adventure of them all. Trapped on a rock, on

The New Yorker
The Gazette of Ennui-sur-Blasé

"I *always wanted to do a collection of short stories."* This is how Wes Anderson presents *The French Dispatch* in the movie's press kit. And while the newspaper with the same name is nothing but fantasy, it is indeed born of a constellation of real-life cross-references. *The Little Review*, *The Criterion*, *Broom* and *The Paris Review*—these are just a few examples of the magazines that imbued *The French Dispatch* with a fragment of their spirit and gave a voice to some of the greatest writers of the turn of the century. If we had to choose just one, however, it would, of course, be the famous *New Yorker*.

As early as in *The Royal Tenenbaums*, steeped in a kind of New York literary mythology, Wes Anderson claimed the legacy of the venerable magazine with which he became enamored as a teenager. *"I always wanted to make a movie about The New Yorker. […] When I went to the University of Texas in Austin, I used to look at old bound volumes of The New Yorker in the library, because you could find things like a J. D. Salinger story that had never been collected. Then I somehow managed to find out that U.C. Berkeley was getting rid of a set, forty years of bound New Yorkers, and I bought them for six hundred dollars. […] I have almost every issue, starting in the nineteen-forties,"*[1] he confided to *The New Yorker* itself, a newspaper whose admiration for him seems mutual.

Founded by Harold Ross and his wife, Jane Grant, a veteran journalist with *The New York Times*, *The New Yorker*'s very first edition came off the press in February 1925. And if the editor of *The French Dispatch*, Arthur Howitzer Jr., the man who *"brought the world to Kansas,"* is undoubtedly an avatar of the filmmaker himself, he is in any case the fantasized

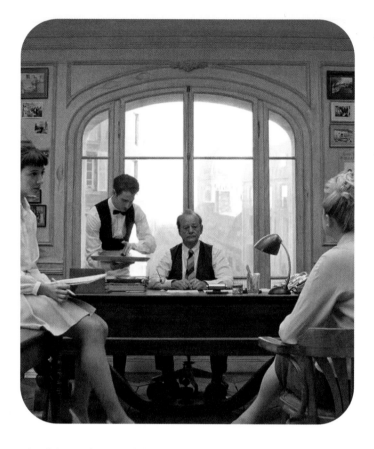

double of Harold Ross, who ruled the magazine's newsrooms with an iron fist from 1925 to 1951. To his character, Wes Anderson added a hint of William Shawn, who would take over as editor-in-chief from 1952 to 1987. Over half a century of *The New Yorker* thus unfolds, personified in Arthur Howitzer Jr., played by the incredible Bill Murray. After arriving in France, where he published his travel diaries in the Sunday magazine *Picnic*, Arthur Howitzer Jr. decides to settle in the small town of Ennui-sur-Blasé and founds *The French Dispatch*, a French branch of the *Liberty, Kansas Evening Sun*. After years of good and loyal service, pampering, correcting, manipulating and encouraging his team of writers, Arthur Howitzer Jr. will issue his final instructions, as the newspaper's editor-in-chief, from beyond the grave. After his last

1. Susan Morrison, *"How Wes Anderson Turned The New Yorker Into 'The French Dispatch',"* The New Yorker, September 2021.

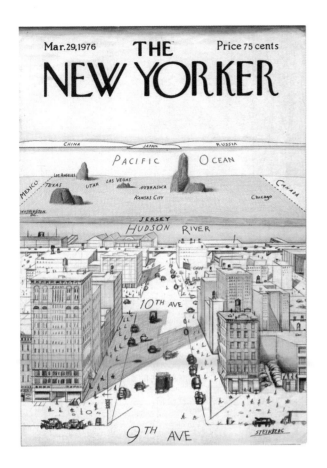

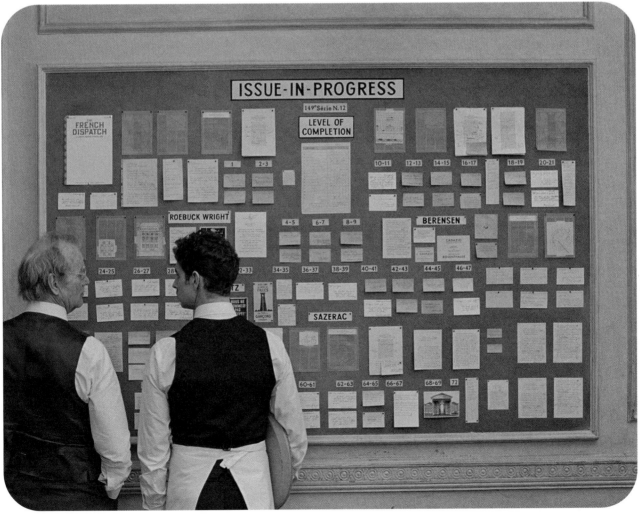

breath, *The French Dispatch* will
come to an end; the presses will be
dismantled, the offices emptied, the
staff dismissed and, on the front page
of the final issue, the editor's and
the newspaper's obituaries will merge.
His will be done.

When the film was released, Wes
Anderson published *An Editor's
Burial*, an anthology of writings that
inspired *The French Dispatch*, many of
which were taken from *The New Yorker*.
This compendium, a genuine companion
to the movie, guides curious viewers
through a host of references and
characters. "*Even though it's not
an adaptation, the inspirations are
specific and crucial to it. So I wanted
a way to say, 'Here's where it comes
from.' I want to announce what it
is. This book is almost a great big
footnote. […] it's an excuse to do a
book that I thought would be really
entertaining,*"[2] Anderson explains to
The New Yorker. Among the many authors
who inspired the editors of *The French
Dispatch* were James Baldwin, Rosamond
Bernier, Mavis Gallant, Luc Sante,

Ved Mehta and Janet Flanner, to name
but a few.

These are the names that echo
throughout the pages of *The French
Dispatch*, all the way back to its head
office in Liberty, Kansas. Indeed,
The French Dispatch is very much an
American magazine, as its illustrated
covers, reminiscent of the famous *The
New Yorker*'s own covers, demonstrate.
Anderson's desire to make a movie
about *The New Yorker* was also combined
with his desire to offer a feature
film to his adopted country, France.
And so, *The New Yorker* lands in the
picturesque market town of Ennui-
sur-Blasé, a postcard town escaped
from a bygone Paris. "*I think it
sort of turned into a movie about
what my friend and co-writer Hugo
Guinness calls reverse emigration.
He thinks Americans who go to Europe
are reverse-emigrating,*"[3] Anderson
continues. In fact, Harold Ross used
to say that the history of New York
was always written by people who
weren't actually from New York. So
goes the story of Ennui-sur-Blasé,

as recounted by expatriate writers who were peerless in their fields. *The French Dispatch* tells the big and small stories of Ennui-sur-Blasé, factually covering international politics, the arts (fine and not-so-fine), fashion, gastronomy, enology, and other sundry and varied facts with the same sophistication as *The New Yorker*. The movie, akin to the gazette that it describes, reflects the biased viewpoint of a handful of talented Americans, including Wes Anderson, of course. So, France could well be an impregnable enclave, where revolutions follow one another, where artistic creations accept no compromises and where gastronomy remains both a standard and a requirement. In this light, Ennui-sur-Blasé indeed deserves to host the French edition of *The New Yorker*. ⚷

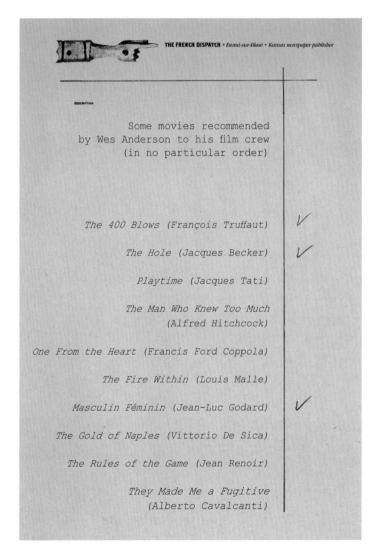

Some movies recommended by Wes Anderson to his film crew (in no particular order)

The 400 Blows (François Truffaut) ✓

The Hole (Jacques Becker) ✓

Playtime (Jacques Tati)

The Man Who Knew Too Much (Alfred Hitchcock)

One From the Heart (Francis Ford Coppola)

The Fire Within (Louis Malle)

Masculin Féminin (Jean-Luc Godard) ✓

The Gold of Naples (Vittorio De Sica)

The Rules of the Game (Jean Renoir)

They Made Me a Fugitive (Alberto Cavalcanti)

Zeffirelli's Manifesto
Revolt and Rhetoric

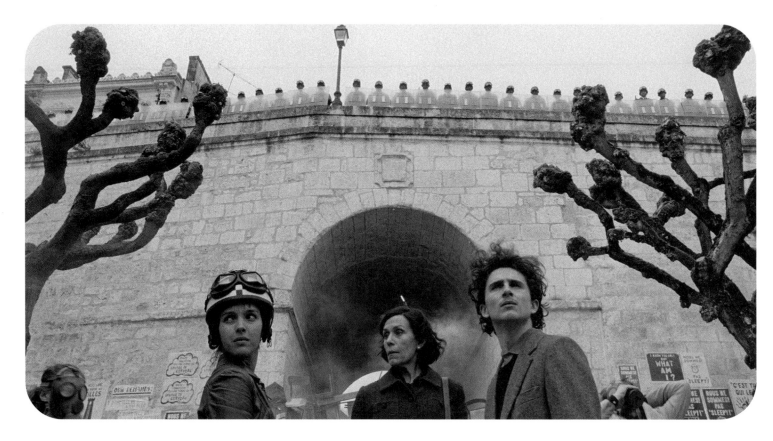

"It's all very well for men to believe in ideas and die for them,"[1] wrote Jean Anouilh in his play, *Antigone*. Zeffirelli indeed has no shortage of ideas, and the student meticulously fills the pages of his notebook with his indecipherable handwriting. What the apprentice revolutionary is preparing is nothing less than the manifesto of a mysterious cause, which will define for good the principles and resolutions of a romantic youth that thirsts for freedom. Freedom—this is what the students of the Université Supérieure d'Ennui-sur-Blasé (which translated literally means "Higher University of Boredom on Jaded") are striving for. In *The French Dispatch*, Zeffirelli's manuscript is dutifully broken down, discussed, dissected and debated by Anderson's characters, however, without giving viewers anything tangible to sink their teeth into. Indeed, spectators will know nothing of the content of this manifesto

that unleashes passions, except that instead of uniting the youth, it is the cause of internecine and futile quarrels. At the very heart of the revolt, from the Café Sans Blague ("Café No Joke") to the improvised barricades, the text divides the students into factions that are quick to fuel the fire of incessant debate.

Wes Anderson mischievously takes great care of this: the clauses governing this famous manifesto will always remain hidden from us. Sometimes, the voice of Lucinda Krementz, narrator and journalist, covers the public reading; other times, the radio stops broadcasting, or Juliette mumbles the text in the unintelligible and charming manner of students revising their lessons. What we do know, however, is that it is a devilishly complicated manuscript, rife with asterisks, corrections and appendixes. The cause that it serves only appears more confusing to us. Juliette, an

1. Jean Anouilh, *Antigone*, 1944.

ZEFFIRELLI
ZEFFIRELLI
ZEFFIRELLI

MANIFESTO
"LE SANS BLAGUE"

ZEFFIRELLI
ZEFFIRELLI
ZEFFIRELLI

Prix:0 fr.

ardent activist, will in fact describe it as "*an obtuse, ambiguous, poetic (in a bad way) document.*" As in Jean-Luc Godard's movie *La Chinoise*, released in 1967, which took the pulse of young students and, in many ways, foreshadowed the events of May 1968, the revolt is first and foremost rhetorical. One year before the events, Godard discussed the cultural revolution, establishing the presence of a consummated generational divide. However, amid this egalitarian utopia, what emerged were contradictory, muddled and incomplete thoughts and discourses, rather than precise proposals and concrete political directions. In their bourgeois flat, these armchair revolutionaries wrote this now famous slogan on the wall: "*Il faut confronter les idées vagues avec des images claires*" (We must confront vague ideas with clear images).
La Chinoise is not yet a political film, but a film *about the political idea*. And if the characters in *The French Dispatch* aren't as free to discuss the content of their convictions, it's because the distance imposed by Wes Anderson is even greater. What matters is not the revolution itself, but the romantic idea of a revolution.

With her notebook in hand, journalist Lucinda Krementz witnesses the birth of this revolt, of which she provides a precise chronology (in the "Politics/Poetics" section, pp. 35–54). Everything begins with an armchair revolution. It is at the Café Sans Blague that this light-footed, sharp-tongued youth comes to drink lemonade and over-sweetened coffee, until the event that will trigger the students' wrath. Against his will, Mitch-Mitch is sent to National Duty Obligation in the Mustard Region. He deserts and, in a defiant act of protest, burns his patch, leading to his arrest. The friendly student café is instantly transformed into a headquarters, where the students forming the "*Movement of Young Idealists for the Revolutionary Overthrow of Reactionary Neoliberal Society*" organize themselves. Or, to put it more simply, it's the eternal revolt of the youth against the elders. The photo of the singer Tip

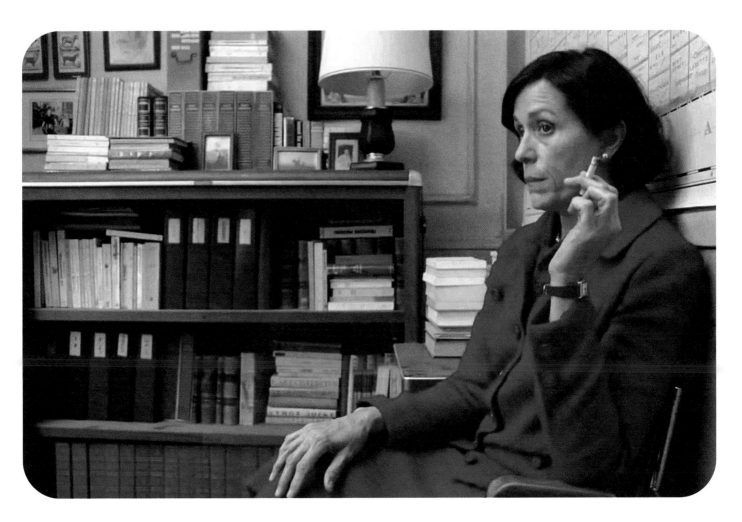

Top is soon replaced by a portrait of the intellectual François-Marie Charvet, no doubt an avatar of the philosopher and writer Jean-Paul Sartre, who showed his support for the French student uprising of May 1968.

This is the birthplace of the Ennui-sur-Blasé's students' revolution. In the middle of the summer, a whisper campaign is organized among the town's good people to smear the protesters. In September, Café Sans Blague's license is revoked by official decree. In October, the students install a DIY pirate radio on the roof of the Physics Department (let us remember that, from the tree house in *Moonrise Kingdom* to the Zubrowka observatories, Wes Anderson has a penchant for dangerously perched structures). In November, students organize the blockade of the cafeteria. In December, the *Bibliothèque principale* (or main library) restricts its borrowing policy. In January, Mitch-Mitch is released to strict parental custody. In February, an uprising takes place in the girls' dormitories.

In March, finally, the revolution truly begins. March 1st: negotiations are underway at the university to gain free access to the women's dormitories. March 5: a demonstration featuring protest slogans ("*The children are grumpy*") is severely repressed. That evening, in his bath, Zeffirelli pens the first resolutions of his manifesto, in a style that Lucinda Krementz describes as "*a little damp.*" March 10: a major student blockade begins, bringing the whole city to a standstill, from its schools to its public transport and waste collection services. Neither mail nor milk bottles will be arriving at the doors of the inhabitants of Ennui-sur-Blasé who, living up to their town's name, are indeed rather blasé. Raising a makeshift barricade, the students engage in a long-distance duel with the authority's representatives—both metaphorically and literally, as the fate of the revolution rests on a game of chess.

As defeat is announced and rubber bullets rain down on the student

crowd, Zeffirelli and Juliette stop arguing and indulge in the other game played by grown-ups—love. For these Romeo and Juliet lovers, inspired by the May 1968 protesters (note here that our hero happens to have the same surname as Franco Zeffirelli, director of *Romeo and Juliet*, filmed in 1968), happiness will be short-lived. What subversive political ideas does this manifesto contain? Nobody knows. However, Zeffirelli will not hesitate to give his life to spread its message, as he climbs up to the rickety radio station to repair the antenna. In death, Zeffirelli joins the ranks of the revolutionary icons he looked up to, because young people need their heroes. Among these icons, Zeffirelli reminds us of the students in revolt in Victor Hugo's *Les Misérables* and their fragile barricades erected against the rest of the world. The student reminds us of the great romantic figure of Enjolras, the young revolutionary graced with angelic beauty, who presides over the students' table at Café ABC, and who would meet a tragic death. "*Life, misfortune, isolation, abandonment, poverty, are the fields of battle which have their heroes; obscure heroes, who are, sometimes, grander than the heroes who win renown,*" wrote Victor Hugo. The

young people of Ennui-sur-Blasé hold Zeffirelli's banner high, like a symbol of freedom, before sensibly returning to their classrooms in a final surrender.

In Wes Anderson's movies, big dreams come with big revolutions. Struck down in his youth, Zeffirelli died for ideas of which we know almost nothing. But what did he know himself? On March 15, a few days after his death, Lucinda Krementz finds these few words, hastily scribbled by the boy: "*An invincible comet speeds on its guided arc toward the outer reaches of the galaxy in cosmic space-time. What was our cause?*" This manifesto, of which a few former students of the Université supérieure d'Ennui-sur-Blasé may still hold a crumpled copy among their old notebooks, remains a mystery. What it does contain, as we know, is all the exaltation of youth, with its fevers, its new passions and its illusions, like comets that we once thought to be invincible. ⚷

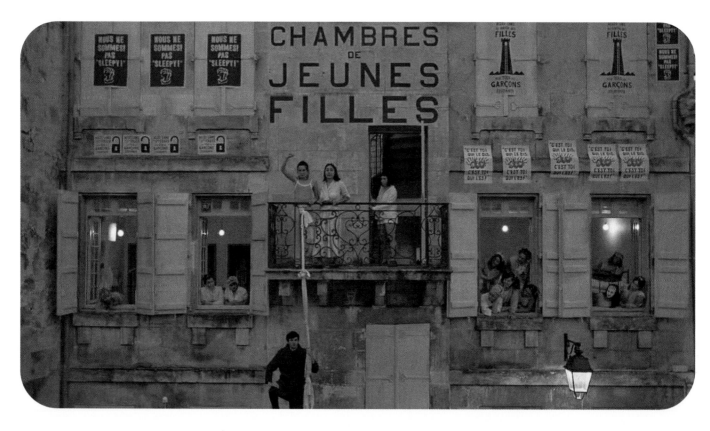

Suzy's Books
The Travel Library

What books would you take with you to a desert island? Here is a question that has been asked a hundred times before, that many of us would be lucky to have to answer once and for all. As she packed her suitcase, Suzy had to make one final decision: she needed to choose, from the library's well-stocked shelves, a few books that would be like so many adventures in her journey. When she proceeds to take inventory, for instance, Suzy opens her heavy yellow suitcase, inviting us to discover a collection of large books with colorful covers, stacked neatly on top of each other—a genuine travel library that we have decided to store here, on the shelves of our imaginary library. "*These are my books.*

I like stories with magic powers in them. Either in kingdoms on Earth or on foreign planets. Also, time travel, if they make it realistic. Usually, I prefer a girl hero, but not always. I couldn't bring all of them because it got too heavy," says Suzy. After dutifully noting the contents of his luggage in a pocket notebook, Sam examines the books with the same care. The thick plastic protecting the books' covers is hardly misleading: these books have been "borrowed" from the New Penzance library. Discovering this petty theft, Sam reacts with a childlike seriousness: some books are clearly well past their return date… Stabbing a child with left-handed scissors is one thing, but some things, like library rules, are

CITY DEPT. OF LIBRARIES NEW PENZANCE

Nan Chapin, illustrated by David Hyde Costello

AUTHOR

Shelly and the Secret Universe

TITLE

CITY DEPT. OF LIBRARIES NEW PENZANCE

Gertrude Price, illustrated by Juman Malouf

AUTHOR

The Francine Odysseys

TITLE

DATE DUE	BROROWER'S NAME

CITY DEPT. OF LIBRARIES NEW PENZANCE

Burris & Burris, illustrated by Eric Anderson

AUTHOR

Disappearance of the 6th Grade

TITLE

DATE DUE	BROROWER'S NAME
FEB 3	Max Fischer

CITY DEPT. OF LIBRARIES NEW PENZANCE

Isaac Clarke, illustrated by Sandro Kopp

AUTHOR

The Girl from Jupiter

TITLE

DATE DUE	BROROWER'S NAME
NOV 27	Antoine Doinel
JAN 15	Jean-Paul Sartre
FEB 3	Charlie Brown
APR 5	Franny Glass
MAY 22	J. Y. Cousteau
JUN 8	Suzy Bishop

utterly sacred. "*Do you steal?*" asks the young boy. Suzy's response to this question is superb: "*I might turn some of them back in one day. I haven't decided yet. I know it's bad. I think I just took them to have a secret to keep.*" In a world where one has to share one's possessions with invasive little brothers, and where parents bark orders through a megaphone, it's only natural for a twelve-year-old girl to seek a little privacy. Beyond that, however, in Wes Anderson's work, the female characters often keep their secrets close to their chest. Margot, for example, cultivates secrecy for both major events (her first marriage) and for things of little significance (her smoking habit). Suzy is hardly different; under the surface, the quiet, slightly uncontrollable child (the hot-tempered young girl is indeed prone to fearsome temper tantrums) obviously has a thriving inner existence, which she cultivates in the secrecy of her bedroom. Stuck in a life that is simply too narrow, in a family that is falling apart and doesn't understand her, on the threshold of adolescence, Suzy seeks escape, which she finds in her books—books that preferably take her to faraway places, inhabited by strange creatures, filled with mysteries and magic.

So, in her suitcase, Suzy packs six of her favorite novels. These books are presented to us a little more officially in a short video, *Moonrise Kingdom: Animated Book Short*, which accompanied the release of the film. The narrator, played by Bob Balaban—none other than the island's librarian—introduces us to them one by one, through brief animated sequences that bring these fictions to life. They are listed here in the order of their appearance. *Shelly and the Secret Universe* by Nan Chapin is the story of a teenage gymnast who possesses a powerful amulet. The young girl, seriously estranged from her family, sets off to jump: "*Our story begins as her toes leave the ground*"—A tailor-made incipit for Suzy, who is on the brink of taking the plunge and running away from her family's home. Suzy's favorite book, however, is

The Francine Odysseys by Gertrude Price—the story of a little girl in the faraway kingdom of Tabitha, and of a depressed lion ruler. "*My people were once led by a great and noble beast, and I no longer see his face in this reflection,*" declares the melancholic lion, as he observes himself on the surface of the shimmering water. This book could well echo the situation of the Bishop family, which is of particular concern to Suzy, as her father, deeply devastated and humiliated by his wife's infidelity, gradually sinks into depression. The book will remind viewers of some of the great fantasy epics written for young audiences, such as C. S. Lewis's *The Chronicles of Narnia* and its majestic lion, Aslan. On her beach at the end of the world, Suzy then immerses herself in *The Girl from Jupiter*, a novel by Isaac Clarke—a name, we suppose, that is a cross between two illustrious science fiction authors, Isaac Asimov and Arthur C. Clarke. The novel's back cover shows a map that bears a striking resemblance to that of Arrakis in Frank Herbert's *Dune*. Then, there is *Disappearance of the 6th Grade* by Burris & Burris, whose title suggests a strange disappearance of children, while the parents are searching the countryside

for the runaways. Then, *The Light of Seven Matchsticks* by Virginia Tipton, which sees its heroes, Barnaby Jack and Annabel, hatching a plan of attack as the little scouts ("*Hide this in your socks, and be ready at midnight*"). Last, Miriam Weaver's *The Return of Aunt Lorraine*, the story of a pragmatic little girl and her aunt, a professional witch hunter, which symbolizes Suzy's peaceful return to the comfort of her home.

While they indeed look like real children's books, these novels have obviously been created from scratch by illustrators, including Wes Anderson's brother, Eric Anderson, and his partner, Juman Malouf. The filmmaker's eye for detail even extends to writing short paragraphs for each of these books, once again confirming Wes Anderson's penchant for entangling the true and the false in the form of an inextricable knot, going so far as to superimpose layers of fiction. These interlocking narratives all fall within Wes Anderson's lasting tradition of double narration, and we would be mistaken to consider them as merely playful or decorative devices. On the contrary, sooner or later, they serve the main narrative. "*And I thought this girl, maybe, is a big reader,*

COPING WITH THE VERY TROUBLED CHILD

BY DR. ROMULUS TRILLING, M.D.

and at a certain point I sort of gave her a suitcase full of all these books. I started writing these little passages and kind of inventing what her books were, and somewhere along the way I started thinking, maybe the movie should be as if it were one of her books, you know?"[1], Wes Anderson explains.

Last, one last book deserves a mention, and although it doesn't quite belong in Suzy's travel library, it nonetheless finds its way into her suitcase. Among these extraordinary novels is a coldly pragmatic booklet: *Coping with the very troubled child*, by Dr. Romulus Trilling. When Sam asks Suzy about her problems, she shows him this booklet, which she found on top of the fridge. This little black book, contrasting starkly with the fabulously illustrated covers, comes to us from a childhood memory of Wes Anderson. *"Well, I found that pamphlet, in fact, at about that same age and when I saw it— and it was literally on top of the refrigerator—and if either of my brothers had found that pamphlet they both would've known it was me. They were never going to make a mistake and think it was themselves. I knew it was me. They would've known it was me.,"*[2] he confided to Terry Gross. Going through with his parents' divorce, the filmmaker remembers his childhood anger, which, of course, echoes Suzy's tantrums, which get her into so much trouble, both at school and at home.

As a counterpoint to the fantasy books into which the little girl Like a metaphor for the little girl's rumbling anger, the skies over New Penzance grow heavier and heavier, full of electricity, and the storm threatens. For Suzy, the storm will need to break, sweeping away everything in its path, before calm can finally return. In the meantime, she will find refuge in the parallel universes of the imagination. Her travel library, akin to a doorway to mysterious dimensions, allows her to leave New Penzance for a while, to explore other worlds, to live other lives. What books would you take with you to a desert island? Those that allow you to leave the island, of course. ⚷

1. Matt Zoller Seitz, *The Wes Anderson Collection*, Abrams, 2013.
2. Terry Gross, *"Wes Anderson, Creating A Singular Kingdom"*, Fresh Air, 29 May 2012.

IV

THE PORTRAIT GALLERY

It is a large room where paintings of all shapes and sizes are presented, lined up with mathematical precision. You've now entered the portrait gallery, where you are free to admire the friendly fauna that populates Wes Anderson's cinematographic world. These characters' names are Steve Zissou, Mr. Fox, Royal Tenenbaum or Patricia Whitman. To bring them to life, a whole troupe of actors and actresses comes together—most of them regulars at Wes Anderson's table. These characters and actors are the director's film family; they form a traveling circus of sorts, with no tightrope walkers or fire-eaters, but rife with unworthy fathers, wild children, mothers, brothers, journalists, cooks, explorers, scouts, jaguar sharks and valiant doggies. Comfortably settled in the collective imagination, these characters are akin to wonderful figurines that the movie director seemingly holds in the palm of his hand. Gathered here, they form a curious bestiary, the likes of which only Wes Anderson's imagination could summon—proof, if proof were even needed, that the meticulous process of their creation is first and foremost the work of a man madly in love with his characters. So, why does this unlikely gallery fascinate us so much? It is because every one of us probably recognizes, in these marginal, mildly unsympathetic, slightly offbeat, delightfully exuberant or frankly depressive characters, something that we are ourselves. We might even like to join their clans and live one thousand and one adventures at their sides, from the far reaches of the Republic of Zubrowka to the student revolutions of Ennui-sur-Blasé, from Indian overnight trains to the mysteries of the aquatic kingdoms. *"L'aventure, c'est l'aventure"* (an adventure is an adventure), as Lino Ventura and his gang would say. So, here is a small selection that is, however, by no means exhaustive, given that Wes Anderson's characters would all deserve to have their portraits painted.

Portrait of Steve Zissou

The Alternative Phantasmagorical Story of Captain Jacques-Yves Cousteau

Before we begin, the authors feel it necessary to draw up a (non-exhaustive) list of features and characteristics that link Steve Zissou to the great Commander Cousteau.

Kingsley (Ned) ZISSOU

Team Zissous H.Q, Pescespada Island WX2700

THIS WILL SERVE TWO PURPOSES

Improve this text's credibility.

Win the trust of our visitors, once and for all.

So, here is a non-exhaustive list of features that both men have in common:

1. Much like Captain Cousteau, Steve Zissou is hardly a pleasant fellow;

2. Much like Captain Cousteau, Steve Zissou wears a red hat;

3. Much like Captain Cousteau, Steve Zissou loses a son in a tragic accident;

4. Much like Captain Cousteau, Steve Zissou is not excessively fond of children;

5. Much like Captain Cousteau, Steve Zissou will spend his life trying to find money to finance his expeditions.

It's safe to say that characters that are adrift, caught in the throes of existential doubt, questioning their own destiny, are the cornerstone of Wes Anderson's filmography, and Steve Zissou is no exception to the rule. Looking more sinister than ever, Bill Murray plays the captain of the *Belafonte* (his very own *La Calypso*, named after Harry Belafonte's "Calypso"—quite the perfect circle). Throughout the movie, he strives to stay on course, without really knowing where he's headed—perfectly aware, however, of what he is seeking: the jaguar shark that ate (and consequently, killed) his friend Esteban.

The jaguar shark is a protected species that the oceanographer nonetheless decides to kill. Why? Zissou promptly replies: "*Revenge.*" The scene is reminiscent of behavior that Captain Cousteau was criticized for: the cruel treatment of sharks by his team. Later in the movie, a shot shows *Team Zissou* setting off explosions using dynamite to "explore" the seabed. This too recalls criticism that was rightfully leveled at Cousteau. The latter would never really apologize for this, explaining that this was the way "exploration" was practiced at the time. Cousteau would, in fact, refuse to cut these scenes at the request of American broadcasters, so as never to hide the mistakes made in the past; he would also publicly express his relief at seeing how mentalities, including his own, had evolved. Far beyond the exploration of underwater realms (as magnificent as they may be in Wes Anderson's works, bringing to life a vast imaginary fauna—who wouldn't dream of seeing a crayon ponyfish?), however, Zissou's relationship with his son, Ned (played by Owen Wilson), that is the movie's beating heart.

For Zissou, this is a complicated and new relationship—a rock in his shoe, an improvised son whom he will nevertheless try to shape as he wishes, even going so far as to try and change his first name. Indeed, young Ned shows up out of the blue and confronts Zissou, who has never really acknowledged his paternity. This is another point that Zissou and Cousteau have in common— Cousteau's son, Philippe, would join *La Calypso* after years of absence. It is all about learning: how can someone over fifty become a father? In Steve Zissou's case, you never truly become one; instead, you merely get accustomed to the invasive presence of a son, because, as he says: "*[…] I hate fathers, and I never wanted to be one.*" However, Zissou will do everything in his power to save Ned from the wreckage of their helicopter, in vain. Much like Captain Cousteau, Steve Zissou will lose his son—an irremediable fate that Wes Anderson will accept and harness cinematically, with his habitual finesse—however, not without a slight touch of absurdist humor that somewhat mitigates his viewers' emotions.

Much like Captain Cousteau, again, Zissou remains obsessed with staging his life and his expeditions on screen, constantly asking whether the events are really "in the can," and which lens and what aperture were used.

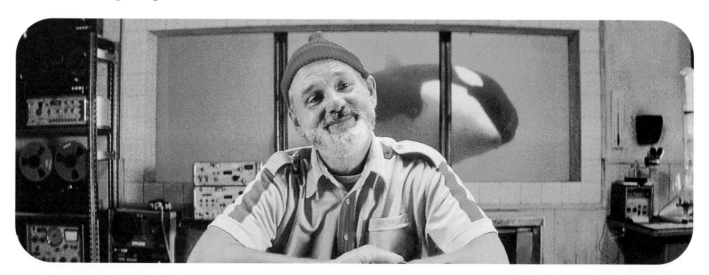

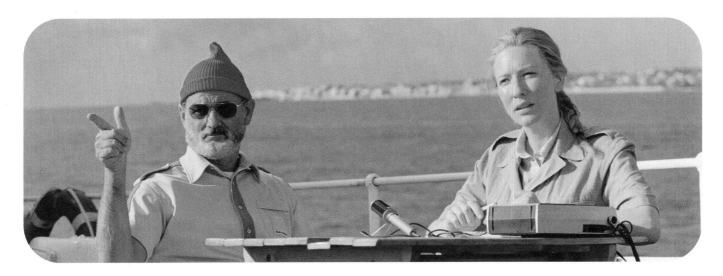

Cousteau defined himself as a filmmaker, first and foremost. Indeed, the cinematographic world would not fail to acknowledge the Commander's prowess, awarding him a *Palme d'Or* and an Oscar for his movie "*The Silent World*," directed with Louis Malle (who also greatly inspired Wes Anderson), a technical feat that would welcome viewers of the time to discover, for the first time, a previously hidden and unknown universe. A brilliant inventor, Cousteau shared Zissou's taste for mechanics, technology and rickety analog DIY contraptions that, today, seem obsolete. Opposite Zissou stands the extremely wealthy Alistair Hennessy, played by Jeff Goldblum, a researcher who has access to cutting-edge technical innovations, while Zissou continues to approach his craft in the most artisanal way possible. It is easy to see, in Steve Zissou, an aquatic reflection of Wes Anderson, while Hennessy appears as an all-conquering and almighty avatar of James Cameron. Last but not least, Steve Zissou evokes the captain of *La Calypso* on screen. With this, Wes Anderson invites us to consider his movie as a fantasy mirror of Jacques-Yves Cousteau's life, a parallel world tinted with brighter colors, where the hidden face of events is revealed to us; an imaginary documentary dedicated to the life of the former naval officer, who long remained the favorite personality of the French. After his passing in 1997, he was showered with honors from all over the world, up to and including a ceremony attended by President Jacques Chirac himself, in the heart of Notre-Dame de Paris. As for Steve Zissou, who knows where he might be at the time of writing, likely in search of some unknown fish, mistreating the "*pack of strays*" (indeed, this is how he describes his crew) that follows his cause aboard the rickety *Belafonte*, honoring the memory of Captain Cousteau in his legendary red hat, sailing seas far and wide, his proud gaze never leaving the horizon. ⚷

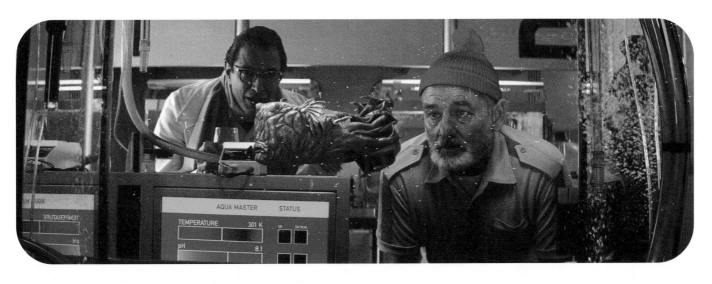

Portrait of the Jaguar Shark
The Terror of the Oceans

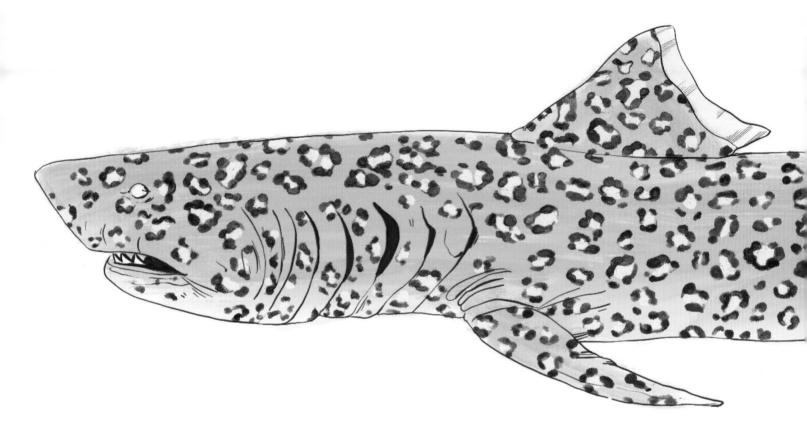

It is to Steve Zissou what Moby Dick was to the fearsome Captain Ahab: his Leviathan, the biblical embodiment of chaos, the dreadful expression of an evil that threatens to engulf mankind. Even if, in more modest terms, this jaguar shark has only swallowed the faithful Esteban du Plantier, comrade in arms and retired member of *Team Zissou*. Steve Zissou now feels a boundless hatred for the marine creature that robbed him of his lifelong friend. And when, at the Loquasto Festival, he presents the last images of his living friend to an audience that remains somewhat indifferent to his misfortune, Steve Zissou is taken to task by the festival's attendees. What does he intend to do now? "*[…] hunt down that shark or whatever it is, and, hopefully, kill it*," Steve Zissou replies with a determined expression (and also, as we will mention further along this visit, a rather depressed one). Boarding the *Belafonte*, akin to Captain Ahab sailing aboard the *Pequod* (that is to say, armed with an iron will and a questionable measure of sanity), Steve Zissou wholeheartedly throws himself into this new quest—the quest of an oceanographer who, to re-establish his somewhat blunted legitimacy, has no choice but to prove to the world the existence of a creature as exotic and curious as the jaguar shark. However, this is also the quest of a bereaved man who, succumbing to a bout of all-consuming depression, makes it his mission to avenge his friend with blood. In this respect, the relationship that develops between our humble jaguar shark and Steve Zissou reminds us of Herman Melville's phenomenal novel, in which the aging Captain Ahab scoured the seas, sails billowing in the winds, in search of the great white whale.

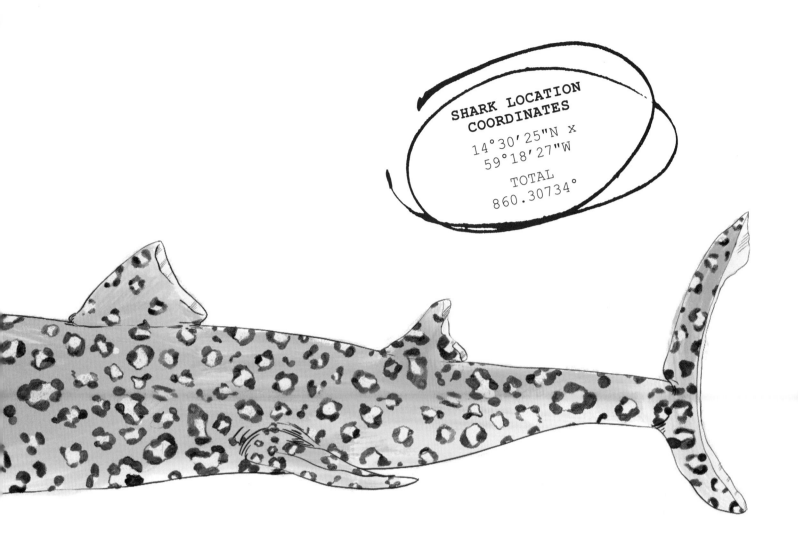

This is how Captain Ahab, consumed by his desire for vengeance, roams all the seas of the world in search of the monster that once took his leg. Behind the captain's murderous quest lies a metaphorical struggle between good and evil, a ferocious battle driven by pride and obsession—for the foolish old Ahab, all the suffering, evil and malice in the world are soon personified by the beast, and confrontable within it. The same is undoubtedly true of the jaguar shark, which also crystallizes all the bitterness and torment felt by Captain Zissou, then in the throes of an existential crisis.

And while there is no evidence on film of the strange sea monster's existence, a beacon attached to a spear remains firmly planted in the beast and will, after many adventures, lead the crew to it. Crammed into their little yellow submarine, the *Deep Search*, the crew of the *Belafonte* finally comes face to face with the great jaguar shark, gracefully sliding through the dark waters. With its large luminescent spots, the beast swims gently above the ship, oblivious to the all-too-human battle that opposes it to Zissou. *"Oh! Ahab,"* cried Starbuck, *"not too late is it, even now, the third day, to desist. See! Moby Dick seeks thee not. It is thou, thou, that madly seekest him!"*[1] Herman Melville wrote. While Ahab, in his ruthless madness, led his crew to their doom, Steve Zissou is captivated by the beauty of the creature that he has hunted for so long and forsakes his revenge, embracing a different path for himself and for his crew. *"We're out of dynamite, anyway."* ⚷

Portrait of Jopling
The Zubrowka Ogre

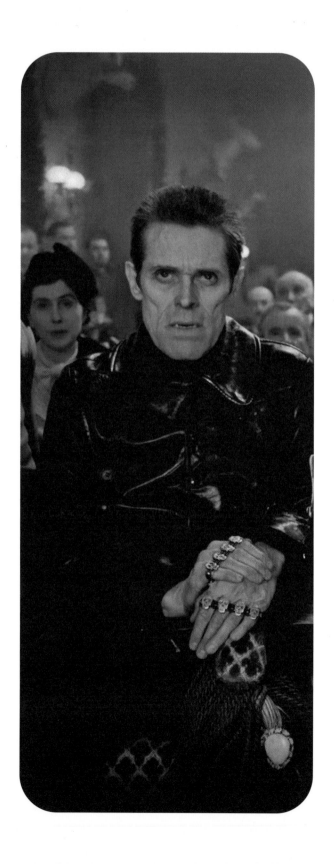

Merciless, unstoppable, cruel, bloodthirsty, barbaric, ferocious, inhuman, insensitive, cold, savage, evil and brutal. J. G. Jopling embodies all of these traits, and more yet. Of all the characters featured in the Wes Anderson universe, Jopling is unquestionably the most implacable and dangerous. In the pay of the sinister Dmitri (played by Adrien Brody, embodying a perfect bastard and future fascist), J. G. Jopling is, in a way, the Terminator of the great adventure movie *The Grand Budapest Hotel*. Roaming the cold streets of Lutz, in Nebelsbad, he prowls, always on the lookout, eyes wild, jaws clenched, ready to pounce on his prey.

Dressed in a long charcoal-black leather coat concealing multiple pockets in the lapel—this is the world of Wes Anderson, where even an overcoat has its share of surprises and hidden details—, Jopling always carries a small flask of booze, a revolver and a few sharp blades. With his fingers covered in rings adorned with skulls (we told you he's really bad!), his hair styled in an incredibly rigid, brush-like crew cut and his disquieting, toothy grin, Jopling has all the trappings of the perfect villain. Furthermore, Wes Anderson's character conforms to a certain tradition of thriller movies, rich with all manner of villains; indeed, the pursuit scene inside the museum pays direct homage to Alfred Hitchcock's *Torn Curtain*. With his razor-sharp canines and his Nosferatu-like appearance, J. G. Jopling is a somewhat theatrical villain; however, he demonstrates to anyone who might still doubt it that Wes Anderson's little universe is much more than a gigantic bonbonnière. On the contrary,

violence does not fail to spatter the tasteful, muted backdrops of the Grand Budapest with vivid red splashes, particularly when Jopling is around. Indeed, while Wes Anderson is a filmmaker capable of the greatest delicacy and the loveliest feelings, he also doesn't fear exploring the darker side of his cinematographic world. Contrary to popular belief, punches fly and bullets rain down in the Texan director's world, and casualties (both human and canine) abound. And if anyone still had any doubts about the outbursts of violence in Wes Anderson's movies, J. G. Jopling's character should not fail to convince them.

In the course of his adventures, the henchman will kill in cold blood, behead an innocent woman, lop off a few fingers—and, worst of all, toss a magnificent Persian cat out of the window, leaving the pet lying dead on the forecourt, in a pool of blood, with its guts spilling out from its belly, some fifty feet below— and all this, without the slightest trace of emotion. The cruel J. G. Jopling is played here by Willem Dafoe, who seems to find childish enjoyment in dismembering an insect. In comparison, Dafoe's Green Goblin character (*Spider-Man*, Sam Raimi, 2002) could pass for an amiable ice cream salesman on a Mediterranean beach, in the middle of August. As you will have gathered, the character who ends up being pitifully pushed off the top of a Zubrowka mountain is Wes Anderson's most absolute figure of evil. Admittedly, Jopling is a heartless creature; however, we would gladly enjoy a glass of exotic dry vermouth with him by the fireside, as the clock strikes four, while night already falls on Lutz and temperatures drop below freezing.

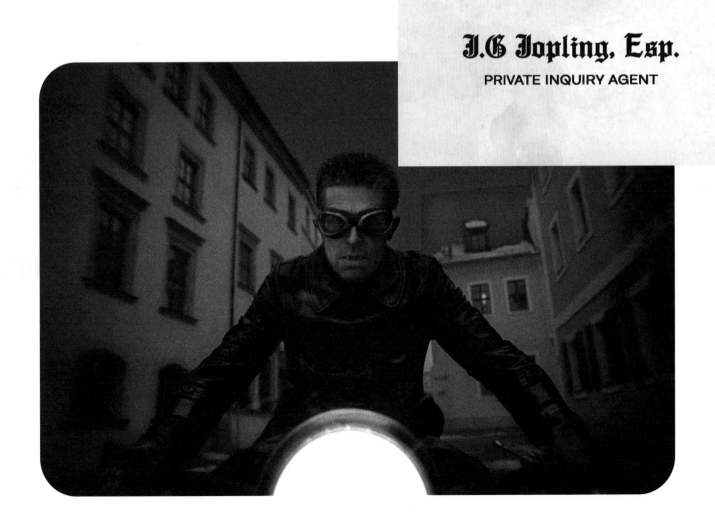

Portrait of Royal Tenenbaum

Bad Education

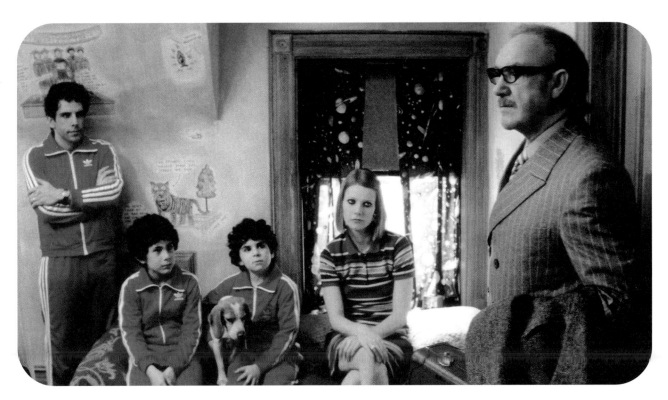

As we all know, Wes Anderson's work is strewn with more or less disastrous father figures. These unworthy, shiftless or absent fathers, brilliantly irresponsible figures or pathological liars, frequently appear throughout Anderson's filmography, reminding us that becoming an adult involves much more than simply growing. However, in the midst of this fauna of failed fathers—from Mr. Henry (*Bottle Rocket*) to Steve Zissou (*The Life Aquatic*) and Herman Blume (*Rushmore*)—, there is one character who will long embody the characteristically Andersonian bad father in all his splendor. This ultimate *pater familias* is indeed Royal Tenenbaum.

At 111 Archer Avenue stands the sumptuous red-brick New York home of the Tenenbaum family. This is where Royal and his wife Etheline live, surrounded by their three exceptionally gifted offspring. Chas is a small-time financial tycoon; Richie, a tennis court champion, and Margot, their adopted daughter, a budding playwright. The little Tenenbaum tribe is thus promised a brilliant future, until the day when the father abandons ship, also forsaking its crew—and damn the consequences. Two decades of disappointments, failures and disasters later, we meet once again with the Tenenbaum children—

now in their thirties, disillusioned, neurotic or even frankly depressed. During these twenty-two long years of absence, Royal has enjoyed a peaceful life at the Lindberg Hotel, in suite 604, where he settled down and remained until his bank accounts ran dry. Indeed, despite his unchanging gray double-breasted suit jacket and neatly knotted striped ties, Royal has long since been disbarred. Absolutely broke, destitute and somewhat offended by the news of Etheline's remarriage, he now has only one thing on his mind: to regain his rightful place within the Tenenbaum family. And so, the disgraced head of the family does the only thing that he can do in such circumstances: lie shamelessly. And when he returns to the limelight, announcing his incurable (and imaginary) illness, one by one, the former prodigies return to the fold.

Although *The Royal Tenenbaums* is presented as a novel, there is something in its fast-paced opening that sends us lurching straight into the eye of the storm. In Wes Anderson's bittersweet world, children are already adults, and adults are still children.

While the Tenenbaum children have all the attitudes and seriousness of grown-ups, Royal comes across as

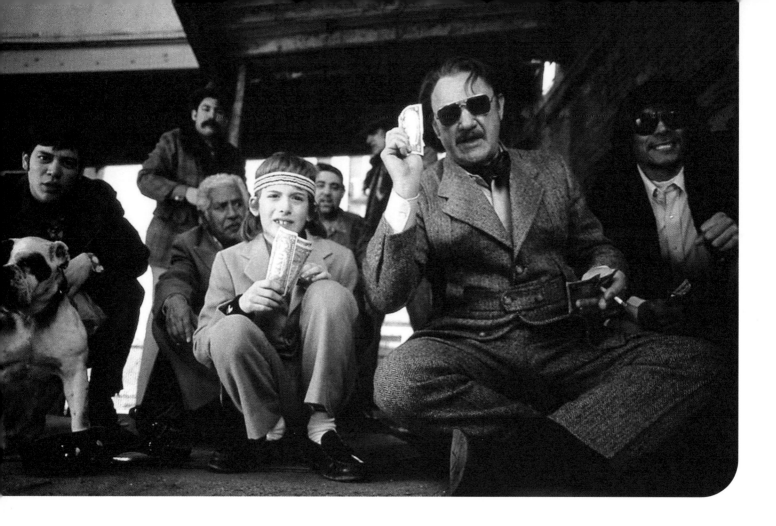

frivolous and irresponsible; even his dishonest acts display the rebellious, candid charm of children caught red-handed. It's an inverted value system that is highly prevalent in Wes Anderson's works. Right from the prologue, Royal is presented to us through a long and accusatory list of failings to his duties: as a husband, first of all, when he grudgingly acknowledges his many infidelities; then as a father, by disappointing each of his children, one after the other. For instance, Royal Tenenbaum unscrupulously takes advantage of his eldest son Chas's business acumen, even if it means defrauding him. *"There are no teams,"* he reminds him during a game of BB guns that goes awry. With Margot, Royal makes a cruel distinction, reminding everyone that she is an adopted daughter, always regarding her as half-Tenenbaum. Finally, Royal openly displays his preference for his son Richie. This doesn't make him a better father, however; blatantly unaware of his son's gentle temperament and artistic sensibilities, he drags him into dubious adventures such as dogfighting in the slums of New York. In this four-handed script penned

by Wes Anderson and Owen Wilson, the characters firmly stand at the helm. *"We had a good idea of the characters and who they were long before there was any story,"* states the director. *"I've never had a movie where it started with a plot, but the characters gave us a plot and sort of took over… Royal was not the main character at the beginning… [but] that character came in and took over because he made things happen in the story."*[1] For Anderson, the face of Royal Tenenbaum was an obvious choice, as the role of the appalling father was specially written for Gene Hackman—who *"reluctantly"*[2] accepted it, as the director likes to say. The actor explains: *"I told Wes not to write the part specifically for me. Generally speaking, I don't like things written for me—or rather I don't like having to be restricted to somebody's idea of who I am. So we had this nice chat. I told him not to do it, and then he went off and did it anyway!"*[3] After declining the offer, Gene Hackman finally accepted the role of the patriarch, and became the head of this prestigious cast. Of course, *The Royal Tenenbaums* is punctuated

80 1. *The Royal Tenenbaums*, press kit, Touchstone Pictures, 2001. 2. Matt Zoller Seitz, *The Wes Anderson Collection*, Abrams, 2013.
3. The *Royal Tenenbaums*, press kit, Touchstone Pictures, 2001.

with autobiographical details. To better prepare for the role of Etheline, Wes Anderson even sent Anjelica Huston a few photos of his mother—an archaeologist by profession, like her character—, and went so far as to ask her to wear the same glasses. However, the filmmaker would always deny any resemblance between his own father and that magnificent bastard, Royal Tenenbaum.

It would take the Tenenbaum father no less than twenty-two years to return to the corner of Archer Avenue. Within the redemption of the incorrigible Royal also lies that of his family, whom he manages to unite around another of his big old lies, which he alone knows how to conjure up. For the Tenenbaum siblings, there is only one way forward: to return to their childhood home, the epicenter of the disaster, to forgive their father's neglect and to learn to become nearly functional adults. After the subterfuge has been discovered, the aging trickster speaks emotionally of the few days spent in their presence, then, surprised by his own speech, realizes that he is sincere.

These are the small epiphanies that feed *The Royal Tenenbaums*. Royal is an even clearer forerunner of the universal and intimate theme that runs through Anderson's works: the ties of the heart, the families that we choose, and the families we repair. In the winter of his life, before the curtain drops, Royal Tenenbaum attempts to reclaim his place within this whimsical and dysfunctional tribe. Fragile creatures, who have not quite made it out of childhood, the Tenenbaums are all driven by one same desire—to belong to a family. *"I always wanted to be a Tenenbaum, you know?"* Eli tells Richie. Standing in the doorframe, with a sigh, Royal replies: *"Me, too. Me, too."* 🔑

Portrait of M. Gustave
The Man With the Golden Keys

He is the undisputed master of the establishment; the man who holds the golden keys, the "pastry chef" of this gigantic pink and white wedding cake that proudly rises between mountains of icing sugar. Within the walls of the Grand Budapest Hotel, in its heyday, M. Gustave is the guardian of all things, the warden of a certain established order (albeit a rather dusty one), the valiant defender of the way the world is, the way it should be and the way we would like it to remain. Such is the mission to which he devotes his life: to preserve the reputation and the prestige of this luxury hotel which, in the looming dark days, might well be the last vestige of a civilization standing on the brink of extinction. Indeed, behind the glittering pink walls of the Grand Budapest lurks an evil that does not speak its name—that of the Zig-Zag Division, which will soon mar the hotel's walls with its dark initials. However, as totalitarianism rumbles at the gates of the Republic of Zubrowka (even the morning edition of *Trans-Alpine Yodel* issues a warning), M. Gustave has his own problems to solve.

Far from being a mere servant to the old continent's elite, M. Gustave is the heart and soul of the establishment—and, as Zero Moustafa confirms, it is also for him that the Grand Budapest's distinguished clientele flock to the hotel. Indeed, M. Gustave belongs, body and soul, to this declining aristocracy; not by birth, as we know him to be of modest extraction, but by taste, ideology and love. While a volley of curses occasionally escapes our gracious concierge, M. Gustave is a man graced with impeccable manners, a lover of poetry, which he feverishly declaims to his staff, and of paintings, which he occasionally steals; he is also a dear friend to the respectable

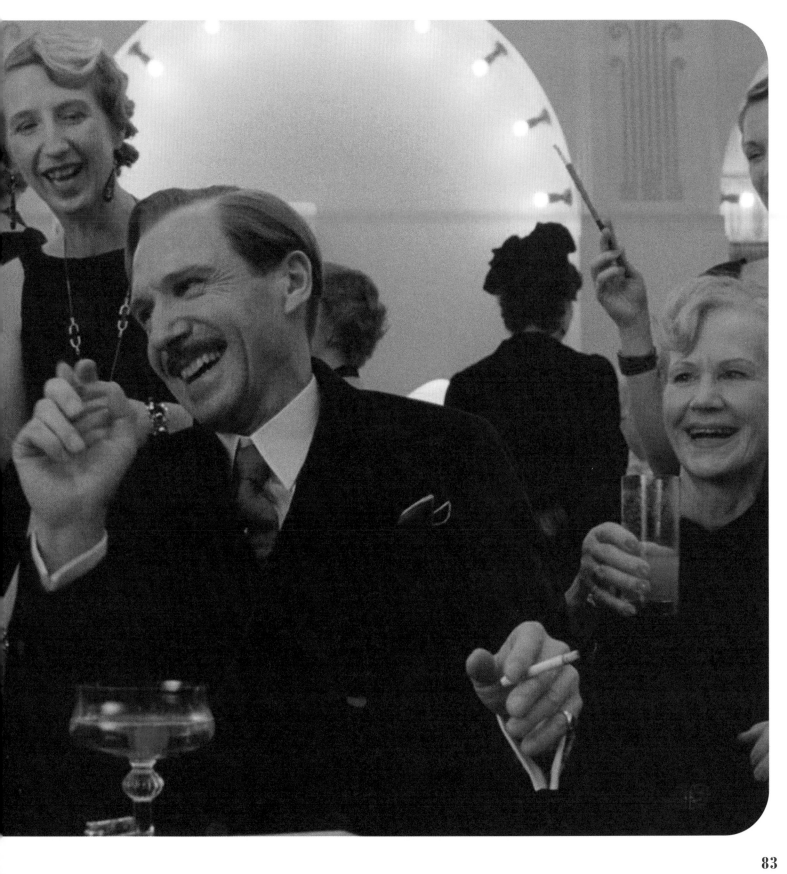

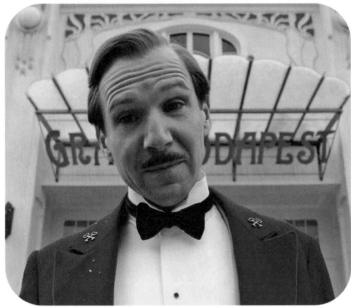

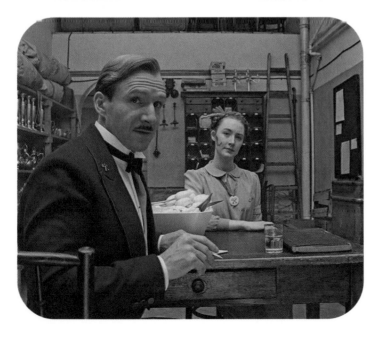

elderly ladies who travel to the Grand Budapest to spend days in loneliness, which the concierge endeavors to mitigate. An ambassador and warden of good taste, M. Gustave speaks no less than three languages—German, English and Italian. It is, however, not known whether he owes his elegant upbringing to his love of poetry or rather his love of rich heiresses. In the end, it matters little where M. Gustave comes from; indeed, this former bellhop devotes his life to what is beautiful and what is light and precious in this dear old world. This stubborn sense of lightness is perhaps, in the end, what most closely ties our character to the director—his ability to treat the darkest or most slapstick subjects with unchanging elegance and grace, without ever losing his sense of humor.

However, the taste of sugar isn't sweet enough to conceal the impending sense of the fascist catastrophe. And so, in the character of M. Gustave, one also recognizes the (mustachioed) figure of one Stefan Zweig, who was madly in love with his old continent, and to whom the film pays a final tribute. There is every indication that, within our museum's library, a small number of the Austrian writer's memoirs are to be found. Faced with the collapse of his world, of a Europe he considered his *spiritual homeland,* Stefan Zweig preferred to take his own life. M. Gustave, on the other hand, will enjoy a brief moment of happiness, when he finally takes possession of the inheritance left by Mrs. D., thus becoming one with the good society that he has been courting for so long. It's a short-lived happiness, because, whether driven by recklessness or by courageous pacifism, he protests once too often against the authorities who have taken over his beautiful homeland. An exit from the stage which, like the cologne with which he abundantly douses himself, has great panache. ⚷

Portrait of *Boy with Apple*
Lot 117

Boy with Apple undoubtedly is a quintessential product of Italian mannerism, soaked in German Renaissance, sprinkled with a pinch of the great European dynasties, in the style of the Habsburgs or the Tudors. In short, *Boy with the Apple* might have been nothing more than an amusing joke aimed at art history students… but is it just that? This illustrious portrait of an equally illustrious stranger, about to bite into the forbidden fruit, a potent Judeo-Christian metaphor, if ever there was one, has unquestionably earned its place on the walls of this Imaginary Museum's prestigious portrait gallery. Dear visitor, let us take a closer look.

He is the "*only son of the eleventh duke. 1627 A.D.,*" if one is to believe the pompous Latin inscription that frames the boy's melancholic face. Seated in front of a heavy red velvet curtain, this young blonde man, whose three-quarter profile is reminiscent of self-portraits by painter Giorgio De Chirico, pensively observes the viewer. When contemplating this work, many, many inspirations inevitably come to mind, ranging from Raphael's *Young Man with an Apple* to the works of the Florentine Bronzino and those of the German Albrecht Dürer. Dressed in brocade, velvet and a sable pelisse, the young boy holds the apple of discord between his gnarled fingers. The discord, indeed, is not that between the goddesses of Olympus, but that opposing the graceful M. Gustave and the somber Dmitri Desgoffe und Taxis (whose resplendent, imaginary surname borrows from the princely house of Thurn und Taxis).

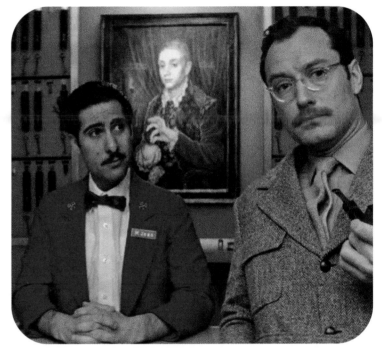

To understand the importance of this portrait in the history of the Grand Budapest, we need to turn our gaze toward the intransigent M. Gustave, who, in the hotel rooms, "courts" the very elderly Mrs. D. Following her sudden and somewhat suspicious passing (even for a woman of her age), she bequeaths her good friend a priceless painting. Well aware that the scorned heirs will do everything in their power to recover the murdered countess's treasure, M. Gustave decides to steal the painting, with the assistance of the helpful household staff. This portrait, soberly entitled *Boy with an Apple*, is attributed to the (fictitious) painter Johannes Van Hoytl the Younger (1613–1669). However, before becoming this invaluable faux portrait painted in the style of the Renaissance, *Boy with Apple* is, first and foremost, a superb example of a McGuffin. This astute

little plot device, as theorized by Alfred Hitchcock himself to François Truffaut, consists in introducing a narrative item that will give its protagonists something to pursue throughout the movie. A McGuffin is a fantastic narrative force, and can take on a wide variety of forms, depending on which characters are hunting it down—a strictly confidential document for a spy, a briefcase full of cash for a gangster… Naturally, for M. Gustave, this McGuffin could not have been anything less than the absolute height of refinement. So, while some protagonists chase a

in its own pomp and privilege that it failed to notice its own fate. Furthermore, Zero Moustafa and M. Gustave hastily replace the painting with a (fake) Egon Schiele, a modern painting presenting angular features and raw nudity, in the middle of a Sapphic love scene. And so, our elegant concierge, blissfully unaware of the "new things in the world," and visibly unmoved, forsakes a true treasure of modern painting in favor of a supposedly priceless *Boy with Apple*. Egon Schiele's art, with its spindly lines and immodest bodies, was labeled "*Entartete Kunst*,"

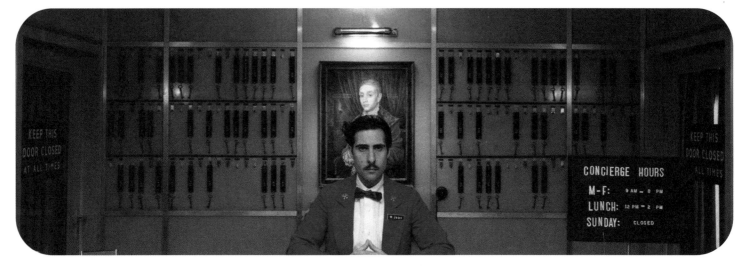

mysterious attaché case, like others chase their *Maltese Falcon*, M. Gustave and Dmitri set off in pursuit of the *Boy with Apple*. And like any respectable McGuffin, the painting will ultimately prove to be utterly insignificant. From a historical point of view, first of all, since it will not be displayed in the prestigious *Kunsthistorisches Museum* in Vienna, but rather, will sadly hang in the hotel lobby, now stripped of its former glory. From a narrative point of view, too; indeed, its value lay not in the painting itself, but only in Mrs. D.'s will, cleverly concealed between the wood and the fold of the canvas.

This painting by Johannes Van Hoytl the Younger (whoever Van Hoytl may have been) is in fact the work of a real-life English artist by the name of Michael Taylor. A tribute to the masters of the Renaissance, this painting is a metaphor for a *Mitteleuropa* that was so immersed

i.e. degenerate art, by the Nazis. Schiele's works, considered ill-natured, were largely despoiled by the regime. So, while one can enjoy the harmless joke that is *Boy with Apple*, one should also reflect upon its punchline. When the fearsome Dmitri, a supporter of the regime, discovers that his painting is missing, he destroys the (fake) painting by Egon Schiele, in a fit of rage. While this lack of foresight could almost make one smile, in retrospect, the destroyed work could be one of Egon Schiele's lost paintings, perhaps the first painting that the fascist regime would deprive the world of. With this interplay of tableaux, Wes Anderson delicately and symbolically interweaves fiction within a fiction. ⚷

Portrait of Patricia Whitman

Mother Superior

Wes Anderson's filmography is full of disgraced, immature or untrustworthy fathers, who appear in their family's life only to put its cohesion to a severe test. And since family is at the heart of the filmmaker's concerns, a number of maternal figures also manifest with some regularity. One actress, in particular, has played this role in several of the director's movies—and certainly still does, in our imaginations. She is the mother superior of all Andersonian dynasties, casting a tender or stern gaze over her disorderly tribe. This definitive mother in Wes Anderson's work is none other than Anjelica Huston.

In *The Royal Tenenbaums*, Wes Anderson wrote a role that was made-to-measure for her—that of the matriarch Etheline Tenenbaum. For the actress, whose warmth and sophistication he admired, Anderson imagined a character more or less consciously reminiscent of his own mother, Texas Ann Anderson. Anjelica Huston was immediately given sketches of the character, along with a few photos of Texas Ann—an archaeologist by trade, just like Etheline. "*He even produced his mother's old eyeglasses for the early scenes. I asked him, 'Wes, am I playing your mother?' I think he was astonished by that idea,*"[1] Anjelica Huston laughs. A loving and deeply involved mother, Etheline compensates for the devastating influence of Royal, whom she eventually kicks out of the household. For Anjelica Huston, this is "*a necessary heartbreak.*"[2] Faced with the wreckage of her marriage and Royal's blatant irresponsibility, this mother figure redoubles her efforts to secure the future of her offspring, while also keeping her career afloat. And while Etheline intends to work miracles, she will be required to make a number of sacrifices—starting with

1. *The Royal Tenenbaums*, press kit, Touchstone Pictures, 2001.
2. *Ibid.*

her personal life. "*To tell you the truth, I haven't slept with a man in eighteen years*," she admits to Henry, her suitor. Other important maternal figures can be found throughout Wes Anderson's filmography. There is the figure of the courageous mother, Felicity Fox, determined to build a safe and peaceful home for her fox

cub. Then, there is the surrogate mother, Eleanor Zissou, once again played by Anjelica Huston. Indeed, while Eleanor's desire to have children is curbed by her husband, she is the mother figure who watches over *Team Zissou*, and is also truly the brains behind the operation. Some mothers are more fallible, such as the character of Mrs. Bishop, in *Moonrise Kingdom*: guilty of adultery, she appears to betray both her maternal role and her marital role. At home, she speaks to her children through a megaphone, acknowledging the physical and emotional distance that separates them from her. When she speaks to her daughter or her husband, this distance is maintained by the lawyer's vocabulary that she adheres to, imposing a strange stiffness on her family relationships. And yet, Mrs. Bishop, much like Etheline, is a devoted mother, capable of intimacy, which Wes Anderson's characters seldom are. Two scenes in bathrooms testify to this maternal tenderness. In *The Royal Tenenbaums*, Etheline rescues Margot, too depressed to exit her bathtub. In *Moonrise Kingdom*, Mrs. Bishop washes Suzy's

long hair, while having an emotional conversation. In Wes Anderson's work, other maternal figures are marked by the intensity of their absence. These are the mothers who died too soon, leaving their husbands and children adrift, like Max's mother in *Rushmore*, Chas's wife in *The Royal Tenenbaums*, or Augie Steenbeck's mother in *Asteroid City*, whose grief embodies the movie's true gravitational center. In a world where fathers fail in all their duties, where the roles of adults and children are undone by absolute confusion, in Wes Anderson's work, the mother figure becomes both a safeguard and an anchor point to the world, making her absence all the more cruel. Yet, at the heart of Anderson's filmography is a mother figure like no other: when Anjelica Huston receives two nuns' figurines in her home, she knows something is afoot. The polar opposite of Etheline, Patricia Whitman in *The Darjeeling Limited* is a mother whom one could describe as resigned. When her husband passes, she leaves the country without warning, leaving behind her three grown-up sons. She

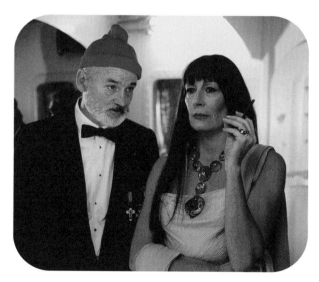

flies to India, where she leads a spiritual and altruistic life in a convent, built atop the foothills of the Himalayas. The unspoken purpose of the Whitman brothers' great Indian expedition is, of course, to find their mother; not so much to confront her, however, as to heal their own wounds. Arriving in the Himalayan highlands, the Whitman brothers are met by an independent, rebellious woman with little maternal instinct and little

interest in becoming the great answer to her adult sons' existential anxieties. Patricia's answers to their questions are vague and dogmatic: "*You're talking to her. You're talking to someone else—not me. I don't have the answers to these questions, and I don't see myself this way.*" It's easy to see how difficult it is for these three sons to distinguish reality from lies (the man-eating tiger, in fact, turns out to be real), to know whether their mother's display of mysticism is sincere or whether it's just a cop-out, a smokescreen that she is deploying to remove herself from an uncomfortable situation. After a silent and emotional reunion, Patricia once again disappears into the night, leaving her sons' breakfasts on the doorstep as a final gesture of affection. Is Patricia Whitman a bad mother? Nothing is less certain, and the movie cautiously shies from drawing any such conclusions. What *The Darjeeling Limited* puts into perspective is the temptation to look to our parents for the answers that we don't find within ourselves. "*There's so many things we don't know about each other, aren't there?*" laments Patricia. What do children really know of their parents? With the mystical and volatile character of Patricia Whitman, Wes Anderson

creates one of the greatest enigmas of his filmography. ⚷

Portrait of Mr. Fox

Dr. Fox and Mr. Anderson

Beneath Mr. Fox's corduroy suit lies a ferocious beast, slumbering and biding its time before it suddenly manifests. Its time, specifically, is dinner time. Mr. Fox's wild instincts are unfailingly regulated by his stomach. Whenever it comes to food, when it's time to sit down for lunch, when it's time to give his dinner plate what for, the charming Mr. Fox completely loses his mind. No matter how hard his wife tries to "civilize" the Fox of the house, when the time comes to put his feet under the table, Mr. Fox will engulf his meal in one go, with a voracious and grotesque appetite, without even stopping to breathe. Indeed, beneath his gentlemanly exterior, Mr. Fox

Mr. Fox, with his tailor-made suits, his pipe and his morning paper, with his delightful wife at his side, he certainly looks like the model father. Everything seems to be copacetic in fox country…

But we are all too familiar with the saying: "*A leopard cannot change its spots…*" Of course, our Mr. Fox will be no exception. Although he has promised his wife that he will no longer succumb to his hunting impulses and will lead the life of a domestic fox, Mr. Fox will soon break his oath. No matter how hard he tries to subdue his true nature, burying it as deeply as possible, even underground, nothing helps: it

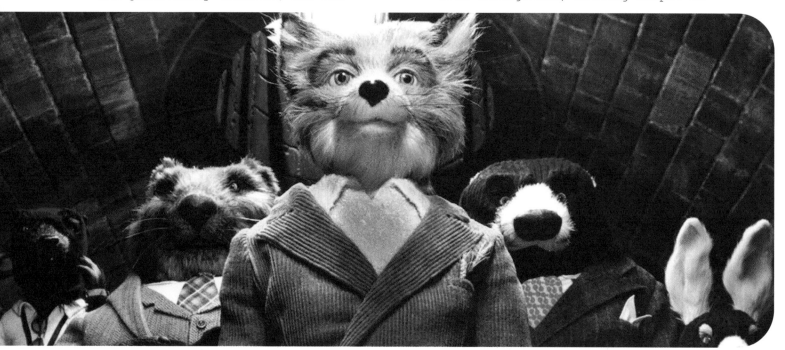

conceals the soul and manners of a fox from a children's tale: cunning, vicious—and, let's admit it, full of violent impulses. Yet, nothing predisposes our character to such bestial behavior. On the outside, the Fox family has all the trappings of an average family, settled down beneath a hollowed-out tree, in a comfortably furnished interior. As for

always comes back stronger than ever. For the worldly fox grappling with his old demons, this is a full-blown identity crisis. The scene that best illustrates this pivotal moment, the moment when the wild animal reclaims its rights, when the gentleman falls prey to savagery, is where he devours his meal unceremoniously and noisily, in the blink of an eye, shredding the

roast chicken with all his claws and fangs. It's as if he needs to kill this carefully prepared meal a second time, to hunt the already cooked prey with his own hands—in short, that primal instinct that he tries so hard to conceal under velvet clothing needs to be released to the surface. This description could apply to Wes Anderson himself. It's not that our director mercilessly devours roast chickens, nor that he feels like a thief or a fox (although…). However, Wes Anderson indeed also displays this dichotomy, this gentle, dormant madness, and beneath his sharp suits may lay a wild instinct that one can unveil by studying his feature films. Behind the pastel colors and dollhouse decors that characterize his movies, Wes Anderson also possesses a ferocious appetite and a sense of excess. Beneath the apparent gentility of his characters lurks a dull violence that sometimes even leads to murder—quite simply. So, Wes Anderson may, after all, not be the "light" and somewhat "quaint," even "carefree" director that some perceive him to be. Between two mouthfuls of Mendl's splendid pastries, the characters in *The Grand Budapest Hotel* must deal with barbarity, violence and death. The same goes for each of Anderson's movies and each of his stories. One cannot fail to notice, in fact, that as his filmography expands, the sky grows a little darker with each release. However, the filmmaker has the elegance to trust in his viewers' intelligence, in their ability to lift

the corners of the rug, to crack the varnish and reveal the true meaning of his discourse. Think about it, and never forget: beware of what lies beneath a reassuring velvet jacket, and always take a man who smokes a pipe seriously. ⚷

Portrait of Roebuck Wright
The Feather in the Mayonnaise

It is said of him that he possesses a photographic memory, which is completely untrue. Indeed, Roebuck Wright has a typographic memory, a quality that enables him to memorize written texts with flawless accuracy and precision, to the point of being able to mentally "dog-ear" his narrative.

He keeps a tenacious memory of every word that he has written down on paper over the course of his lengthy career; and, alas, the same goes for unrequited words of love… Wes Anderson imagines Roebuck Wright as a clever cross between the writers James Baldwin and Tennessee Williams, and the *New Yorker* (of course) journalist A. J. Liebling, who regularly appeared in the newspaper as a food critic and a connoisseur of French cuisine. In *The French Dispatch*, on the television set where he is a guest, in a setting reminiscent of vintage treat box, Roebuck Wright appears as a man of taste, dressed in a sand-colored suit, an orange shirt and elegant brown boots. It is on the subject of one of his articles, published in the "Goûts et odeurs" section of *The French Dispatch*, that the presenter asks him to exercise his talent by reciting this column, live and from memory.

It all begins with this enigmatic question: "*Do students of the table dream in flavors?*" This is the first question prepared by Wright for his meeting with the famous Lieutenant Nescaffier, the figurehead of what is known as "*Gastronomie Gendarmique*," and a renowned specialist in stakeout picnics and other van snacks. He is the ranking chef at headquarters on the narrow river peninsula known as the "*Rognure d'Ongle*." It is here, in this labyrinthine police station, that the journalist is preparing to "grill" the chef. However, the meeting

SNACK
LE TOUT VA BIEN
BAR
STATION

196805 ENNUI-SUR-BLASÉ
Tél. : (78) 80-37-83

takes a completely different turn, sending Roebuck Wright into a genuine detective story.

Wright is a singular character, who is no longer concerned about being misunderstood. He is a free man, and one could listen to him talk for hours, punctuating his stories with French words spoken with an American accent that brings a whole new dimension to the language of Molière. Indeed, akin to Wes Anderson and his adopted city of Paris, Wright is a stranger in the small town of Ennui-sur-Blasé. After crossing the United States from one side to the other, from the Midwest to the Deep South, young Roebuck Wright never found his place in Uncle Sam's country. It is in the small French town of Ennui-sur-Blasé that he would find a surrogate family, when one idle evening, he was arrested in the low-rent district, in a drinking establishment, with a number of newly found companions. The reason for his arrest: love. Roebuck Wright is gay and, as he would confide to viewers years later, a love that is considered to be wrong can put you in great jeopardy. However, these things matter little to editor Arthur Howitzer Jr., who sees Wright as a talented writer and works to have him released. Howitzer welcomes him to the ranks of *The French Dispatch*, under this sole nebulous instruction: whatever you write, make sure that you give the impression that you wrote it that way intentionally.

This is how Wright joins this large family of expatriates, which includes the members of his editorial team, Lieutenant Nescaffier—and, of course, Wes Anderson. As the filmmaker himself should know, with exile—even chosen exile—comes solitude. This solitude, which he experiences as a foreigner, is a form of romantic spleen that Roebuck Wright describes emphatically: "*There is a particular, sad beauty well known to the companionless foreigner as he walks the streets of his adopted (preferably, moonlit) city. (In my case, Ennui, France.) I have so often shared the day's glittering discoveries with: no-one at all.*" However, this melancholy is also

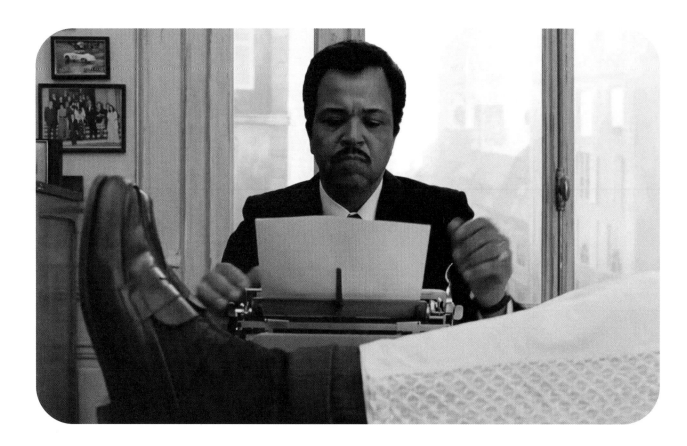

a muse and a friend to Roebuck Wright, as it may have been to Anderson. It is she who guides the journalist toward his true vocation, as a food critic: "*But always, somewhere along the avenue or the boulevard: there was a table. Set for me. A cook, a waiter, a bottle, a glass, a fire. I chose this life. It is the solitary feast that has been (very much like a comrade) my great comfort and fortification.*" This solitary feast is the feast of a man who, in the familiar rituals of respectable brasseries, worldly restaurants or neighborhood bistros, has found shelter—better still, a home from home. This is how, many years later, as a gourmet, Roebuck Wright would be invited to a formal dinner with the *Commissaire*, at the table of the formidable Lieutenant Nescaffier. In a strange turn of events, Wright would set aside his knife and fork to cover the kidnapping of the *Commissaire*'s son, Gigi (whose full name is Isadore Sharif de la Villatte), which he would report in the pages of *The French Dispatch*. This astonishing story ends with an extraordinary chase and a handful of poisoned radishes to neutralize the kidnappers. The heroic Lieutenant Nescaffier tastes the poison to

better deceive the criminals, barely surviving this act of bravery. In agonizing pain, the boss will whisper this strange confidence to Wright: "*The toxic salts. In the radishes. They had a flavor. Totally unfamiliar to me. Like a bitter, moldy, peppery, spicy, oily kind of—earth. I never tasted that taste in my life. Not very pleasant, extremely poisonous, but still: a new flavor. That's a rare thing, at my age.*"—the epiphany of a police chef de cuisine. That time, Roebuck Wright, for his part, wrote his best paper ever. ⚷

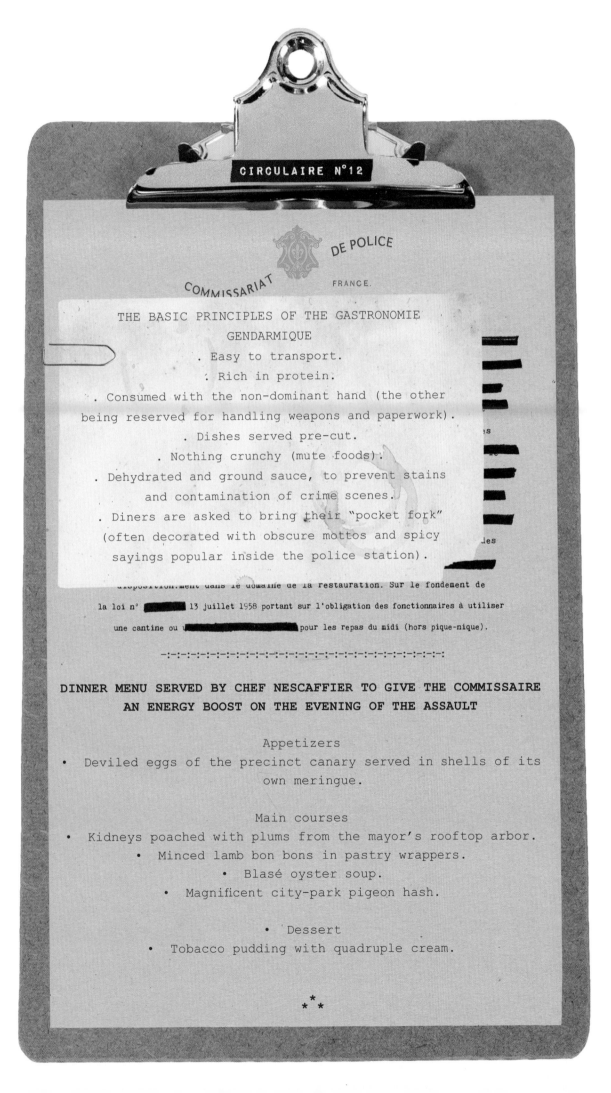

COMMISSARIAT DE POLICE
FRANCE.

THE BASIC PRINCIPLES OF THE GASTRONOMIE
GENDARMIQUE

. Easy to transport.

. Rich in protein.

. Consumed with the non-dominant hand (the other
being reserved for handling weapons and paperwork).

. Dishes served pre-cut.

. Nothing crunchy (mute foods).

. Dehydrated and ground sauce, to prevent stains
and contamination of crime scenes.

. Diners are asked to bring their "pocket fork"
(often decorated with obscure mottos and spicy
sayings popular inside the police station).

disposition ment dans le domaine de la restauration. Sur le fondement de
la loi n° ▮▮▮▮▮ 13 juillet 1958 portant sur l'obligation des fonctionnaires à utiliser
une cantine ou ▮▮▮▮▮▮▮▮▮▮▮ pour les repas du midi (hors pique-nique).

-:-

**DINNER MENU SERVED BY CHEF NESCAFFIER TO GIVE THE COMMISSAIRE
AN ENERGY BOOST ON THE EVENING OF THE ASSAULT**

Appetizers
• Deviled eggs of the precinct canary served in shells of its
own meringue.

Main courses
• Kidneys poached with plums from the mayor's rooftop arbor.
• Minced lamb bon bons in pastry wrappers.
• Blasé oyster soup.
• Magnificent city-park pigeon hash.

• Dessert
• Tobacco pudding with quadruple cream.

* *
*

Portrait of Herman Blume
To Laugh or to Cry

Deadened eyes under heavy eyelids, an impassive face on which time has already taken its toll. With his characteristic hangdog expression, Bill Murray has become one of the quintessential actors in Wes Anderson's little menagerie. He is also the most eminent ambassador of an illness that seems to afflict many characters in the filmmaker's filmography: a chronic, colossal and inextricable depression. Caught in worlds on the brink of collapse, many of Anderson's characters are struggling, devoting themselves body and soul to their obsessions—in short, desperately attempting to stay afloat in the ocean of their depression. Caught in worlds on the brink of collapse, many of Anderson's characters are struggling, devoting themselves body and soul to their obsessions—in short, desperately attempting to stay afloat in the ocean of their depression.

Of course, with Wes Anderson, depression has taken on faces other than that of Bill Murray. It has taken on more juvenile features, such as those of actor Luke Wilson—first, in the role of Anthony in *Bottle Rocket*, freshly released from the psychiatric clinic where he was sent to rest, then

in the character of Richie Tenenbaum, who even attempts to end his misery in a grueling suicide scene, where blood flows freely. Depression is also a burden carried by Captain Sharp, in *Moonrise Kingdom*. It pursues the Whitman brothers to the far reaches of the mystical India in *The Darjeeling Limited*, and even torments Augie Steenbeck in *Asteroid City*. However, no one has carried the banner of sadness higher than Bill Murray, from his very first incarnation in Wes Anderson's movies.

Bill Murray first entered Wes Anderson's world with the character of Herman Blume, in *Rushmore*. A pure product of the American dream, this self-made man, stumbling over the futility of his existence, is unquestionably a deeply comical character. A true local personality, Blume has all the trappings of social success: a lovable family, a lavish house with a swimming pool,

invitations to speak at the best school in the country and a flourishing career in the metal industry. At the heart of this factory where sparks fly, Blume is enthroned in an office perched atop steel pylons, the first movie set ever truly built by Wes Anderson. And yet, Blume is a father disappointed by his offspring, whom he observes with a disbelieving and rather dismayed gaze. He is also an unhappily married man, whose wife cheats on him brazenly. The imposing family portrait, intended to immortalize the glory days of this model American tribe, perfectly reflects Herman Blume's feelings toward his family: featuring strange perspectives and slightly distorted faces, it is a failed portrait. Nothing can be done about it; even presented on canvas, the Blume family is a huge fiasco. At a time when behavioral sciences and psychoanalysis are gradually becoming more popular and accessible, cinema has not failed to embrace the question

BLUME
INTERNATIONAL
SAW Pipes USA, Inc.

432 Stamford Way
Houston, TX 77008

You guys have it real easy.

I never had it like this where I grew up. But I send my kids here. Becouse the fact is: you go to one of the best schools in this courtry.

Rushmore.

Now for some of you it doesn't matter. You were born rich and you're going to stay rich. But here's my advice to the rest of you: take dead aim on the rich boys. Get them in the crosshairs. And <u>take</u> <u>tham</u> <u>down</u>.

Just remeber: they can buy anything. But they can't buy backbone. Don't let them forget it. Thank you.

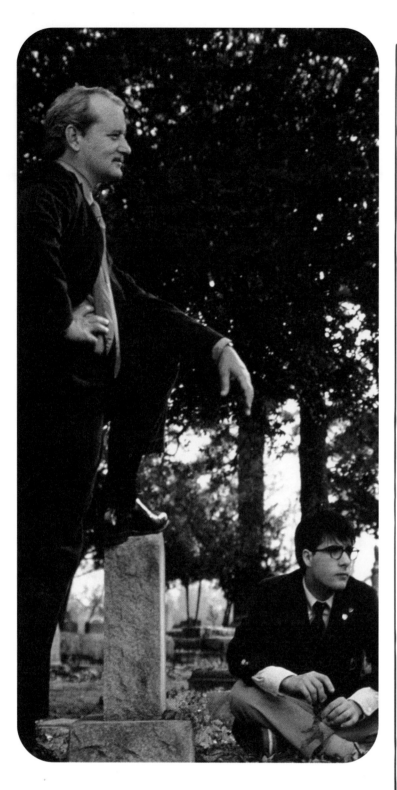

the most absolute horror (from *The Cabinet of Dr. Caligari* to the terrible Hannibal Lecter, in *The Silence of the Lambs*)—, it has now become acceptable to lie down on the couch of a complete stranger and digress at great length about one's problems. Woody Allen, the paragon of the genre, views this situation as an irrefutable comedic device, depicting chatty, self-centered heroes who never cease to talk about their neuroses, which they can't help but fiddle with, dissect and investigate: an overwhelming fear of aging, the denial of one's own mortality and all manner of sexual disorders. Almost all suffering is now cause for laughter.

Contrary to Woody Allen's inexhaustible angst, depression in Wes Anderson's characters takes on a wholly different form. While American comedy never tires from listening to itself succumb to depression, in Anderson's cinema, depression is an unspoken evil, that gradually drags his heroes down, luring them into a contained sadness. No therapists are available to welcome his overwhelmed characters to confide in the audience. No great scene of introspection ever enlightens viewers on the nature of this spleen. When Max comes across his friend Blume, drunk, his face swollen, dazed with grief, he asks him how he is feeling. "*I'm kind of lonely these days,*" Herman Blume replies, from the darkest depths of his distress. Depression, in Wes Anderson's cinema, is certainly not talkative. Bill Murray carries this quiet melancholy with him from one movie to another: one can see it in Raleigh St. Clair, debonair husband to the unfaithful Margot in *The Royal Tenenbaums*; in Walt Bishop, another cheated husband in *Moonrise Kingdom*, and in Steve Zissou as well—but also, to some extent, in the discreet role of the breathless businessman in *The Darjeeling Limited*. This feeling of being in the doldrums even pursues him in the works of other filmmakers, such as Sofia Coppola's *Lost in Translation*. However, the glamorous tedium and languid depression that unfurl in Sofia Coppola's films should not be confused with the tragicomic numbness exhibited

of fatigue and depression, an ailment that has swiftly become a cornerstone of American comedy. Both on screen and in real life, it is a time for introspection, and the spoken word comedy thrives on these highly diverse neuroses. While the study of our subconscious long embodied a source of anxiety, invading thrillers and suspense films—among which Hitchcock's works *Spellbound* and *Marnie*, and even

by Wes Anderson's characters. When one contemplates Bill Murray's face, one is reminded of Tex Avery's cartoon dog Droopy, with his drawl and apathetic air which, in the Texan cartoonist's fast-paced world, stands out for its characteristic slowness and lethargy. If one should venture to draw a parallel, it is that the actor embodies the most comical side of this depressive state. However, the laughter elicited by these characters, caught in a downward spiral, is rather more indulgent, and even compassionate. In their failures, Wes Anderson's antiheroes are revealed to us in all their humanity. "*Failure, and in particular acknowledgment of failure, lends characters grace notes absent when they don blinkers and gallop towards the perceived rewards of success. […] Disillusionment is not all bad—to shed illusions is to become wise,*"[1] writes Sophie Monks Kaufman in her essay on the filmmaker. However, even if this sadness more often than not tends to draw a smile, Wes Anderson's depression nonetheless strikes a chord. It comes alive in a few rare, but poignant moments of truth, when characters emerge from their torpor and reticently express, in hushed tones, the depth of their grief. Faced with these fragments of raw distress, which has so rarely been stripped of its humor, viewers are left speechless. "*I hope the roof flies off, and I get sucked up into space. You'll be better off without me,*" Mr. Bishop quietly says, contemplating the ceiling of the master bedroom. There's no laughter to be had here. ⚷

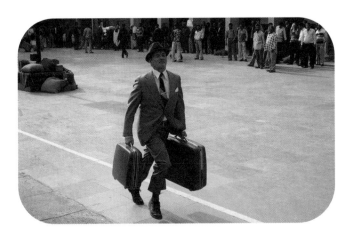

1. Sophie Monks Kaufman, *Wes Anderson*, William Collins, Little White Lies, 2018.

Portrait of Chief
Canis lupus familiaris

Does Wes Anderson hate dogs? This is a question bluntly asked by Ian Crouch in the pages of *The New Yorker* in 2012[1], a few years before the Texan director's great canine epic took shape. Indeed, man's best friend is seldom spared in Wes Anderson's universe, and the list of unfortunate pooches grows longer from one movie to the next, whether they are run over, poisoned or abandoned—viewers needed little more evidence to suspect that Wes Anderson holds a grudge against our four-legged companions.

It all begins within the ranks of *The Royal Tenenbaums*, with the tragic fate of Buckley, a courageous beagle with floppy ears and a gentle gaze, and the first canine victim in Wes Anderson's filmography. Buckley escapes the terrible crash that claims the life of Chas Tenenbaum's wife, and the dog, once a symbol of untroubled happiness, completing the portrait of the model American family, returns to find his home shattered, crippled by fear and grief. While he miraculously outlives his mistress (is this something that we can really forgive him for?), the gentle pooch's only reward is indifference, and during the safety drills that Chas requires his sons to complete, rescuing the dog doesn't seem to appear on the agenda. Buckley is now part of the scenery, condemned to passivity, at the end of a leash that is too short and tied here and there for his own safety. However, in Wes Anderson's movies, chaos never lurks very far from their protagonists, and despite all these precautions, Chas's safety fantasy is shattered when a convertible crashes into the fence, exactly where poor Buckley was tied. His (hardly empathetic) humans' reaction consists in replacing him, without further ado, by a brand-new Dalmatian, with black spots similar to those on the Dalmatian mice from Chas's childhood. One should also note that the

日本一の
ペットフード
ブランド

愛犬の健康食
ご近所の米屋さんで
お求めください

PUPPY

パピー スナップ

SNAPS

新製法

500グラム

1. Ian Crouch, *Does Wes Anderson Hate Dogs?*, The New Yorker, June 2012.

Tenenbaum patriarch has a penchant for dogfighting in the city slums; our canine friends are decidedly not held in high esteem.

Examples abound in the Andersonian corpus. In *The Fantastic Mr. Fox*, beagles are once again the collateral victims of Master Fox's schemes. The *Vulpes vulpes* indeed seems to know a lot about dogs (who are, after all, distant canine cousins)—beagles love blueberries, but should never be looked in the eye, and not one, but four of these unfortunate creatures will succumb to Mr. Fox's poisoned berries. In *The Life Aquatic*, chance brings together a three-legged stray dog and Steve Zissou when, after attacking the *Belafonte*, pirates leave behind this anonymous dog, of an unidentified breed, who starts merrily limping around its new adoptive family. Steve Zissou is beside himself, but tolerates the presence of this companion, whom he hastily renames Cody. During an encounter with Alistair, Zissou's sworn enemy, Cody catches a nasty blow to the snout with a newspaper, before being abandoned again by the crew, who forget him on a desert island. Finally, one of the cruelest fates to befall these brave beasts is that of Snoopy, the wire-haired fox terrier who trots alongside the little scouts at Camp Ivanhoe.

The faithful pooch falls victim to a stray arrow, shot by a furious scout, during a confrontation. "*Was he a good dog?*" Suzy asks. "*Who's to say—but he didn't deserve to die*," Sam replies, standing over the little animal's remains.

How can one explain this lack of respect for dogs? Some will justify this by the slightly antisocial quality presented by Wes Anderson's cinematographic works, where characters sometimes suffer from a chronic lack of empathy. Dogs, because they are so lovable by nature, underline the emotional daze into which these characters are plunged and their inability to return the affection that they are offered. One could also suspect a cartoonish approach, inspired by Tex Avery— another great Texan figure, who never hesitated to indulge in the most explicit feats of violence. This is a glimpse of the black humor that hangs over Anderson's cinema, the more sinister side of which has often been overlooked by critics in favor of the power displayed by his film direction. For Ian Crouch, however, by killing dogs, Anderson is breaking one of the great Hollywood taboos. For good measure, let us remember how Anderson, in *The Grand Budapest Hotel*, has no qualms whatsoever about persecuting

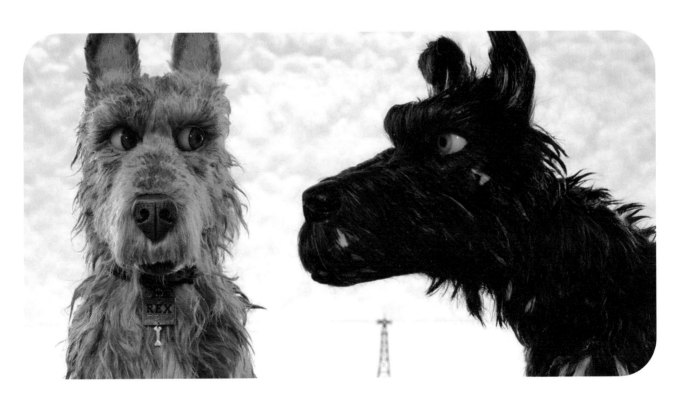

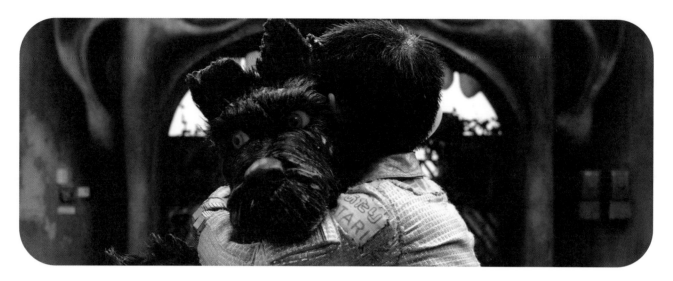

a cat, which meets its end comically spread out on the pavement several floors below.

Viewers would have to wait until the movie *Isle of Dogs* to learn more about the filmmaker's feelings toward our furry friends. Once again, animals suffer the consequences of the moral failings of humans, and more specifically of adults. Condemned to exile by their own masters, while an anti-dog propaganda campaign sweeps through Megasaki, the animals display all the humanism that humans themselves now seem devoid of. These dogs, to whom Wes Anderson gives voice in his movie, are also endowed with reason, morality and a deep sense of duty and justice, leading them to adopt democratic principles. And while dictatorship and corruption run amok in human societies, in this small canine community, voting by show of paws becomes the rule. That is not to say that these dogs are without

their faults; however, of all the Andersonian bestiary, they have the privilege of embodying a certain ideal of humanity, comradeship, loyalty and dignity.

Within this pack, Spots and Chief are like two sides of the same coin. A fable imbued with social determinism is born of the tale of these dogs from the same litter, whose lives have led them to different shores. Spots has devoted his life to his human master, and must now learn to live for himself and his people, as a free dog, while Chief, the stray dog, follows the opposite path and allows Atari to tame him. From Spots, Chief receives his new canine duty—that of protecting the young boy.

The shadow of Antoine de Saint-Exupéry's *The Little Prince* falls very close indeed, from the moment the "young pilot" arrives; and while his plane does not crash-land in a

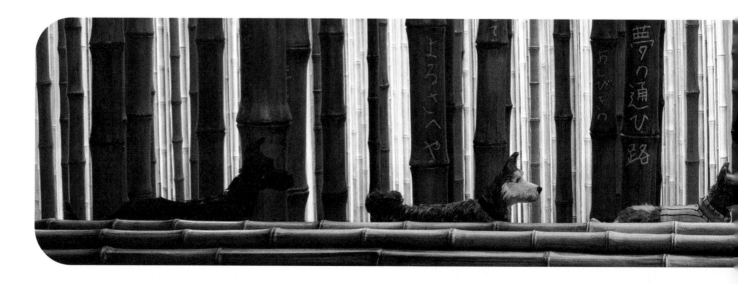

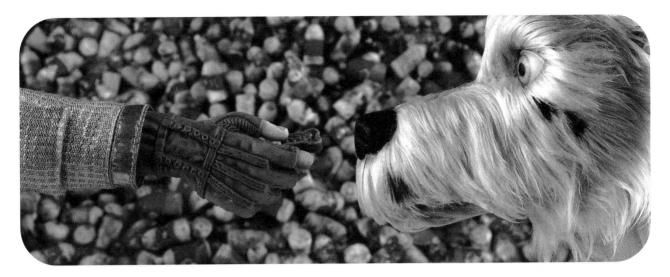

scorching desert, it crashes on a desolate island filled with trash. The parallel grows even stronger as the friendship grows between Chief and Atari, recalling the relationship between the Little Prince and the fox. *"What does that mean—tame?"* Little Prince asks in Saint-Exupéry's novel. *"It is an act too often neglected,"* says the fox. *"It means to establish ties. [...] To me, you are still nothing more than a little boy who is just like a hundred thousand other little boys. And I have no need of you. And you, on your part, have no need of me. To you I am nothing more than a fox like a hundred thousand other foxes. But if you tame me, then we shall need each other. To me, you will be unique in all the world. To you, I shall be unique in all the world..."*[2] Like the Little Prince and his fox, Atari and Chief tame each other, until they belong to each other. In a touching scene, the two swear a nightly oath, the kind that only a child and his dog can share. With eyes filled with tears, they promise each other friendship and loyalty. This is the great lesson in humanity that the fox will teach his Little Prince, and which ultimately hangs over the *Isle of Dogs*: *"People have forgotten this truth, the fox said. But you mustn't forget it. You become responsible, forever, for what you have tamed."* ⚷

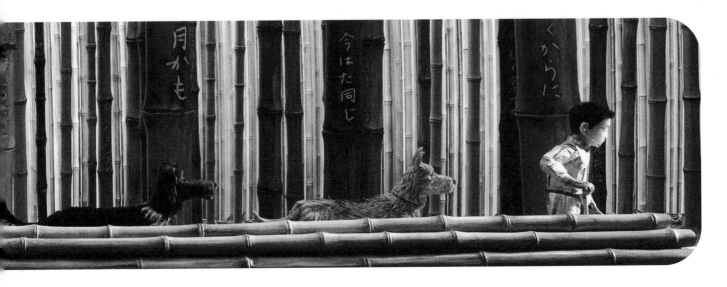

1. Antoine de Saint-Exupéry, *The Little Prince*, 1943.

V

THE KITCHENS

To your spoons, forks, spatulas, saucepans and peelers!
The time has now come to gather around the table for a copious meal. The delicate aroma wafting through the air has not deceived you—indeed, here we are, in the very belly of the beast. Welcome to the bustling, gleaming kitchens of this Imaginary Museum! Now, allow us to don our finest embroidered aprons and cook up some of the most delicious dishes served in the Texan director's movies.

These are dishes from the four corners of the world, marinated and prepared with the greatest care, as Wes Anderson's movies always are. On the menu, with no misplaced pride whatsoever, sushi prepared according to the greatest Japanese tradition sits beside acidic drinks concocted for teenagers or even a humble ham and butter (salted or unsalted?) sandwich—a French classic served at the Café Sans Blague, seasoned with smoked Malabar pepper. In the great hall, even coffee takes on a completely different flavor, roasted with sea spray and salt, which will be served

P.S.: Please inform the museum staff if you have a ticket granting access to the cozy little siesta room, located behind the third door on the left, just outside the kitchens. You will be provided with soft cotton pajamas and Alpine breath chewing gum.

to you amidst a flurry of duels and hostage-taking events. Now, please slide your feet under the table and tie your checkered napkin around your neck. Indeed, the visual presentation of Andersonian gastronomy requires a great deal of preparation, which one needs to detail and, better even, decipher in order to fully capture its senses and flavors. On the following pages, you will find a non-exhaustive, yet highly representative selection of Wes Anderson's gastronomy. A slow-digesting gustatory journey, an odyssey through an imaginary restaurant populated by comforting, soft, crunchy, bitter or excessively sweet dishes…and sometimes, all at once—a complex culinary alchemy, indeed!

Follow the flavors and aromas wafting through our corridors. It is high time to tantalize your taste buds and fill your legs with strength and courage before you take on the rest of the tour. So, please join us as we open the doors to Wes Anderson's kitchens!

The Courtesan au Chocolat
Not Your Ordinary Pâte-À-Choux

Vienna can take pride in its *Sachertorte*, a chocolate tart decorated with the seal of its bakery, Budapest has its *Esterházy torta*, featuring five layers of dacquoise and Cognac-flavored buttercream, while Wachau treats us to the delightful apricot *Knödel*, small, garnished balls of dough sprinkled with powdered sugar. And lastly, what would Salzburg be without its *Nockerln*, the three soufflé hills reminiscent of the city's landforms? In this old continent that is certainly not prone to foregoing desert, it was only right that the town of Nebelsbad, located in the Republic of Zubrowka, also be entitled to a sweet treat. And indeed, Herr Mendl indeed serves up one of the seventh art's most immediately coveted delicacies.

It comes neatly wrapped in pink cardboard, the same soft pink that adorns the walls of the Grand Budapest, stamped with Mendl's name and girded with a beautiful blue ribbon. In its box, the "Courtesan au Chocolat" is a strange, layered dessert that seems to defy the laws of gravity. An elegant variation on the religieuse, the Courtesan au Chocolat is composed of pâte-à-choux generously filled with chocolate pastry cream. Three sugar glazes cover the cake's three tiers: white for the base, almond green in the middle and soft pink at the slightly awkwardly perched top. Between these cleverly stacked pâtes-à-choux, blue icing allows this adorable little tower to remain upright until it is delivered to the Grand Budapest (or to the nearest prison, according to circumstances). At the top, as if placed on its pastel pedestal, sits a chocolate almond, the pinnacle of sophistication. This dessert should accurately reflect the image of the good society that it is intended

is hard at work. It is here, in the intimate setting of her workshop, that one can observe all the stages in the making of the Courtesan au Chocolat: with a serious expression on her flower-covered face, Agatha presses her piping bag, decorates her pâtes-à-choux, adds the finishing touch—then, perched on her bicycle, delivers her batch, which she hangs from her shoulders. A true love letter to the craft that reigns supreme in Wes Anderson's films, both inside and out. Behind the scenes, hundreds of busy little hands make the director's worlds come alive, from letter painting to the revival of stop-motion techniques. In his movies, the kitchen, with all its rituals and preparations, is undoubtedly the place where this love of gesture is expressed most clearly: from Agatha's touching concentration to the unrivaled dexterity displayed by the *itamae*, the master sushi chef on the *Isle of Dogs*.

Check-point Nineteen. In a shabby prison cell, far from the glitz and glamor of the Grand Budapest, M. Gustave shares a delicious Courtesan au Chocolat with his fellow inmates, carefully cutting the cake into segments with a lovely "throat-slitter." For these hardened fellows with criminal pasts, who are rather more accustomed to eating bowls of porridge than wonderful pastries, M. Gustave's thoughtfulness and delicacy strike a chord. *"You're one of us, now,"* states a prisoner. This is the beginning of a fantastic escape for these strangely likable eccentric characters, thanks to Agatha and the tools that she conceals beneath in ornate icing that the prison guards, overwhelmed by the beauty of the work, cannot find the courage to break open. Made with just the right amount of love and sugar, the Courtesan au Chocolat has the power to deceive enemy vigilance, but also to soften even the most hardened hearts. The Courtesan au Chocolat is the last gourmet bastion, the final creamy, colorful fortress standing against the barbarism and darkness that are devouring its sweet world in bite-sized chunks. ⚷

for: distinguished, delicate, and admittedly, very rich. In the end, the Courtesan au Chocolat is the ideal patisserie for the true sycophant that is M. Gustave. While the war's shadow gradually looms ever nearer to the gates of Greater Budapest, the Courtesan au Chocolat stands, with her three pâtes-à-choux, as the true symbol of a civilization dedicated to a certain *art de vivre* (and, ultimately, to failure); a civilization whose old-fashioned charm flirts with the ludicrous and which, akin to the delightful Courtesan au Chocolat, stands on the verge of collapse. However, Herr Mendl's specialty should not be reduced to its symbolic value; indeed, hidden from view in the chef's kitchen, his talented apprentice Agatha

The *Darjeeling Limited* Tea
Or How to Hold Back Time

Train travel. A very Andersonian way of observing movement, of reaching a destination at a controlled speed, neither too fast nor too slow, Just enough to appreciate the time that separates us from the goal of our journey. *The Darjeeling Limited* appeared to be the perfect vehicle for our three Whitman brothers, perfectly played by Adrien Brody, Jason Schwartzman and Owen Wilson. Comfortably installed in their (non-smoking) sleeper cabins, these three work-shy guys are offered a beverage that appears to be indissociable from train travel, namely tea—this drink, brewed from a selection of dried plants, is abundantly consumed on board the Trans-Siberian Railway, at all hours of the day and night). Served in delightful Indian-patterned glasses, scalding hot tea sets the tone: passengers will need to take their time and savor the moment—something that the three slightly anxious brothers will have great trouble doing, even in the comfort of their cabins.

And yet, the company running *The Darjeeling Limited* has spared no expense, and everything here seems designed to welcome passengers in the best possible conditions. While the action does not take place on board the luxurious suites of the *Orient Express*, the king of all trains, the bedsheets are immaculate white, and the bunks, while not exactly spacious, are decently sized. The walls are a magnificent shade of turquoise blue, and there is a small washbasin where one can freshen up and get a close shave to remain fresh and elegant before heading off to the restaurant car. Lastly, a little table located near the windowsill more than ever invites passengers to savor the warmth of a tea that will be served to them in due time.

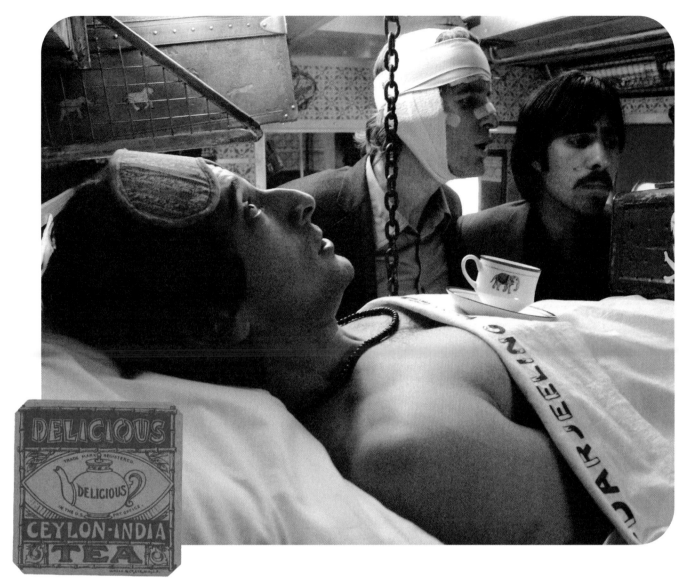

One would assume that this tea is Earl Grey, owing to the history that closely intertwines the kingdom of England to India—an old tradition, inherited from a tormented past, which is nonetheless light on the palate. Unless, of course, the tea served is Darjeeling, a black tea from the province of Bengal, in the middle of the Himalayan foothills, which boasts an amber color and aromas of ripe fruit. One would like to take a break, to hold on to this moment with our three companions, and to invite them to enjoy the moment. Indeed, The Darjeeling Limited will give them plenty of time to chase their destiny, in the same way that Peter Whitman (Adrien Brody) boarded the train, running as fast as he could, barely making the departure time. Behind him, costumed and out-of-breath, Bill Murray had become too old for final sprints such as this (he would, however, catch the next train). In any case, the brothers won't be able to race any faster than the train travels along its tracks, nor will they even be able to decide how fast the train travels. Unlike coffee, which is rarely served very hot in fine establishments, tea is best served at the table at the ideal temperature of 85-90°C (185-194°F) for an Earl Grey black tea, or 75-80°C (167-176°F) for a green tea (Alexandre Desplat, Wes Anderson's loyal movie score composer and a great Japanese tea enthusiast, will no doubt confirm this). In other words, one needs to be patient and to enjoy the scenery as it unfolds; there is no need to burn ones' lips on this tea, which has not yet cooled down and reached the right temperature. "*Wait a little longer, my friends, we have the whole trip ahead of us,*" the noble, steaming beverage appears to whisper. ⚷

The Café Sans Blague

"Under the Paving Stones, the Café"

In the collective unconscious exists a commonplace, an image that is as widespread as a postcard and remains inseparable from the very *idea* of France (and which the country shares with its neighbor, Italy). We mean the café, of course. In French, le café (the location) and le café (the hot beverage) are quite obviously indissociable. Here, however, we are talking about the location. From the *estaminets* of Northern France to the literary cafés, these establishments are places of joyous discussion, lively debates, passionate love declarations and violent separations, to the sound of clinking glasses and the smell of cigarettes that saturate the air with a thick veil. Of course, French cinema is full of these "café scenes," and Éric Rohmer's chatty characters, seated on the terrace or indoors, are no exception to this great French tradition. One cannot help but think of Claude Sautet and his unforgettable scenes shot in crowded cafés, where the café's owner calls out to a patron at the other end of the room because Yves Montand has something to tell them; "*C'est urgent!*."

Wes Anderson has extracted the very essence of these outdated locations, whose quaint charm and atmosphere are now sought after by many, and has injected it into his movie *The French Dispatch*, in a café called the "Sans Blague." "Sans blague!" (No joke!), one might indeed be tempted to exclaim. Indeed, the café's name is an obvious choice, and truly finds its place at the heart of the Andersonian universe. Featuring predominantly yellow colors, a terrazzo floor in autumnal shades, a gum ball dispenser, chromed zinc, bistro chairs and advertisements on the walls, the Café Sans Blague welcomes viewers to rediscover a location where the redoubtable Jean-Luc Godard could very well have declaimed a revolutionary speech, in May 1968, before glasses and chairs began to fly through the air.

And Wes Anderson indeed makes no mistake, inviting his characters to turn the café into a place of debate and invective, a popular, anti-establishment headquarters for young men with pipes in their mouths, disheveled hair and velvet jackets, and for young women with short skirts blowing in the wind, speaking in haughty tones. We, spectators of this "new new wave," observe the patrons of this small world prepare their micro-revolution, as they lean against the bar, holding a ham and butter sandwich in hand (see recipe opposite), with a few hard-boiled eggs placed on the counter, washed down with a "Picon Bière"—and all this before ordering their fourth coffee of the day. They, like us, will remain here, as they did yesterday, until closing time. 🔑

Ingredients
of the Sandwich

(The Café Sans Blague ham and butter sandwich)

2
GHERKINS
(CUT IN
HALF)

3
SLICES OF HAM

1/2
BAGUETTE

SALTED BUTTER

1. Half a baguette; fresh, crisp and cooked to perfection,
yet with a crumb that slightly melts in the mouth, cut
lengthwise

2. Three thin slices of ham, one smoked (one should almost
be able to see through the slice when placed in front of a
lit light bulb)

3. Two well-vinegared gherkins, cut in half (plus a third
gherkin to munch on while making the sandwich)

4. Fresh salted butter from Brittany. Pay great attention
to the Café Sans Blague's rule: the thickness of the
butter, spread evenly on both sides of the baguette, must
be equal to the thickness of the slices of ham

5. A twist of Malabar smoked black pepper

LE SANS BLAGUE 27 Rue Dubas, 196805 Ennui—sur—Blasé

Sushi
How to Make Sushi in Tsukiji

Amid hurried shopkeepers and watchful restaurant owners, curious crowds gather to soak up the premises' atmosphere, long before the first rays of dawn. One needs to have traveled to Tokyo's Tsukiji market in the early hours of the morning to experience the excitement of the world's largest fish market and to savor the unrivaled taste of sushi prepared while one waits—not that it is impossible, however, to enjoy the very fresh sushi served in other wonderful restaurants. However, it is only here, in Tsukiji, that the decor and atmosphere combine to pay genuine homage to the preparation of this unique dish. From the meticulous cutting to the preparation, every step is performed before your eyes, surrounded by an intense hubbub of machines and humans toiling in every corner of the market. Tsukiji is an open-air factory, perhaps best avoided by vegetarians and other friends of oceanic fauna. In fact, one cannot help but wonder what the reaction of the famous Commander Steve Zissou and his crew would be to discovering this astonishing spectacle—a sight that is every bit as fascinating as it is repulsive, as live crabs attempt to flee their impending doom and tentacles continue to writhe on the cooks' worktops.

The sushi preparation scene in *Isle of Dogs* is an ambitious demonstration of stop-motion filmmaking, which shows the director's unambiguous desire to pay tribute to the chefs' skills. Of course, it details the precise carving of the ingredients, the meticulous handling of the utensils, and the hand that, with a merciless gesture, brings down the blade of a saber-sharp knife or, on the contrary, so delicately adds a final touch of seasoning. The

fatty, juicy tuna is expertly cut up, then lightly seared with a blowtorch. The crab is separated into pieces, before being carefully wrapped in a crisp sheet of seaweed. The tentacle is tenderized, carved up and then placed on a mound of rice, before being seasoned with a touch of wasabi. It is a cruel and poetic dance, in which technique and speed of execution pay tribute to an ancestral Japanese know-how that is passed on from one generation to another. In addition, this scene pays an equally vibrant homage to the talent of the stop-motion artists who worked to bring it to life. This is a fitting metaphor for Wes Anderson, the movie's true chef, whom one can imagine working with his sets, puppets and his entire world, in the same way that chefs prepare sushi in Tsukiji: with speed, precision, sharpness and music.
This preparation is a festival that delights the senses and turns

mealtimes into a sacred moment—in stark contrast, of course, to the food waste that our unfortunate four-legged companions have to rummage through to survive over there, on their garbage island. And yet, as always with Wes Anderson, there is also an unpleasant aftertaste; a strange *je ne sais quoi* that gnaws away at us viewers, a slightly sadistic twist that causes us to take pleasure in watching an octopus being chopped up into little pieces, while it was quietly minding its own business and asked only to be left in peace, tucked away under a rock at the bottom of a peaceful cove. What lurks beneath the apparent dexterity and the conscientiously observed ritual is indeed a death drive. This is made quite obvious to viewers, and in the end, the chef finalizes his masterpiece by placing a dab of poisoned wasabi on the last sushi. It's the hand of an artist and a murderer that closes the bento that will kill poor Professor Watanabe. For Wes Anderson, cooking is a virtuoso and formidable art, in which life and death drives are intertwined: the result is as beautiful as a haiku. ⚷

P.S.: Please don't travel to Tsukiji to taste this legendary sushi, as the market has closed. What a pity.

The Espresso Machine
Time for a Break

The day-to-day life of Commander Steve Zissou's crew is pervaded by a sense continuous tinkering, a manner of permanent building, of perpetual change—as if nothing were ever quite finished. Here, one notices a name that has been struck out on a submarine; there, a machine that one can only guess has been poorly screwed into place, and a plethora of measuring instruments that often don't work as they should. All this jumble of equipment and machinery is obviously a reference to the real Commandant Cousteau, who would never cease to chase the funds and grants that enabled him to undertake his expeditions to the ends of the earth. Steve Zissou is no exception to the rule: he doesn't have a penny to his name, and struggles to maintain his flagship, the *Belafonte*, and his little submarine—as yellow as the Beatles', reminiscent of a huge model submarine inspired by a toy, then built to 1/1 scale.

In the midst of all this aquatic life swims the exact opposite of Steve Zissou and his never-ending tinkering prowess; his nemesis, his sworn enemy, always ready to defeat him on just about all accounts: richer, stronger, bigger, better-looking—just more. This narcissistic oceanographer is none other than Alistair Hennessey. One cannot fail to be impressed by his last name, which one imagines to be noble, as if he were the descendant to a prestigious line of entrepreneurs and scientists, a family rumored to have traveled the entire world, discovering countless tribes and vegetal and animal species over several generations. Equipped with a colossal, immaculate white ship and technological power that Zissou both envies and despises, Alistair Hennessey leaves his rival little chance of success. He embodies this new generation of scientists: corporatist, technophile and over-equipped. So, when Zissou and his crew

of misfits break into Hennessey's semi-secret base, they discover the extent of the world that separates them from that of the wealthy scientist.

Nothing is too good for Alistair Hennessey: the most ingenious instruments, the most accurate charts, the most advanced radar and sonar… However, that isn't really what our favorite motley crew will be focusing on. While the crew does, of course, take with them some of the equipment required to hunt the jaguar shark, what they really make a point of running off with is a brand-new espresso machine. But is it a final thumbing of the nose at their long-standing adversary, or rather a genuine improvement in the daily life of the *Belafonte* crew? Nothing beats a good espresso, just before a well-earned siesta, after a hearty meal…and well, well before a forthcoming scuba dive that may or may not take place, because nobody will have remembered to fill the oxygen tanks. Of course, scientific discovery and the exploration of the seabed are important to Commander Zissou, but in the absence of his wife, who is the real brains behind the operation, the crew's sense of priorities lies in shambles, and comfort prevails over all other matters. Pelé dos Santos (played by Seu Jorge) is indeed seldom seen busying himself as the crew prepare for an expedition, and rather seems more interested in playing guitar on the bow of the boat—in the sun, if at all possible. So, there is no world in which a cup of well-dosed espresso, prepared by a perfectly set up and functional machine, can be anything less than an ideal accompaniment to his sunbathing sessions. It is hard not to relate to the *Belafonte's* merry crew. In a hectic world, in the middle of a pirate hostage crisis, between two gunshots, after the death of a friend devoured by a jaguar shark, is it not time for a well-earned break? Time well spent enjoying an espresso is already a minute gained resisting the ruthless pace of the world. The fish can wait. ⚿

Tang
And Other Adventurous Picnics

It is a sweet powder with a beautiful orange hue, which one stores in a cool, dry location, in its round metal box marked with large white letters. This ingredient from another time is Tang. When diluted with the right amount of water, the powder produces a beautiful, brightly colored, non-carbonated drink, like a kind of instant fruit juice. It is, of course, the most convenient drink to take with you when leaving your scout camp to go on an adventure with your loved one, So naturally, it can be found in the heavily loaded rucksack carried by Sam, the intrepid little explorer in *Moonrise Kingdom*.

Carefully arranged in one of the famous *God's Eye shots* (Wes Anderson's specialty shots from above, in which he likes to create elaborate compositions from a number of objects), Tang appears amidst an array of autumn leaves, pebbles and pine cones, alongside a map, a pipe and a compass. Served in a small steel hiker's cup, this beverage provides a fantastic way to enjoy a break while finding one's bearings in the forest. A nostalgic detail if ever there was one, the presence of Tang on screen can perhaps reveal a generational divide of sorts. While some viewers will let out an amused exclamation when the famous orange box appears on the screen, others might remain very perplexed indeed. What is Tang? This sweet, freeze-dried beverage, born in the United States, was marketed from the end of the 1950s, but was never a huge success. However, that was without NASA, which decided to incorporate the famous powder into the Gemini manned space flight program. The year was 1965, just a few months before Sam and Suzy's famous summer of adventure. Naturally, Tang had reached the height of its popularity, and was now officially

regarded as "the astronaut's drink."
Advertising campaigns would indeed
remind audiences of this, multiplying
advertisements and inventing this
ingenious slogan: *"Tang. For Spacemen
and Earth Families."*[1]

When Sam Shakusky takes this box
of Tang with him when he runs away
from Camp Ivanhoe, he is no doubt
aware of the aura of adventure that
surrounds the beverage. And while its
artificial flavors and bright color—
which is honestly far too orange for
its' own good—somewhat contrast with
the yearning for the great outdoors
and the back-to-the-earth attitude
of every good scout, Sam remains
a child like all the others, or
almost. Although Wes Anderson's child
characters act like real little adults
(and conversely), a few details often
give them away. Generally, to take an
inquisitive look at the inventory of
objects chosen for their runaways:
Suzy takes a kitten, a large pile of
library books and a portable record
player; Sam, who is a little better
equipped, still takes chips and hot
dogs. There is also Margot Tenenbaum,
who takes her brother on a runaway
to the ends of Africa (or rather, to
the African wing of New York's Museum
of Public Records), equipped with a
sleeping bag, a book and, as food
reserves, crackers and root beer.

There's something about Wes Anderson's
regressive picnics that tenderly
reminds us of the contradictions
of childhood. Imperious and self-
assured, with all the self-confidence
that grown-ups no longer have, these
turbulent children set off on an
adventure, listening only to their
thirst for independence and their
eagerness to stand on their own two
feet. For adult viewers, who know
that one should never grow up too
fast, all one has to do is open the
bags carefully packed by these young
adventurers to discover a child's
treasure trove of picture books and
sparkling drinks. It is reassuring
to find, under these children's
excessively serious faces, fantasies
that belong to their age. As for Tang,
its nostalgic evocation undoubtedly
exerts the same power on adult
spectators—that of bringing back the
taste of sugar, like a tangy chemical
madeleine, evoking Proustian memories
from the depths of our childhood. ⚷

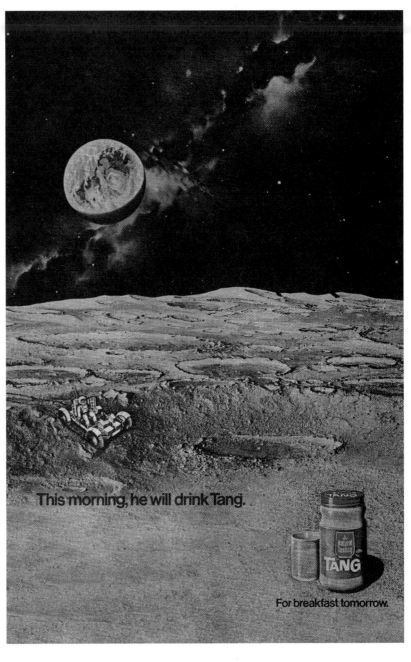

This morning, he will drink Tang.

TANG

For breakfast tomorrow.

Bean's Cider
A High-Quality Beverage

Fresh and clear, yet with a very slightly cloudy color, packaged in a beautiful, transparent bottle, a drink that sparkles and crackles between one's teeth—Mr. Fox's coveted cider is a precious treasure, and above all, a well-guarded one. For the Fox family patriarch, this alcoholic beverage made from apples is nothing less than the nectar of the gods. Much like his elegant autumn-colored corduroy suit, this cider seems to have been created for him only. This delicious nectar is concocted by Franklin Bean, "*possibly*" the most terrifying man in the world, on one of three farms in the area. Bean is an apple producer, and also breeds his own species of plump turkeys—beautiful, tiger-striped poultry. And above all, he has created a brand-new variety of apples—the "Red Remarkable," whose smooth skin is covered with little golden stars, guaranteeing their extraordinary quality.

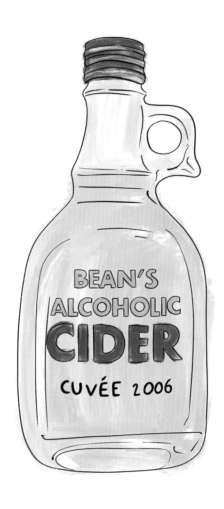

In the basement of his farmhouse, Franklin Bean produces his cider like a mad scientist, using an intriguing mechanism featuring rails, tubes, pistons and boiling balloons, with warning lights and push buttons. This infernal machine enables him to extract a few drops of this highly potent, aromatic and alcoholic liquid. By contrast, another machine, located in the fermentation room, produces astronomical quantities of cider, packaged in large, smooth glass bottles with red caps, on which one can read, in capital letters: "*BEAN'S ALCOHOLIC CIDER*." However, one should beware of this artisanal cider's addictive power. Indeed, Franklin Bean himself feeds almost exclusively on it, downing two to three bottles every day.

In Mr. Fox's eyes, this unique cider has two benefits: it is every bit as exquisite as it is dangerous… Indeed, while chickens, tiger-striped turkeys and chubby geese form a perfectly acceptable diet for a family of hungry foxes, cider is a luxury. For our adrenaline-seeking fox, plundering Franklin Bean's cider reserves is the epitome of thievery. This pilfering, motivated by neither hunger nor need, is every bit as epic as a bank robbery. And as in every good heist movie, before the bandit retires, he needs to tempt the devil one last time. Emboldened by the heists in the Boggis Farms Chicken House and Bunce Industries smoked goods storage, Mr. Fox intends to end his career on a high note.

Getting hold of the precious cider reserves would require a foolproof plan, that unfolds without a hitch, or almost. But as soon as Mr. Fox enters the cave of wonders, his path crosses that of an old enemy, a deceitful and vicious rat, dressed in a tight-fitting sweater with wide red and white stripes. Unlike Mr. Fox, who fancies himself as a gentleman burglar, this rat is a thug of a whole different sort: armed with a blade, snapping his fingers like the gangs of *West Side Story*, he has no qualms about sullying Mrs. Fox's reputation. And that is all it takes to start a fight that could well scupper the whole operation. When Franklin Bean's wife shows up unannounced, interrupting the fight, Mr. Fox rushes to the cellar shelves and curls up in an unlikely position, imitating the shape of one of the cider bottles. But just as our fox seems to be getting off lightly, the farmers are preparing to strike back.

Torn between his wild instincts and his good upbringing, Mr. Fox is in the grips of a full-blown existential crisis. For this sharp-toothed worldly fox, it's hard to completely obscure his predatory impulses… So how can he reconcile his two natures? Cider, that supreme beverage, maybe offers our fox the illusion of aligning his two worlds.

In his delusions of grandeur, Mr. Fox needs a heist to match his ambitions, and so, he bids farewell to chickens, turkeys and other cackling fowl, which are nothing more than petty larcenies for hungry foxes. Mr. Fox, like any self-respecting dandy, goes in search of the most beautiful thing that the world has to offer, just as others go in search of a masterpiece or a river of diamonds. As a gourmet, our four-legged Arsène Lupin couldn't have chosen a better loot; indeed, Franklin Bean's cider is one of the best in the world. "*It burns in your throat, boils in your stomach… and tastes almost exactly like pure, melted gold,*" Mr. Fox declares. For his friend Badger, it causes "*sunbeams and rainbows,*" no less—which truly makes us want to invite ourselves to the table of the fantastic Mr. Fox and sip a few glasses of this fabulous beverage with him. But to do that, we will need a plan. One always needs a plan. ⚷

The Asteroid City Diner
Where Pancakes Come to Die

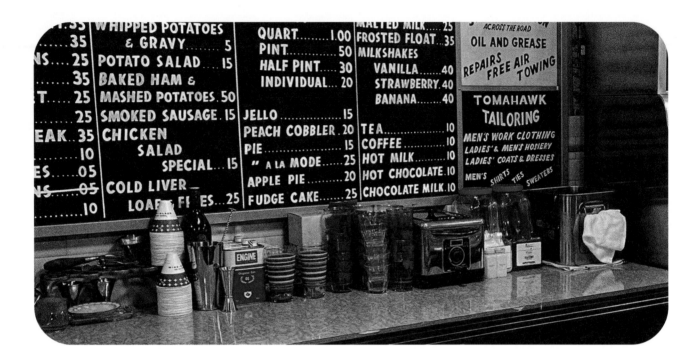

It is a small town, lost in the middle A Technicolor desert, which barely deserves to be called a city. "Asteroid city," in reference to the galactic pebble that came crashing down here several centuries before, has little to offer other than a motel flanked by a few bungalows, a gas pump, an observatory and, of course, a diner. A true American icon, the diner cannot really be compared to a French café, and is not really a restaurant either. The diner is an unhoped-for oasis that welcomes both locals and foreigners who have come to stop off after a trying journey. Anyone who has never experienced long hours driving through infinite vastness of the Californian desert cannot quite imagine the joy of coming across one of these prefabricated oases along the way. The place immediately brings to mind the gentle scent of coffee, apple pie (and sometimes, key lime pie), burgers and French fries. And then, there's the decor, which is endemic to America, with imitation leather seats worn out by the jean-clad buttocks of thousands

of truck drivers, large picture windows overlooking the parking lot, gleaming stainless steel reminiscent of railway restaurant cars, freshly washed vinyl floors, long Formica counters and, above all, its large blackboard presenting the list of the establishment's delicacies, modestly priced, in dollars.

The *Asteroid City* diner is no exception to these unspoken rules, and nothing is missing on the screen. The bell signals the arrival of patrons, while a neatly permed waitress in uniform looks up at the newcomers. Coffeemakers are heating up rather dismal coffee, ketchup bottles are perfectly lined up, a regular is reading the latest edition of the local rag, pancakes are neatly stacked up and the antique jukebox is humming away in a corner of the room. The scorching atmosphere of this desert at the gateway to Arizona, California, and Nevada (why choose one only?) is only refreshed by a few touches of lagoon blue and mint green, which

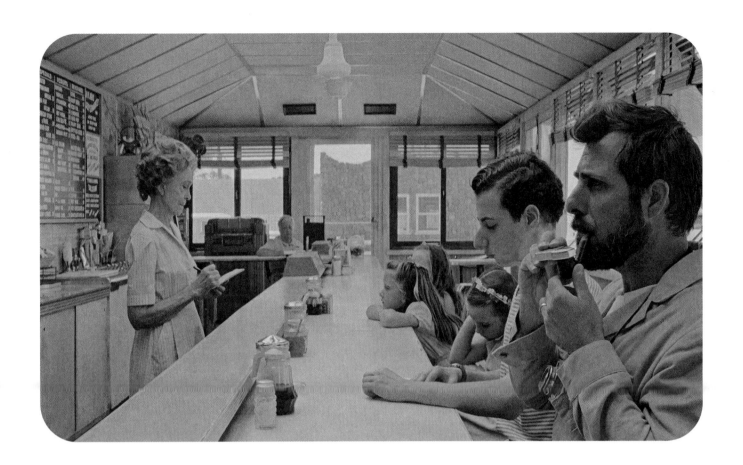

ASTEROID CITY

DINER
BREAKFAST
LUNCHEON
HOT SUPPER

NEXT TO THE MOTEL AND
OPPOSITE THE GAS STATION

Wes Anderson will generously arrange throughout the movie, as if to quench viewers' thirst. On the walls, a Far West tapestry, strewn with cacti and cowboys, reminds us that this is America, the real deal.

But isn't this diner, like this little desert town, just too American to be true? Indeed, this place doesn't exist in our world any more than it does in the movie. *Asteroid City*, of course, is one of those Russian doll games that Wes Anderson excels at. He even takes the logic one step further, revealing a new doll in his matryoshka: the diner in Asteroid City is in fact the backdrop for a play performed on a Broadway stage by a troupe of actors, while the play itself is a television show produced in Channel 8 studios by a narrator who reminds us of Rod Serling, and the television show, *ultimately*, is a Wes Anderson movie. How far away the diner now seems, buried under all those layers of fiction! Asteroid City is not America, but a representation

of America, which conjures up and stirs up enough myths to leave our minds reeling: The mythical Great West, swathed in country music, dotted with red mountains, producing curious perspectives; the conquest of space, featuring young prodigies with their eyes set on the stars and the discovery of unknown forms of life; the nuclear age, with towering explosions on the horizon, delivering an ominous reminder of the power of the atom; and lastly, the world of show business, whether Broadway or Hollywood, featuring professionals trained in the Actors Studio, directorial disagreements and cinematic ghosts that populate Wes Anderson's entire movie. This cornucopia of myths and legends is enough to awaken our thirst, and now, it's time to return to our cozy cafeteria.

The Asteroid City diner is the real gateway to the film. Its highly

familiar settings, which have so often been immortalized on the silver screen, paint a minuscule portrait of America in the blink of an eye. The diner also has the onerous task of introducing the main characters, orchestrating their meeting and, finally, their exit from the stage. Indeed, our charming road stop is, in essence, a stopping-off point, and an opportunity for viewers to see how just far our characters have come since the beginning of the movie. The adventure ends with a scene that is symmetrical in every way: the order is identical (coffee, flapjacks and strawberry milk), the questions are the same ("*Who needs to pee?*"), the atom bomb tests continue, more than ever, and the car chases return to the road. Everyday life takes over again, habits die hard, and America remains America, barely jarred by the anomaly of this extraterrestrial visit.
To say that the *Asteroid City* diner is a place of passage means, first

and foremost, that at some point, the film's characters will need to leave it. For these protagonists, Asteroid City can only be a parenthesis, and once the lockdown has been lifted, each of them will return to their own existence, forgetting everything about this small town, its inhabitants, its five-dollar milkshakes crowned with a cherry that you would not share with anyone for anything in the world. Before we leave the diner too, we'll allow ourselves to be tempted by the lure of grilled cheese sandwich and a nice, hot coffee, or maybe some lemonade instead. The diner is a haven of peace, a return to a setting that is both familiar and reassuring—a place that, contrary to some cinematic legends, still exists. If you happen to come across one of these magical places, it means that it's time for you to make a stop, if only to take a well-deserved break from driving, because the road ahead is still a long one. ⚷

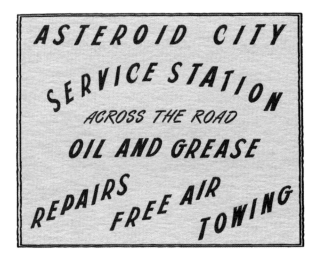

ASTEROID CITY
SERVICE STATION
ACROSS THE ROAD
OIL AND GREASE
REPAIRS FREE AIR
TOWING

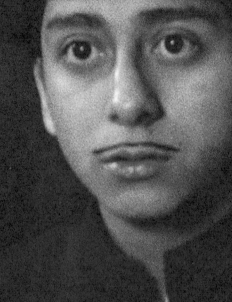

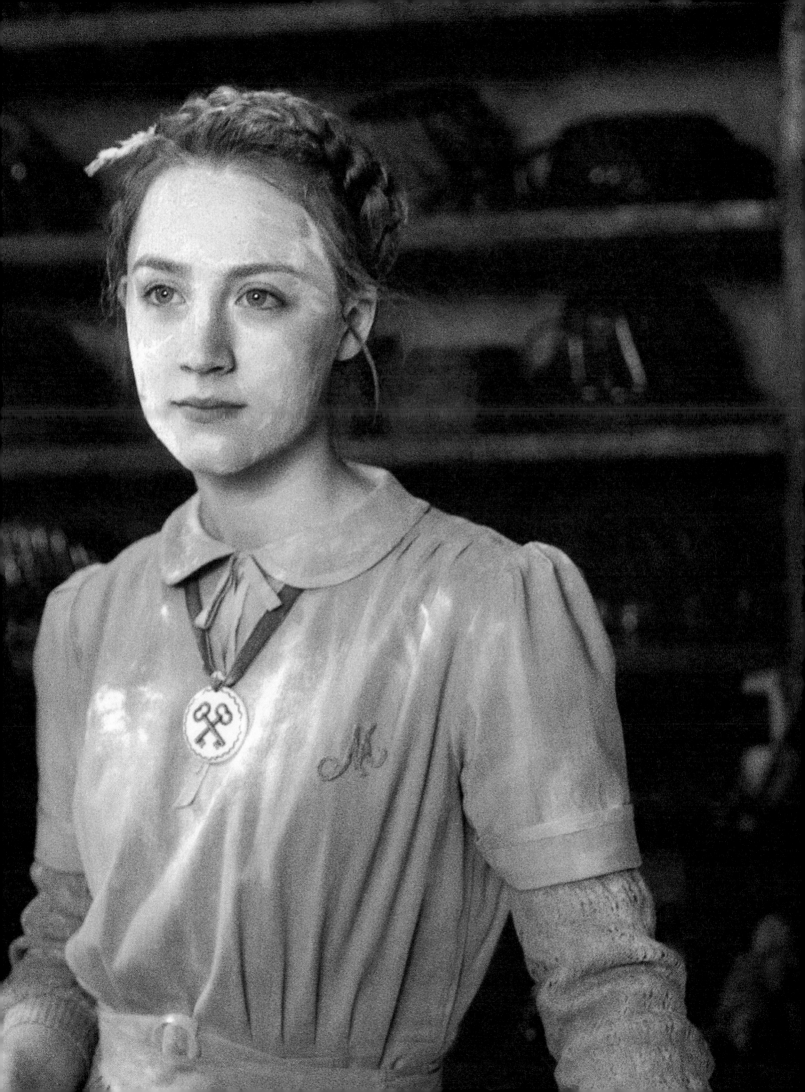

VI

THE AUDITORIUM

You are now entering the auditorium of this Imaginary Museum. As you will notice, despite its modest dimensions, this small room in the shape of a Roman theater has been fitted out in accordance with the most exacting acoustic standards. On the central stage, in the morning, scruffy neurology professors and revolutionary speakers talk to a relatively sparse audience. In the evening, however, the auditorium hosts an unusual program. Bengali musicians open for children's choirs, and balalaika orchestras take to the stage after very retro French pop acts. Indeed, while images rightly hold an absolutely decisive place in Wes Anderson's works, let's not forget the role played by music in this singular universe. Who here hasn't found themselves humming the tune of Joe Dassin's Champs-Elysées for days on end after watching *The Darjeeling Limited*? Who, at the sound of Françoise Hardy in *Moonrise Kingdom*, hasn't been tempted to rise from their seat at the movie theater and break out into a frenetic twist that wouldn't be out of place between the tables at the Café Sans Blague? Who, when watching Rushmore, hasn't been seduced by the unstoppable sixties pop sounds produced by the Perfidious Albion? The music in Wes Anderson's movies unquestionably deserves its own room; in fact, it would even deserve its own exhibition. Few directors have so beautifully elevated the art of choosing a soundtrack, composed existing titles and music. For record hunters and collectors of all kinds, Wes Anderson's soundtracks are veritable treasure maps—to the extent that, when the screening ends, it's not uncommon to see some spectators head over to the nearest record shop, fork out a few banknotes, and leave holding one or two vinyl records, in order to prolong the showing that they already miss attending and, in the depth of their ears, the gentle tune of nostalgia à la Wes Anderson.

The "Yé-Yé" Movement

A Quiet Revolution and a Seventh Heaven for Wes Anderson

The time is the early 1960s. France has not yet undergone its metamorphosis; the streets are still very quiet, people are sipping their coffee quietly on terraces, with a newspaper in their hand and a pipe in their mouth. General de Gaulle has been President of the French Republic since 1959, and closely watches over the nation. However, the baby-boomer generation, the youth born after the war, is feeling restless; they feel an urge to shake things up, to dance, and a cultural movement is going to provide them with an opportunity to get up from their chairs, flip tables over, and wake their sleepy country from its slumber.

The "Yé-Yé" were born—a musical movement that owed its name to the enthusiastic "*Yeah!*" that were already

setting the rhythm of American twist or rock hits. It was in 1963, in the columns of the French newspaper *Le Monde*, that the sociologist Edgar Morin named this movement that was conquering the hearts of French teenagers (or, as he referred to them, "decagenarians"). This new wave of young singers would soon challenge the crown of Georges Brassens, Jacques Brel and Marcel Mouloudji. The old guard, talented though they were, were being pushed out the door by excited hordes of "decagenarians." Only Serge Gainsbourg would manage to sneak into this group, appearing on the cover of the magazine *Salut les Copains* in an iconic shot taken by the man who would photograph the music scene for years to come: Jean-Marie Périer, son of the great actor François Périer, a star of the French crime thriller movies of the 1950s.

The names of these new idols were Johnny Hallyday, Sheila, Claude François, Françoise Hardy, France Gall, Christophe, Michel Berger, Eddy Mitchell and Richard Anthony, to name but a few—artists who have since gone down in history and would forever forge the image of French youth abroad. *Life Magazine* ran the headline "*Hooray for the Yé-Yé Girls*." In Japan, the movement was met with colossal enthusiasm, and became *Shibuya-Kei*, a subgenre of J-pop embodied by groups such as Chocolat, Belle Époque and Paris Match—you really can't make this kind of stuff up! With this, France's musical influence extended as far as the Land of the Rising Sun. Everywhere, people were dancing the mashed potato in bars and on the cobbled pavements of the Hexagon, before the chaos, the struggles, the agitation, the havoc of 1968 broke out.

Literally everything about Yé-Yé was likely to appeal to a filmmaker like Wes Anderson—whether it was the style, the light-hearted melodies or the kind of naivety that never outlives the tender years, the Yé-Yé movement offers "*a particular form of exaltation devoid of any content, which so greatly displeases adults,*" Edgar Morin wrote. The stage was

perfectly set to provide a musical backdrop for some of the Texan movie director's most emblematic scenes. Let us remember the end credits of *The Darjeeling Limited*, to the tune of *Champs-Élysées*, by Joe Dassin (who, incidentally, was born in Brooklyn, and was the son of French movie director Jules Dassin), or the guinguette improvised on an overcast beach in New Penzance by two teenage runaways, to the sound of Françoise Hardy's *Le Temps de l'Amour*. Wes Anderson is particularly fond of France, where he has lived for over ten years in the legendary Parisian district of Saint-Germain-des-Prés, never far from the Café de Flore. One can easily imagine that the director has created his own France, his own little pocket Paris, which he explores wearing headphones, to the sounds of retro music. In *The French Dispatch*, the cobblestones of Paris are replaced by those of Ennui-sur-Blasé, and the young generation is torn between the frivolity of a pleasant evening in a bistro and the furious debates that are emerging.

It is at the Café Sans Blague that the teenagers of *The French Dispatch* gather to dance the "*Lait Chaud*," sporting hairstyles with strange names (the Crouton, the Pompidou), all the while expressing themselves in a hermetic slang made up of Latin words, philosophical jargon and meticulously studied body language. For the release of his movie, Wes Anderson pushed the envelope even further, casting Jarvis Cocker, lead singer of the band Pulp, in the role of the hit singer Tip-Top. The outcome was a real fake album, *Chansons d'Ennui Tip-Top*, a tasty suite of covers of Chanson Française standards, whispered in a soft, raunchy English accent. It featured tracks such as *Dans ma Chambre* by Dalida, *Il Pleut sur la Gare* by Brigitte Fontaine or *Aline* by Christophe, which even became the soundtrack to the movie's *trailer*, setting the tone right from the outset—this movie would be all about France, our favorite director's new postcard destination. 🔑

The Balalaika
Chords of Nostalgia

What notes, hymns and melodies bring rhythm to the daily lives of the people of the Republic of Zubrowka? With a remarkable "expanded universe," *The Grand Budapest Hotel* boasts a rich imaginary folklore—from its gastronomy to its literature, not forgetting its historical backdrop, continuously blurring the boundaries between reality and imagination, between verisimilitude and fantasy. Among the thousand details and traditions that define this sheltered world, music naturally has a special place. The soundtrack to *The Grand Budapest Hotel*, by French composer Alexandre Desplat, is very much like the small country that it illustrates: a joyful mix of influences from all four corners of Central Europe. At the heart of this soundtrack is an instrument that possesses an evocative omnipotence. A singular pluck of the string is enough to draw us into an imaginary world of Slavic exoticism: this very particular, deep and sweet sound is that of the balalaika.

Indissociable from the history of eternal Russia, this stringed instrument from the lute family is instantly recognizable by its triangular shape, topped by a long, narrow neck. In the movies, the balalaika rose to fame in 1965, thanks to David Lean and his adaptation of the novel by the Russian writer Boris Pasternak. A lengthy movie film caught in the eddies of history, *Doctor Zhivago* turned the balalaika into a symbol: the instrument is Yuri's only legacy, linking destinies and generations of characters. However, it was also its use in Maurice Jarre's score that left its mark, particularly with the famous track *Lara's Theme*. Since no musician in the

MGM studio orchestra knew how to play the balalaika, Maurice Jarre knocked on the door of a Russian Orthodox church in Los Angeles, and proceeded to recruit twenty-five musicians who were familiar with the instrument. From the October Revolution to the civil war and up to the Great Terror, Maurice Jarre's score is marked by the sinister accents of war and the Bolshevik repression; male voices evoke revolutionary songs and the choruses of the Russian army chants, while Lara's Theme provides a redeeming and sensitive counterpoint. With *Doctor Zhivago*, the French composer won the Academy Award for Best Original Score, immortalizing the arpeggios of the balalaika in the cinematographic art.

The sounds of these balalaikas—sometimes joyful vibrations, sometimes melancholic laments—haunt *The Grand Budapest Hotel*. For this movie, which is also caught in the devastating whirlwind of history, Alexandre Desplat composed an original soundtrack full of distant sounds and folkloric echoes. To attain this unique sound, which could only belong to the Republic of Zubrowka, Desplat set up a curious orchestra, concentrating Hungarian, Russian, Romanian, and even Swiss influences. "*For* The Grand Budapest Hotel, *I needed to transport viewers to this small country, which we assume is located in central Europe. I didn't want to feature a classical string orchestra or any music that would allow for a more precise geographic identification. Instead, I preferred exotic fragrances and colors, far from any authentic traditional music, and I think I found them with these balalaikas and these zither, cimbalom or alphorn timbres,*"[1] the composer recalls. He therefore recruited the balalaika orchestra of Saint-Georges de Meudon,

with whom, in turn, he shared the Academy Award for Best Original Score.

Without allowing us to perfectly locate this fictional country, the sounds of the balalaika speak to us in a Slavic language, conveying harsh and distant winters. The yodelers' clear singing tells the tales of towering, windswept peaks, where echoes descend along steep mountain slopes. The thundering brass and the rhythmic marches describe the absurd stiffness of militarism and the arrival of war, the threat of which is mitigated by a bizarre setback. Thus, without any further precision being required by viewers, the original soundtrack concocted by Alexandre Desplat is enough to immediately "situate" the Grand Budapest on an imaginary map. Beyond any geographical intuition, however, this orchestration graces the movie with its atmosphere, its nostalgic hue. And so, the balalaika tremolos in the theme *Mr. Moustafa* never cease to sing the gentle melancholy of the Grand Budapest's owner, the silent witness to the decline of an empire of which only scattered memories remain, strewn throughout his ancient hotel. What remains is the tale of days gone by and the sound of the bow on the balalaika's strings, suspending the course of the world. ⚷

1. François-Gildas Tual, "Un voyage avec Alexandre Desplat," *Maison de la Radio et de la Musique*, 10 September 2018.

The British Invasion
Rebellious Strands of Hair

We are at the dawn of the 1960s, and a tidal wave is about to sweep across the world. Leading this musical and cultural tidal wave are a handful of up-and-coming young men, who go by the names John, Paul, George and Ringo. The Beatles soon exerted a stranglehold on the American charts, seizing The King's crown and triggering a full-fledged *Beatlemania* in their wake—and, above all, opening the door to a youth united under the standard of the "British Invasion." The Rolling Stones, The Who, The Animals, The Kinks and The Zombies were also all very determined to elbow their way to the front of the stage. Meanwhile, on the other side of the Atlantic Ocean, from Soho to Carnaby Street, London was buzzing to the rhythm of the Swinging Sixties, and young people wearing miniskirts and sporting the London look inspired by Twiggy were establishing themselves as the world's most fashionable crowd.

The discovery of some of Wes Anderson's movies awakens the same excitement felt by collectors rummaging through dusty vinyl bins, in search of a rare gem. To delve into these discographic abysses—aboard a certain yellow submarine, alongside the Beatles and Steve Zissou—, Wes Anderson surrounded himself with an eminent musical supervisor. Randall Poster was indeed entrusted with the onerous task of assisting Wes Anderson in his search for the ideal soundtrack, from the corridors of *Rushmore* to the *Asteroid City* desert. And because every collector has their own hobby, their idée fixe (in short, their specialty), Wes Anderson and Randall Poster momentarily immersed themselves in this "British Invasion" phenomenon. *Rushmore* is by far the most Anglophile opus born of their fruitful collaboration: the Rolling Stones cross paths with The Who, The Faces, John Lennon and The Kinks. The *Rushmore* soundtrack has all the trappings of a mixtape, recorded on a cassette to swap with friends. Before Wes Anderson, other filmmakers have, of course, considered their soundtracks from the perspective of a "greatest hits" album, from the *American Graffiti*

THE BEATLES
AUGUST 21 1964
FRI. EVE.– 8:00 P.M.
SEATTLE CENTER
COLISEUM
GOOD ONLY FRI. EVE. AUGUST 21
EST. PR. $2.75
FED. TAX .17 $3.00
CITY TAX .08
SUBJECT TO INSTALLATION
NO REFUNDS — NO EXCHANGES
62 B 11 SEC.
Enter Tunnel 12A
ROW
SEAT
BEHIND STAGE
1964

hit soundtrack to Quentin Tarantino's ultra-referential selections.

For Anderson, however, music must above all reflect his characters' interiority. When they, at times, become silent, it underscores their emotion, finally allowing viewers to synchronize with their inner world. Indeed, Wes Anderson is not one to wait for post-production to shape the links between his heroes and his music. So, even before he began filming *Rushmore*, the filmmaker had already assembled most of his soundtrack, which he played on the set. This soundtrack would set the movie's tone, sometimes even dictating the pace of scenes. In the press kit, Anderson expresses a certain kinship between the dormant madness in Max Fischer, the young hero of *Rushmore*, and this British fever, with icons resembling most upstanding young people. "We used the British Invasion music because it gets at the other side of Max," the filmmaker states. "He presents himself as being very sophisticated, and he wears a blazer and a tie; but, really,

he's a teenager, and he's kind of going crazy."[1]

Following in the footsteps of other iconic movies of this generation, from the fierce anti-conformism of Lindsay Anderson's *If…* to Jerzy Skolimowski's *Deep End*, which tinges the waning Swinging Sixties with an atmosphere of disquiet, *Rushmore* attempts to introduce some of this adolescent madness to Houston, Texas. "*In a sense, there is a certain stylistic parallel that we're illuminating, though clearly the times and realities are very different,*" says Randall Poster. "*But I think the emotional charge of some of these songs really adhere to the film and will reverberate with the audience in terms of the energy and emotional content.*"[2] "Love. Expulsion. Revolution." are the key words that adorn the Rushmore poster, on which Max raises a raging fist to the sky. According to Randall Poster, by appropriating the songs of this "British Invasion," Wes Anderson is first and foremost trying to reconnect with a state of mind—that of an intrepid youth, ready to overturn codes, "*harken back to a music that expresses an emerging post-adolescent energy and vigor.*"[3] More than two decades later, akin to one of those old, hand-labeled compilations that one finds in a cassette player, the *Rushmore* soundtrack still blows with the wind of adolescent rebellion. ⚷

1. *Rushmore*, press kit, Touchstone Pictures, 1998.
2. *Ibid.* • 3. *Ibid.*

The Young Person's Guide to the Orchestra by Benjamin Britten

The Art of the Fugue

First, the woodwind family: flutes, oboes, clarinets and bassoons. This is followed by the brass section: trumpets, horns, trombones and tubas. Then the string instruments take over: violins, violas, cellos, double basses and harp. Lastly, all the percussion instruments: drums, gongs and any other musical object that one strikes. Introductions are made, and the entire orchestra comes together to play Henry Purcell's dazzling theme. At first, this introduction is nothing more than a crackling track played on the Bishop children's record player,

while the household slowly wakes up. However, the Young Person's Guide to the Orchestra soon explodes into a powerful, extra-diegetic melody, at the precise moment when the camera escapes from the family home, slowly zooming out to take us to the other side of the island, maybe as far as Suzy can see through her trusty binoculars, until the red house resembles nothing more than a doll's house or one of the embroideries that adorn the walls of the Bishop family home's. As the movie title traces naive yellow arabesques against a stormy sky, we are already witnessing

the first escape of a movie that is centered around one obsession only: to leave while there is still time.

The Young Person's Guide to the Orchestra, a little guide to music composed by Benjamin Britten in 1946 and conducted by Leonard Bernstein of the New York Philharmonic, serves as the introduction to *Moonrise Kingdom*. The score, at once grandiose and scholastic, commented on by a meticulous little conductor, is much like the film that we are describing here, riddled with the contradictory impulses of childhood and adulthood, all converging toward the fearsome moment that is preadolescence. This work by Benjamin Britten is an initiation (ultimately very much like Wes Anderson's movie) with which many children learned the rudiments of symphonic music at school. Anderson pays tribute to him twice—first in the opening credits, then in the closing credits, imitating his educational process, this time applied to the original score of *Moonrise Kingdom*. As the names scroll across the screen, a child's voice breaks down the score by composer Alexandre Desplat, identifying the instruments one by one, from the banjo to the B-3 organ and the glockenspiel. For this filmmaker who, on occasion, enjoys nothing more than revealing some tricks of the trade, this is a way of introducing the spectator to the confidential workings of his movie's production, much like Benjamin Britten before him.

In the opening minutes of *Moonrise Kingdom*, everything is in movement—orchestral movements, of course, but also camera movements, with traveling shots that, one by one, reveal the house's rooms, adopting the same operatic stiffness, whether presenting us with the majestic intervention of the harp or introducing us to Mrs. Bishop, who is washing her hair directly in the bathroom sink. This four-and-a-half-minute preamble, which comes to an end as the diamond needle leaves the record's groove, exhausts Purcell's theme, dissects it, comments on it and deconstructs it, then synchronizes again in a grand finale. This musical climax is reached as the camera reveals the height of Suzy's determination, as she receives a mysterious letter that signals the launch of a secret plan. The flamboyant reunion of the instruments coincides with the culmination of the attack plan devised by Suzy and Sam, like

the melodic transposition of this thrill of escaping. And indeed, it will take nothing less than the full symphonic scope of the orchestra to convey the urgency of Suzy Bishop's desire for emancipation. Of course, she needs to escape the confinement and monotony of existence, perfectly embodied by the variations and repetitions of the music, so as not to embrace adulthood too soon. Behind Wes Anderson's orderly, precise direction, from the young conductor's conscientious enunciations to the skillfully choreographed camera movements, something is afoot, akin to the deceptive calm that precedes every storm. ⚷

Noye's Fludde
by Benjamin Britten
The Calm Before the Storm

A host of strange creatures—giraffes and elephants, anteaters and unidentified rodents—crowd the church forecourt, dressed in ill-fitting felt costumes. Wes Anderson's affection for Benjamin Britten persists throughout *Moonrise Kingdom*, which pays regular visits to the British composer's work. Furthermore, it continues with another of his scores, *Noye's Fludde* (1958).The metaphor set by the biblical deluge and the huge storm looming on the horizon, against which the narrator constantly warns us, is crystal clear. Thus, our heroes' escape begins with one flood and ends with another.

The summer before the disaster, on the island of New Penzance, St Jack's Church stages a performance of *Noye's Fludde*, a one-act opera by Benjamin Britten, based on one of the Chester Mystery Plays. This is the first theatrical deluge to precede the predicted meteorological disaster. In the heart of the old church, scouts are invited to take place in the nave to watch the island's children perform as the animals of the ark. Symbolically, these "animal children" are those that adults must save and protect from the coming storm. The storm, foreshadowed by this papier-mâché biblical deluge, is both real and metaphorical—a portent of the disillusionment that will soon engulf the entire country. When it finally breaks out, at the end of the movie, torrential rains wash away the Black Beacon dam. In this last act, the church becomes a refuge for the inhabitants, both young and old, sheltering them from the raging waves that threaten to submerge the island. In the film's finale, however, Sam and Suzy deliberately refuse the

SHIRLEY TEMPLE'S TOOVERBOEK

De GROOTSTE kinderrevue tot op heden vertoond

HET
MODERNE
SPROOKJES
TOONEEL.

POPEYE DE ZEEMAN

HET
MODERNE
SPROOKJES
TOONEEL.

protection of this makeshift ark, and flee through the edifice's roof, risking their lives.

If childhood is oftentimes at the heart of Benjamin Britten's work, it is because children are, in turn, subjects, performers or recipients. Again, in the spirit of initiation, this piece was written by Britten to be performed by an amateur cast—by children, in particular—in churches, rather than on the stages of auditoriums or opera houses. The show presented in *Moonrise Kingdom* complies with the great tradition of Andersonian makeshift decors, with its calligraphy poster, painted clouds, lightning bolts suspended from sticks, naive costumes and waves made from paper, shaken by small hands at the front of the stage. Britten and Anderson certainly share this taste for tinkering, and the composer does not hesitate to add instruments of his own to his score, such as porcelain cups struck by a wooden spoon to simulate the sound of raindrops.

However, this rendition of *Noye's Fludde* is also a reminiscence of a childhood memory that Wes Anderson cherishes. "*Well, I don't know*

Benjamin Britten's work that well, but I have always had a particular affection for it, because of this play," Anderson recalled on *Fresh Air*. "*So anyway, I was in a production of it, along with my older brother, when I was 10 or 11 years old. I've been sort of humming these, you know, these hymns and things from that play/opera all my life, and I had a thought that I wanted to incorporate somehow into this, which I didn't know how I was going to do for quite a long time. But somewhere early on I sort of thought the movie should be set to Britten, and we use not only the Noah's Flood pieces, but also we kind of tapped into his—into the whole body of work.*"[1] It is around the memory left by this representation of *Noye's Fludde* that the filmmaker imagines the phenomenal encounter between Sam and Suzy. For his great movie about childhood, Wes Anderson naturally turned to the nostalgic memory of Benjamin Britten's compositions, which are so closely linked, in his imagination, to the tender age when we were all twelve. ⚷

1. Terry Gross, "*Wes Anderson, Creating A Singular Kingdom,*" *Fresh Air*, 29 May 2012.

The Audio Devices
Wes Anderson's Machines or Nostalgia for the Future

"**B**eyond awakening curiosity from innocent onlookers, these technical enclosures open onto an unknown, powerful and magnificent world. Electronics, the masters of these places, are settling in and, day after day, spreading throughout. Here, far from the roar of the trains, the hum of electronic machines manifests, discreet and imposing. Tabulators command tons of steel and thousands of kilowatts, in a gentle murmur of small lights. These indicator lights speak in a colorful language that a technician's eye can translate. And after this information, a finger presses a button, a hand turns a handle… A tiny gesture produces complex movements, moves enormous masses and sends information at lightning speeds. A strange masterpiece, the accumulation of abstract signs, the harmonious writing of electronics, the precision of technique writes the manifesto of a decor where the work of engineers rivals that of artists." These magical, almost poetic phrases are taken from the book *Métro de Paris*, published in 1969 (all translation reproduction and adaptation rights reserved for all countries, including the U.S.S.R.).

It's easy to imagine Wes Anderson taking inspiration from each of these words to describe the actions of one of his characters, who would only have to press the button on a walkie-talkie or tap on the dashboard of a pocket submarine. Indeed, Anderson's filmography is rife with crackling, flashing devices, from the cider machine in *The Fantastic Mr. Fox* to the computers in the hacker's corner from *Isle of Dogs*. However, this electronic predisposition is particularly true when it comes to sound. Naturally, this Imaginary Museum is the warden of an astonishing

collection of audio devices, both imaginary and real. These are always eminently nostalgic devices—from Suzy's sky-blue, battery-operated Barrington record player to Mr. Fox's Walk-Sonic, right down to the Sparkomatic cassette player in *Deep Search*.

All of these enable Wes Anderson's characters to take control of the film's soundtrack, to start or stop the music themselves, definitively blurring the barriers between the diegetic and extra-diegetic soundtracks. There is nothing trivial about him equipping his characters with such a plethora of obsolete electronic devices. Wes Anderson's determination to avoid digital tracks, cutting-edge technology and smartphones also stems from his concern for directing. Aren't these multicolored lights, buttons to turn and switches of all kinds more fun than our screens, however high definition they may be? With that said, there are a few digital attempts, as in *Hotel Chevalier* and *The Darjeeling Limited*, where Jack Whitman, armed with an iPod and a speaker, meticulously chooses the soundtrack to his life. However, the iPod is already a vintage object, which disappeared

from the radar in the 2020s. These examples remain rare. On the other side of the spectrum, objects from the past abound on the screen: vinyl records, plastic corded telephones and even telephone boxes, typewriters, faxes and telexes, oscilloscopes, battery-operated cassettes and electrophones, huge, cumbersome audio headphones, dictaphones, radios picking up the last waves of a bygone era… The list is never-ending.

When asked about his penchant for this accumulation of outdated technology, Wes Anderson explains: "*You know, in the case of [Moonrise Kingdom], I have a good justification for analog equipment, which is the movie takes place in 1965. In the past I've used the same stuff and I have no real way to defend it, except that I think it's nicer to put a camera on a spinning thing rather than something that just sort of beeps or, you know, numbers that tick off.*"[1] Far from the technologies that enslave mankind, the cold screens and mind-numbing machines that stand ready to think for us, Wes Anderson's outdated technological collection may well, on the contrary, have a little extra soul. For this

1. Terry Gross, "Wes Anderson, Creating A Singular Kingdom," *Fresh Air*, 29 May 2012.

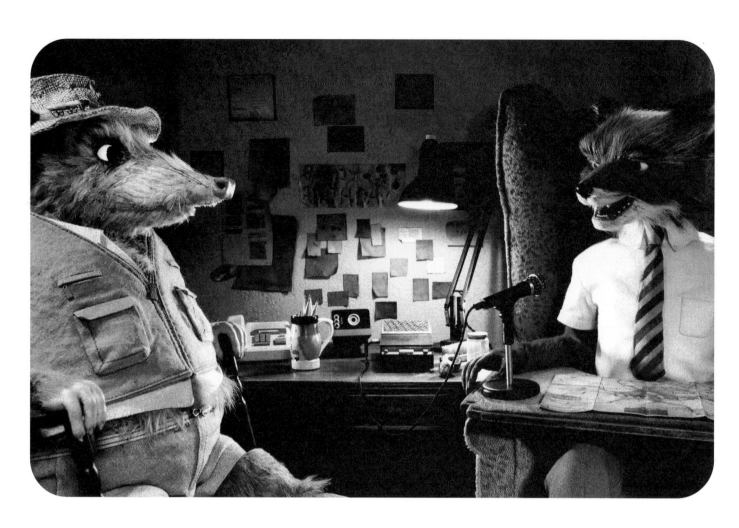

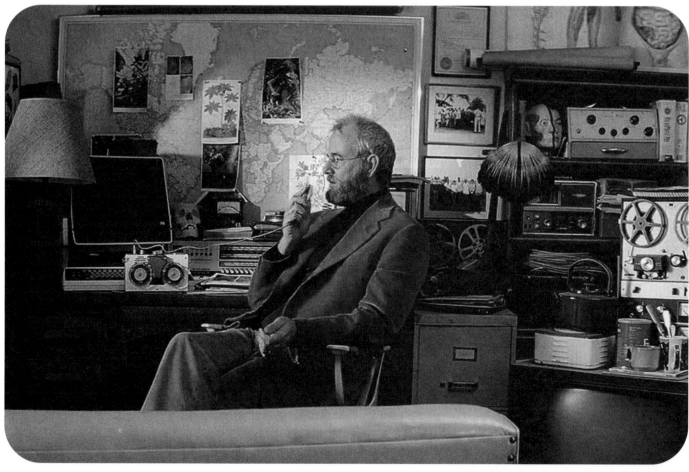

director who enjoys nothing more than producing "tangible" cinematographic works, sound and music also need to find a concrete representation on screen. While some filmmakers paint futuristic portraits of technology, readying themselves to explore all the opportunities (and risks) that it entails, Wes Anderson uncompromisingly embraces the past and its comforting technologies.

The director's only line of defense is a self-admitted, genuine fetish. It matters little that you can use the internet and a search engine to seek an answer to a question at the speed of the future, when you can also do it using an analog machine that produces cute little noises, rising from the depths of ancient circuit boards. It matters little that it is easy to launch a playlist from a touchscreen held in the palm of your hand, when it is so entertaining to load a cassette, turn the knobs on a radio or gently move the pick-up arm on a record player and cautiously place the

needle on the smooth black surface of a vinyl record. Indeed, Wes Anderson is a filmmaker enamored with "beautiful gestures." In his works, objects are granted the right to exist in order to grace elegance with further elegance, and charm has a duty to prevail over utility. This analog passion also contains a "little something" that returns to us from our childhood, the joy of rediscovered objects, both for their nostalgic power and for the pleasure of pressing all their buttons. Wes Anderson's movies are akin to mechanical toys, brimming with electronic mysteries, which, as children, we wanted to unscrew and open in order to reveal their incomprehensible workings. In the same way, we would like to dissect each of the director's movies to unveil some of the analog secrets that govern his world. ⚷

VII

THE SECRET ROOM

What would a Wes Anderson exhibition be without its secret room, its little hidden nook concealing a few buried treasures? Wes Anderson's cinema is full of mysteries, secret societies, plans, jealously guarded recipes, highly confidential letters and unsolved enigmas. It is a tiny room that is off-limits to the public; for you, however, we will bend the rules just a little. To access it, you will need to get down on your knees, and enter through this tiny back door (please mind your head). The light is subdued, so as not to draw too much attention; so please keep your eyes wide open and pay great attention to the details. If, as the saying goes, the devil is indeed in the details, you can be quite certain that Wes Anderson is hiding there too. Of course, there is nothing for us to do here and we cannot linger on, or we will get into serious trouble. For you, we will disclose one or two of the best-kept secrets in the Imaginary Museum's collection. After exiting this room, we kindly ask you to keep your mouth shut and not to reveal anything that you have discovered here. You are now part of a very exclusive club. So, not a word to anyone!

The Secret Plans
The Grand Illusion

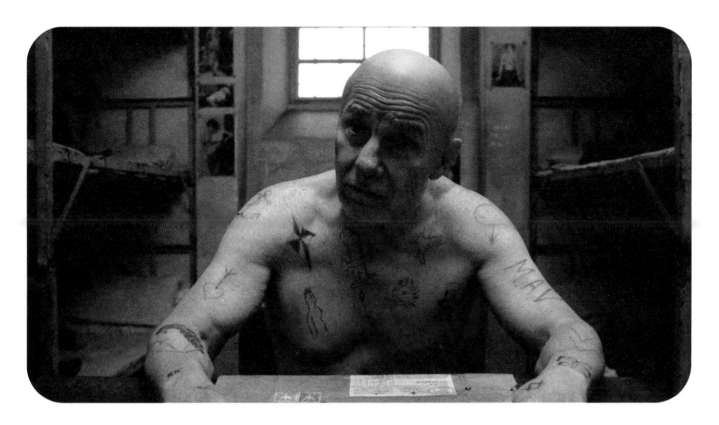

Yellowed, scribbled sheets, meticulously annotated maps, notebooks filled with clumsy handwriting, inventories of unlikely objects, laminated travel itineraries marking out every minute of every day… There's little that Wes Anderson's characters enjoy more than devising intricate plans. Naturally, these archives are now housed in the Imaginary Museum, in a secret room, far away from prying eyes. We apologize to our kind visitors for the great disorder in which they will find these documents.

In a perfectly chaotic and unpredictable world, Wes Anderson's heroes strive toward one single goal: to shape reality according to their own liking. These incorrigible strategists often take control of the film, and exert a significant influence on their peers. The filmmaker never ceases to recount the adventures of leaders, if only within their own small community of misfits. Whether captains or family fathers, scouts or criminals, these gang leaders, who are every bit as determined as they are visionary, strive to control the chaos that pervades their lives through improbable plans—in vain, however. They soon need to come to terms with the facts: their quest is impossible, and their blind pursuit of control could well cause them to lose sight of what is essential.

Wes Anderson's cinema is scattered with these bizarre plans that we are given to see fail, most of the time, and succeed, on occasion—however, always on unexpected terms that turn all the established calculations on their head. Of course, these stratagems are eminently complicated, and rife with a thousand slightly unnecessary details. Luckily, they also provide fantastic storytelling devices: by revealing his characters' designs, Wes Anderson welcomes viewers

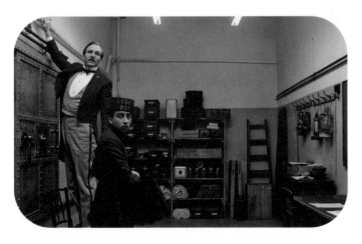

to feast on the inevitable collision between imagination and reality that, in the end, never fails to catch up with his heroes.

In *Rushmore*, Max has two ambitious goals: to graduate from the prestigious academy, and to win the heart of Miss Cross, who has a weakness for aquatic creatures. So naturally, Max sets about building a giant aquarium on the school's baseball field. Armed with a stack of books and documentaries, gathering surveyors and workmen, he managed to fail on all counts: not only does Miss Cross neglect to show up at the opening ceremony, but Max is expelled from the academy. In *The Fantastic Mr. Fox*, an entire chapter is dedicated to the plot, soberly titled: "*Mr. Fox has a plan.*" In the secrecy of his burrow, the fox tells the possum: "*[…] I've decided to secretly do one last big job on the sly. I'm bringing you in as my secretary and personal assistant.*" On his desk, he spreads out the essentials of an intricate plan, a map of the surrounding farms, some high-potency sleeping powder, and an extremely comprehensive file about Boggis's beagles (complete with photographs, medical certificates and complaints filed with law enforcement). Of course, for the whole family, it is a prelude to a world of trouble.

In *The Life Aquatic*, the explorer and documentarian sets out to kill his sworn enemy, the jaguar shark, but also to rob his rival. The plan of attack here takes the form of a sequence from a documentary, *Adventure No. 12: The Jaguar Shark (Part 2)*, in which Steve Zissou explains the operation in great detail, relying on a slideshow to do so. In *The French Dispatch*, at the dinner table, the police inspector lays out a multi-front battle plan that matches the menu served by Lieutenant Nescaffier, while the editor-in-chief organizes his death with the utmost precision, leaving behind a meticulously annotated will. The movie *Moonrise Kingdom*, meanwhile, is dominated by a vast escape plan. But no matter how well-prepared Sam and Suzy may be, with

their inventories, maps, tents and provisions, their escapade fails. Indeed, it will not be lost on viewers that their elopement to this beach at the end of the world takes place on an island—a small one, at that. To locate the fugitives, all the parents will have to do is spend a while scouring the countryside. The great adventure will last just one day. Fortunately, the young scouts, excited by this quixotic attempt, decide to come to their rescue with a foolproof plan, based on newspaper, glue and three yards of chicken wire.

In Wes Anderson's fifth movie, *The Darjeeling Limited*, the desire for control becomes pivotal, if not obsessive. It is expressed, in particular, through the character of Francis, the captain of the expedition. A true control freak, Francis satisfies his obsession by establishing an excessively precise itinerary, cultivating a nasty habit of ordering his brothers' food in restaurants and exhibiting a tendency to turn even the most spontaneous impulses into a three-part plan. Among his many projects, the organization of a redeeming ritual turns into a great moment of comic disillusionment. Driven by a New Age fantasy of sorts, Francis

sets off on his journey to India with the intention of experiencing a veritable rebirth—one that could well save him and his brothers, each of whom is mired in depression in his own way. He unearths a prodigious ritual—that he finds who knows where, and that consists of doing who knows what—which includes so many steps that his brothers give up studying it and resort to improvising wildly with their magic feather. Of course, the ritual does not deliver the anticipated spiritual awakening, leaving Francis with a bitter aftertaste. Together, the brothers set off on the last leg of their journey to meet their mother, and their reunion proves every bit as fruitless.

However, it was Dignan's character, in *Bottle Rocket*, who paved the way for this long line of magnificent plotters. Because he doesn't know how to keep himself busy for the next twenty minutes, the idle young man sets about planning the next seventy-five years (in the short, medium and very, very long term), plotting out his approach to an idealized life of organized crime. Anthony and Dignan embark on their first misdeed—the burglary of a modest suburban house, which turns out to be Anthony's parents' home (to which he likely has the keys). The scene is directly inspired by a funny anecdote told by Wes Anderson and Owen Wilson. During their studies at the University of Texas, both students became friends during a playwriting course, a play prepared by Anderson and a passion for cinema that fueled a number of lengthy late-night conversations between them. They became roommates, and their friendship was soon cemented around an absurd package deal. When the landlord refused to repair their apartment's windows, the two friends decide to break in themselves, in order to better prove the urgency of the repairs. The owner was not fooled, however, and even hired a private detective to look into the matter. This plan, both wobbly and magnificent, would be worthy of Dignan himself. *Bottle Rocket* is a comedy based on

disaster in the making and total disorganization. And so, the entire film is geared toward one big final heist, ordered by Mr. Henry, which will obviously fail in every possible way.

Dignan exhibits the same unfailing determination, capable of sweeping away everything in its path—including Anthony, his melancholic companion. At the very beginning of the movie, Dignan, lurking in a bush, is organizing a great escape from the hospital where his friend is staying. While he is able to leave the establishment at his convenience, Anthony chooses to use the rope of knotted sheets, so as not to dampen Dignan's wonderful enthusiasm. Wes Anderson's leaders are like magnets: they attract other characters, mired in their immobility or depression. Max drags along the melancholic Herman Blume, who has come to cordially detest his own existence. The Tenenbaums get caught up in their father's dirty tricks. Sam leads Suzy, and soon, an entire army of scouts into widespread disobedience. Steve Zissou manages to assemble a loyal crew, Mr. Fox corrupts the brave possum and lastly, in the Whitman family, it is, of course, Francis who leads his brothers on their adventure, going so far as to confiscate their passports, like the parental figure that he believes himself to be.

After laying out maps, plans and lists and anticipating the unforeseen, our characters come face to face with reality, and the illusion of control collapses. The Whitmans illustrate this learning process. One cannot embark on a "spiritual journey" simply by following a laminated itinerary without opening oneself up to the randomness of life, to chance and to the disorders it entails. Chaos will inevitably make a brutal incursion, whether through the tragic death of a little boy or the threat of a man-eating tiger lurking in the shadows. Roman Coppola, co-writer of the film, sums it up: "*The whole spirit behind the movie was to put these characters on the train and then to move fast into chaos, to really roll with the punches, and to always let the unexpected happen.*"[1] Some appearances are emblematic of this chaos, such as that of the jaguar shark—a mysterious, uncontrollable and arbitrary force of nature, ready to pounce on its victims. And by refusing to kill the beast, Steve Zissou finally yields to the reign of chaos.

From Dignan to Max Fischer, from Mr. Fox to Steve Zissou, Wes Anderson's filmography is full of characters who learn the hard way about the limited power they wield over the world. An ironic conclusion, given the filmmaker's work, where mastery exudes from every shot, where every object is custom-made, every composition carefully studied, every color integrated into a harmonious whole and nothing is left to chance. Life is a furious mess, and one has to accept that it will never take on the exact shape of our desires. In the movies, on the other hand, one can wholeheartedly throw oneself into this grandiose illusion and, at last, perhaps, succeed in orchestrating chaos. ⚷

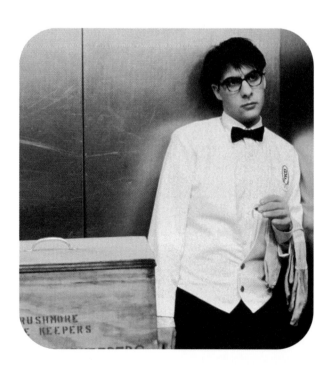

1. *The Darjeeling Limited*, press kit, Fox Searchlight Pictures, 2007.

L'Air de Panache
The Secret Formula

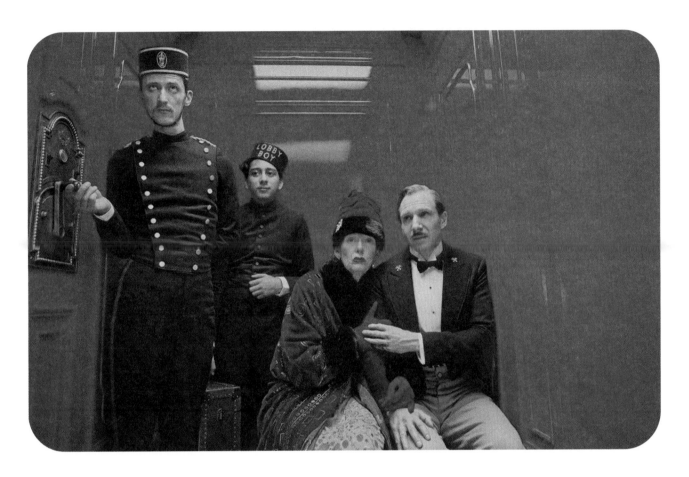

It is a small square bottle, with a quaint blower bulb, filled with an amber-colored liquid. The glass features an enigmatic, poetic inscription, which almost sounds like a promise: "*L'Air de Panache.*" This eau de cologne may perhaps be the best-kept secret of the Grand Budapest; indeed, it is none other than the olfactory signature of the establishment's most eminent representative, M. Gustave, who sprays it generously. In the corridors of the venerable hotel, the scent of this unique perfume announces the arrival of the man with the golden keys, and it lingers in the air long after he has left the premises. As a true dandy, the maître d'hôtel is well aware of this: no man can be separated from his perfume. With *L'Air de Panache*, Wes Anderson has imagined one of those marvelous artifacts that populate his cinema, and leaves viewers with a mystery to dwell on.

What is this fragrance whose formula alone seems to encapsulate all of M. Gustave's aura? What is the secret behind *L'Air de Panache*?

Mark Buxton is a nose, one of these professionals who create perfumes, like modern-day alchemists, dexterously handling all the subtleties of a fragrance. Born in England, this perfumer has been practicing his art for over thirty-five years, from Germany, where he grew up, to Paris, where he now lives. This man, who considers his profession a "*true privilege*" was contacted sometime before the release of *The Grand Budapest Hotel*, and requested to develop the mysterious fragrance that is *L'Air de Panache*. What would be the heady scent that spreads throughout the establishment wherever its' intendant goes? In just a few days, Mark Buxton would concoct

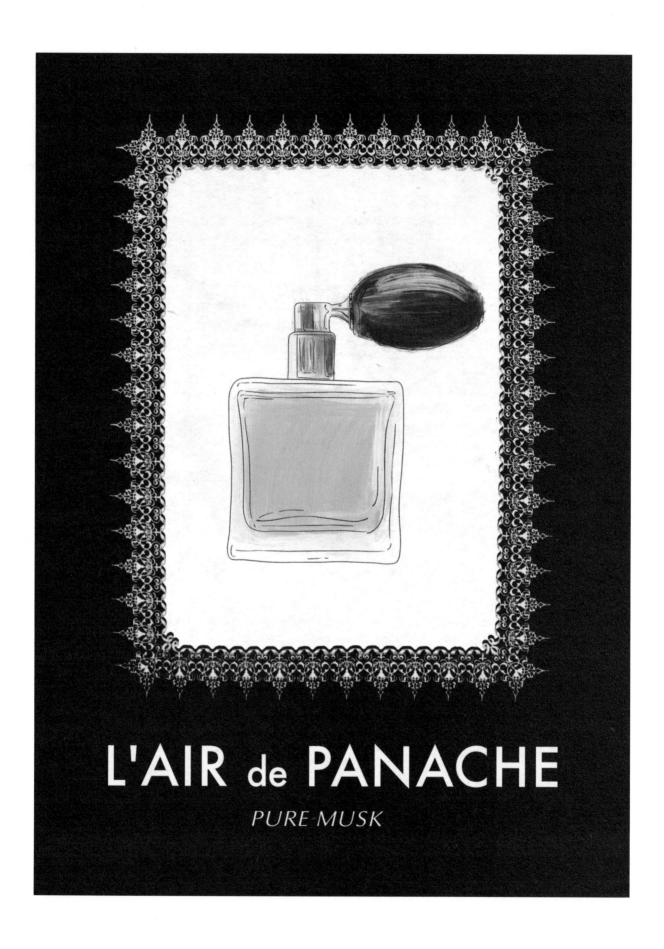

L'AIR de PANACHE

PURE·MUSK

L'Air de Panache, with one foot set in reality and the other in fiction, as is customary with Wes Anderson. He devised the magic formula, and has agreed to reveal some of its secrets here—just a few, however, for fear that, like a great perfume that has remained exposed to the air for too long, the mystery might become stale.

To compose this singular fragrance, Mark Buxton could only draw inspiration from the trailer for the forthcoming movie. Undeterred by this, however, the parfumier immersed himself in the hotel's atmosphere, the color palettes, the settings, the costumes and the characters. He then imagined a classic theme, an eau de cologne inspired by the fragrance's greatest tradition, with a modern, almost naughty twist… A perfect fit for our gallant maître d'hôtel, whose many romantic adventures are well known to us. It boasts a lovely head note, with a hint of apple, in reference to the famous painting of *Boy with Apple*, which so many protagonists are assiduously pursuing. This is followed by a more traditional heart note; M. Gustave is, after all, the guardian of all traditions. Then, at last, comes a modern touch, further back, as the fragrance develops more woody notes. The base note is amber, with a touch of leather that is almost animal-like, and very sensual. It is a demanding fragrance, rich in all these notes, which leaves a long, heady trail. Lastly, *L'Air de Panache* is a unisex fragrance, like so many other eaux de cologne. Mark Buxton insists on this: "*This fragrance was not designed for any gender in particular.*" Remarkably modern indeed!

So, what is the great secret behind *L'Air de Panache*? Once again, Mark Buxton tells it better than anyone: "*The secret is that there really isn't any secret to L'Air de Panache. It's all about the way one does things, the way one approaches things. The idea is that it's an eau de cologne, seemingly completely classic, but placed in a very modern context. Before they actually smell it, I believe that viewers might imagine a radically different fragrance… Yet, all of a sudden, they would smell this fragrance, this fresh, generous head note, reminiscent of green apple. They would notice the way these notes develop in the air, and they would see something traditional in it. Then, something very intriguing happens, when the leather comes out, when those animal-like notes emerge… One needs to follow its trail and really wear it to fully understand it. You know, when entering a room where M. Gustave has been, one would instantly think: 'He was here.' One knows that. One can still feel his presence in the room. That's what it's all about, I think. There is no other secret.*"[1]

1. Excerpts from an interview with Mark Buxton, for this Imaginary Museum.

VIII

THE PROJECTION ROOM

It is a movie theater of modest proportions, to say the least. Only a handful of orange velvet armchairs, lined up in front of the screen, furnish this small room, which is already plunged into darkness. The program schedule, displayed on the front door, is both eclectic and unexpected. You are now entering the holy of holies: Wes Anderson's cinematic temple. Every week, this pocket film library offers our visitors a limited selection of hand-picked movies. Don't be surprised if the schedule includes two screenings of Indian movies, alongside a handful of supercharged cartoons. Indeed, Wes Anderson's cinema is rich in influences from all horizons, ranging from the French New Wave movement to the New Hollywood enfants terribles, from the great classics of American cinema to obscure films, forgotten by all but a few or unknown to the general public. From one movie to another, the director scatters references like clues to a phenomenal treasure hunt. And now, it is up to us to follow their trail. This week, the Imaginary Museum offers a humble selection of these quintessential movies, in the hope that they will not fail to impress you. We now invite you to experience a mini-tour of Wes Anderson's classic movies. Please make yourself comfortable; the screening is about to begin.

NOTE

P.S.: If you chose the popcorn option (salted, sweetened, buttered, or all three at the same time) at the museum entrance, please report to the vendor in the mini-confectionery shop, on your left.

Charulata by Satyajit Ray
Both Near and Far

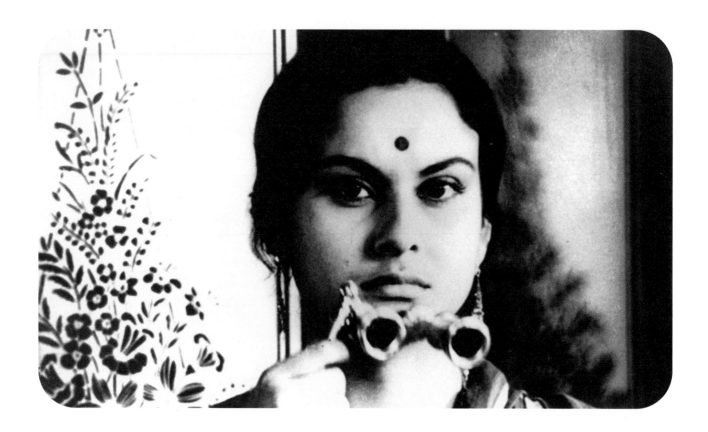

In her beautiful house, Charulata is bored senseless, and explores the world from her window, through theater binoculars. Behind louvered shutters through which rays of daylight enter, she observes the bustle outside—hurried men tending to their business, people going about their lives, of which she is only a spectator. Even within the walls of her home, she observes her husband, too absorbed in his work to pay her any attention. These binoculars, with which she looks out over the world, could well be one of the most beautiful symbols of Satyajit Ray's cinema. Wes Anderson is well aware of this, borrowing this fabulous accessory from Charulata and hanging it from young Suzy's neck in *Moonrise Kingdom*. Using their binoculars to create a new frame within the frame, Charulata and Suzy observe the world from a safe distance. "*It helps me see things closer. Even if they're not very far away. I pretend

it's my magic power," Suzy confides. Charulata's binoculars are a veritable metaphor for cinema, the magical power that makes the invisible visible and brings what is distant closer; they are a reflection of Satyajit Ray's work, a window to the world.

Satyajit Ray is a man of one country, one language and one culture, the Bengali culture in which he was born. For Eva Markovits, he was "*the Bengali filmmaker par excellence.*"[1] The son of the poet Sukumar Ray, a major figure in Bengali literature, he was born in 1921 in the city of Calcutta, where he was raised as an heir to the Bengali Renaissance, the nineteenth-century progressive artistic and intellectual movement. In 1943, Satyajit Ray became a layout artist in a British advertising agency based in Calcutta, before being hired by a local publishing house. At Signet Press, this lover of literature

1. Eva Markovits, "Satyajit Ray était un artiste protéiforme," *Les Nuits de France Culture*, 2 May 2021.

gave free rein to his talents as an illustrator and graphic designer, producing a vast series of wonderful, abstract and colorful covers. A cinephile before he was a filmmaker, in 1947, Satyajit Ray founded the Calcutta Film Society, a film club that would enable him to indulge his

Trilogy (*Pather Panchali*, *Aparajito* and *Apur Sansar*), which drew the attention of critics worldwide and won a series of prestigious awards, including the Best Human Document prize at the Cannes Festival, in 1956, and the Golden Lion at the Venice Film Festival a year later.

love of cinema. The Calcutta Film Society screened many Western movies, ranging from Italian neorealism works to the films of Jean Renoir; in fact, it was in that same year that Satyajit Ray crossed paths with the French director. Just as Renoir was preparing to shoot *The River* (whose influence on *The Darjeeling Limited* Wes Anderson would openly acknowledge), Satyajit Ray guided him through his location scouting on the banks of the Ganges River. The aspiring filmmaker told him about his project: to bring to the screen a classic of Bengali literature, *Pather Panchali*, which tells the story of Apu's childhood in a small Bengali village. Renoir encouraged him to proceed, but it was the screening of Vittorio De Sica's *Bicycle Thieves* during a trip to London in 1950 that definitively confirmed his vocation. Released in 1955, after three grueling years of shooting, *Pather Panchali* (*Song of the Little Road*) is the first part of a three-part work, The Apu

Far from the glitz and glamor of Bollywood, Satyajit Ray's debut film is a lyrical work with a profoundly humanist flair. Eva Markovits explains: "*His project was to leave the studios and film India outdoors, with non-professional actors, and to tell the tale of people's everyday lives.*"[2] Turning his back on the excesses of Bombay's Hindi cinema, rich with musical melodramas, Satyajit Ray revealed another face of India, authentic and sensitive, which would be met with universal acclaim. Over the course of the thirty-six movies that he directed, he experimented with a wide range of genres, ranging from crime thrillers to films for children; however, he would never turn his back on Bengal and his native language, though it was a minority language, at the risk of alienating a number of viewers (*The Chess Players*, in 1977, would provide an exception to the rule). A complete and protean artist, Ray

2. *Ibid.*

Amal forge a close relationship and encourage each other to write. The complicity soon gives way to a silent romance, which both protagonists refuse to admit. And so, their writing becomes a complex battlefield, crystallizing the characters' frustrations, joys and hidden desires. No word or gesture will ever betray this illicit love, and Satyajit Ray then uses the power of cinema to depict the birth of amorous feelings. In a dramatization that spares its effects and movements, every zoom, every close-up suddenly seems charged with meaning. Satyajit Ray scrutinizes his characters' faces, observing their emotions or troubles, scruples or guilt, the sudden darkening brought on by jealousy. His direction sketches the outlines of a limpid love story, where faces disclose what mouths and hands fail to express. Even Charulata's binoculars become a tool revealing her desires; her discreet observation of Amel lying in the garden is a portent of the young woman's nascent love for him, long before she, herself, becomes aware of it.

Satyajit Ray's camera, which seldom strays away from his heroine, hardly ever crosses the threshold of the beautiful Victorian mansion. Yet, Satyajit Ray remains a reliable chronicler of the Indian world. Behind closed doors, the filmmaker paints a portrait of an era, that of the Indian renaissance, whose ideals he shares. He adapted *Nastanirh (The Broken Nest)*, a short novel written by an essential figure of this renaissance, writer and artist Rabindranath Tagore, to whom he had already devoted a documentary in 1961. The social preoccupations of Bengal, even though they are never directly evoked on-screen, mingle with this intimate tale of human passions. Set in British-ruled India, *Charulata* explores the indispensable harmony between the political and the poetic, extremities respectively embodied by Bhupati and Amal. At the heart of this clash of values, it befalls the heroine to find her way. With *Charulata*, Satyajit Ray once again concerns himself with the

distinguished himself as a director, but also as a writer, a composer, an illustrator, an editor and more yet. He brought his many talents to his movies, from scriptwriting to poster design, from watercolor storyboards to cinematography, including calligraphy and the composition of many of his film scores.

With *Charulata,* in 1964, which he considered to be his most accomplished film, Satyajit Ray painted a portrait of a woman in late nineteenth-century Calcutta—at the time, the seat of the British government. Charulata is a young woman too full of life and spirit to indulge in an idle existence. To help her escape the boredom in which she is mired, her husband, Bhupati, invites a cousin into his home, hoping that his cheerful company will overcome his wife's loneliness. Cousin Amal, a dilettante writer searching for success, brings life into Charulata's house. Brought together by their love of literature and poetry, "Charu" and

echoes that of *Nayak: The Hero*; and finally, there is the music, of which almost half a dozen excerpts are scattered throughout Wes Anderson's movie. In fact, Anderson makes a point of collecting these: "*I can't stress enough that these songs really didn't exist on CD. So I had to personally introduce myself to the Satyajit Ray Family and Foundation and convince them that it was worthwhile to digitize all of his master tapes. It was a bit of a process: […] I wound up sitting in Calcutta for five days waiting for them to hand them over. But that was one of the great experiences of my life. And it's some of the most unique music that we've ever used,*"[3] the director recalls. Wes Anderson even indulges in one last nod: on board the return train, in the Whitman brothers' cabin hangs a portrait of Satyajit Ray.

Celebrated today as one of the great masters of cinema, Satyajit Ray is the author of a sensitive body of work, attuned to the world, which will never cease to testify to his deep attachment to Bengal. For viewers around the world, Satyajit Ray's camera, much like Suzy's binoculars, has the power to reveal the invisible, both near and far. Among the admirers of this great humanist was Japanese filmmaker Akira Kurosawa, who wrote the following: "*Never having seen a Satyajit Ray film is like never having seen the sun or the moon.*" 🗝

thwarted destiny of an Indian woman, one of those figures so essential to his filmography. Among these women whose independent spirit clashes with the established social order, Charulata's character (to whom Madhabi Mukherjee lends her large, dark eyes, so beautifully capable of expressing joy, pride or anger) embodies the necessity of renewal.

Satyajit Ray's work would leave a deep, indelible mark on many movie enthusiasts and film directors throughout the world. Wes Anderson, in turn, paid him a tangible and sincere tribute in *The Darjeeling Limited*, where the filmmaker's tutelary shadow is oftentimes perceptible. During this Indian journey, influenced by filmmakers such as Satyajit Ray, Jean Renoir and Louis Malle (the latter, through the documentary series *Phantom India*, *L'Inde fantôme*), Wes Anderson oftentimes references the master's works. There are the village scenes, of course, which remind us of *Pather Panchali*; the train journey, which

3. Blaine McEvoy, "*7 Perfectly-Scored Wes Anderson Scenes,*" *Rolling Stone*, March 2014.

Harold and Maude
by Hal Ashby
Thwarted Love

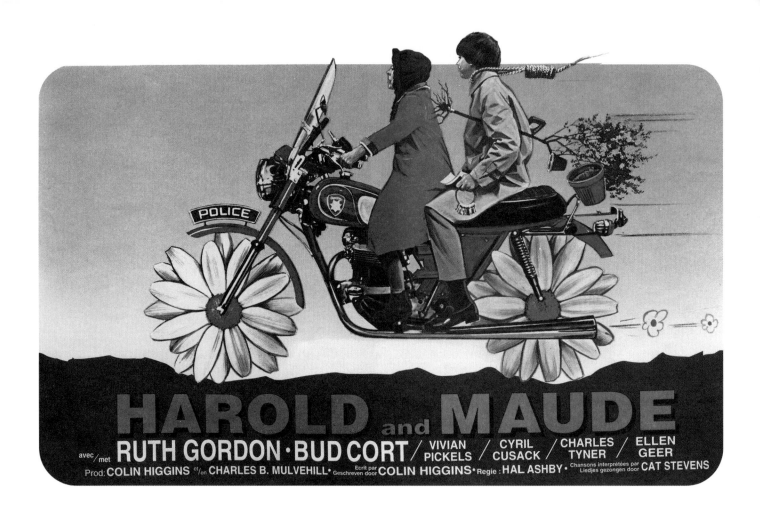

HAROLD and MAUDE
avec/met **RUTH GORDON · BUD CORT** / **VIVIAN PICKELS** / **CYRIL CUSACK** / **CHARLES TYNER** / **ELLEN GEER**
Prod: **COLIN HIGGINS** et/en **CHARLES B. MULVEHILL** · Geschreven door **COLIN HIGGINS** · Regie : **HAL ASHBY** · Chansons interprétées par / Liedjes gezongen door **CAT STEVENS**

Harold is a young man, barely twenty years old, whose vast wealth is matched only by the tenacity of his morbid impulses. Maude, on the other hand, is a young woman aged seventy-nine and a bit, brimming with life, whose boundless enthusiasm has not been dented by the weight of the years. While the former fakes extravagant suicides, the other lives a whimsical, bohemian existence in a dilapidated old train carriage. When the indomitable Maude meets the irredeemable Harold, an absurd and poetic love story begins. The protagonists, played by Bud Cort and Ruth Gordon, are magnificently mismatched, and breathlessly launch themselves into a seemingly harmless romance. However, their romance fails to reckon with the omnipresence of death, in the form of simulated suicides, for Harold, or of Maude's memories, contained within a deportation number inscribed in her very flesh. And if there is a time to live and a time to die, Maude is determined not to miss either of these dates.

An invaluable film in Hal Ashby's sometimes neglected filmography, *Harold and Maude* is a powerful ode to disobedience, to the refusal of norms

and conventions, and an invitation to embrace disorder, to live life with fierce freedom. Playing out to a cheerful soundtrack composed and performed by Cat Stevens, the film turns the song *If You Want to Sing Out, Sing Out* into a sincere hymn to joy. Harold and Maude are one of those movie couples destined to leave a lasting impression on our collective cinephilia. Wes Anderson's will be no exception, and Hal Ashby will figure prominently in the pantheon of his favorite directors. "*Making a movie is complicated, and it's like a miracle when it actually works out. Hal Ashby made six great movies in a row-practically unheard of. […] His movies are far beyond worth seeing. To me, they are some of the best movies ever made,*"[1] Wes Anderson stated. In any case, both filmmakers share a genuine affection for dropouts and outsiders of all kinds, a sense of comedy that borders on the absurd, and an ability to interweave the tragic and the comic. Does the shadow of *Harold and Maude*, released in 1971, reach all the way to *Rushmore*, released in 1998, and even beyond?

From Hal Ashby's film, Wes Anderson's work inherits this feeling of false lightness, where the delicacy of the depiction often conceals the darkness of the subject. He also draws on the folksy chords of Cat Stevens, which haunt the images of *Rushmore*. Lastly, *Harold and Maude* features the mirror play between children and adults, between Harold's grave character Maude's mischievous demeanor, paving the way for a great tradition of Andersonian characters. In Wes Anderson's bitter-sweet universe, from *Rushmore* to *The Royal Tenenbaums*, children are quick to adopt the seriousness of adults as they face the world, while adults, faced with the prospect of the setting sun, hasten to live lightly. For Wes Anderson, as for Harold and Maude, life is too important to be taken seriously. ⚷

1. Jennifer Wachtell, "*The Director's Director*," *Good*, 20 June 2008.

The Magnificent Ambersons by Orson Welles

Sic transit gloria

In 1873, in a quiet little town in the Midlands, the Amberson clan is living its finest hour, and the imposing family home is the stage a joyous social life. Eugene Morgan is wooing Isabel, daughter of the wealthy Major Amberson; despite their feelings for each other, however, the young woman decides to wed another man. From this dispassionate marriage, a son, George, is born, on whom Isabel pours her unconditional love. However, Isabel's maternal devotion and George's privileges of birth turn him into a conceited and arrogant young boy. Twenty years later, Eugene returns to the town in the Midlands, buoyed by the success of his invention—an automobile, which he predicts will change the face of the world forever. While his daughter Lucy falls under George's insolent spell, Eugene attempts to win back the heart of the now widowed Isabel. Unmoved by their reunion, George opposes their love with all his will, showing nothing but contempt for his mother's suitor. The decline of the Amberson dynasty is underway, as the clan's little town gradually expands and darkens, turning into a veritable city. Blinded by his pride, George fails to acknowledge that the splendor of the Ambersons is already no more than an illusion.

"*If we want things to stay as they are, everything will have to change*," Tancredi warns in Visconti's *The Leopard*, observing the slow erosion of the Sicilian aristocracy. At the turn of the century, the Ambersons are teetering on the brink of ruin, while the Morgan family is making a fortune in the fledgling car industry.

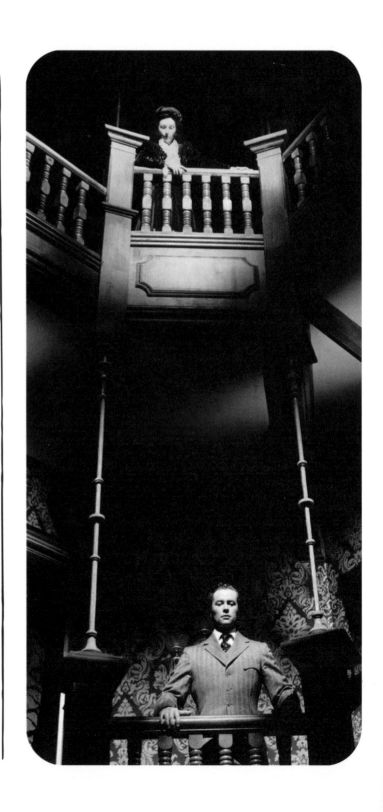

Its smoking, backfiring machines, which parade under the high windows of the manor house, are the symbols of the advent of a new world order. The whirlwind of modernity sweeps away everything in its path, leaving the Amberson family bereft, too certain of their privileges to realize that everything around them is changing and disappearing. Eugene ponders: Is this progress in the service of humanity, or is it rather a manifestation of the decline of civilization? Only time will tell, the inventor admits. Behind this ambitious family fresco, Welles holds, in the palm of his hand, the fate of a world doomed to disappear and that of men who, driven by vanity and pride, believe themselves strong enough to swim against the tide.

Released in 1942, *The Magnificent Ambersons* is one of those cursed movies, featuring alterations, cuts and studio happy endings that gave rise to many heated discussions. This feature film, shot in the immediate aftermath of *Citizen Kane*, was greatly damaged by RKO, who took advantage of the filmmaker's absence to maim the film on the editing table, cutting forty precious minutes from Orson Welles' work. Considering the final act to be too depressing, the studio's masterminds ordered a new ending to be filmed in all haste, betraying the director's intention in the process. Stripped of his movie, Orson Welles experienced the first in a long series of disappointments that would eventually turn him into the studios' bête noire. And yet, despite its elliptical narrative and its awkward conclusion, Orson Welles' second movie nonetheless remains a monument, in the shade of which many filmmakers have found inspiration. Wes Anderson is one of them, and the fate of the Tenenbaum family is closely linked to that of the Ambersons.

The story of the Tenenbaum family is that of another fallen dynasty, another tale of glory and demise. Even the title of Anderson's movie, *The Royal Tenenbaums*, is inspired by Orson Welles' masterpiece, similar to a distant echo of *The Magnificent Ambersons*. Right from the introduction, Anderson conjures up Wellesian ghosts: the presentation of the Tenenbaums in the form of *dramatis*

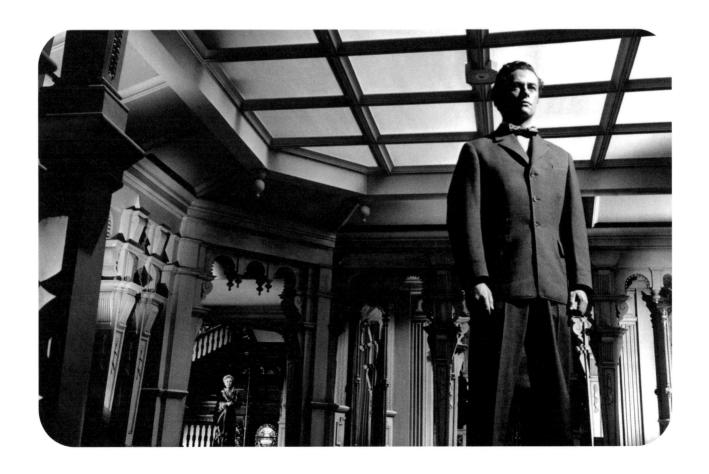

person**æ**, in the great theatrical tradition, recalls that of the characters in *Citizen Kane*; the huge table at which Royal Tenenbaum summons his children, imposing a physical distance symbolizing the emotional distance between the characters, is also a borrowing from *Citizen Kane*. However, while *Citizen Kane* advocated a total deconstruction of the narrative, it is rather from *The Magnificent Ambersons* that Wes Anderson borrows his narrative structure (with this two-decade ellipsis) and his literary device, that of an omniscient narrator, to whom Welles himself lends his voice. This slightly sarcastic storyteller chronicles a world doomed to oblivion. In *The Royal Tenenbaums*, Alec Baldwin (who, we guess, is the director's alter ego) lends his voice to this novelistic narration.

The colossal Amberson mansion has nothing on the Tenenbaums' residence; it in fact resembles it in many ways, with its tower and its monumental staircase. On these obvious similarities, Wes Anderson commented: "*Well, [it's] a lucky accident, but probably also because it was in my mind.* The Royal Tenenbaums *was really inspired by* The Magnificent Ambersons

more than anything. […] And I walked up there, and what I probably saw was a house that looked just like the one in Ambersons, and I thought, 'That's the place.'"[1] However, while Wes Anderson made a point of shooting in a real house, Orson Welles, as a formidable illusionist—quite literally, in fact, since he was an exceptional magician—turned the Amberson mansion into one of his many magic tricks. The filmmaker had only a number of the elements from the façade built, which he then assembled to create a painted illusion. And instead, he devoted most of his attention and his budget to the manor's interiors. It is an unusual setting, which borders on the gigantic, with pillars, distant staircases and arches opening onto even larger rooms, creating an infinite depth of field. Welles imagined a remarkable sequence of rooms, all connected as they would be in a real house, built from floor to ceiling. The camera traverses these, from one end of the house to the other, with grandiose and elaborate movements. It is here that Orson Welles shot a virtuoso ball scene—a perfect chase, a mirror of the games of influence and the characters' feelings. In fact,

1. Matt Zoller Seitz, *The Wes Anderson Collection*, Abrams, 2013.

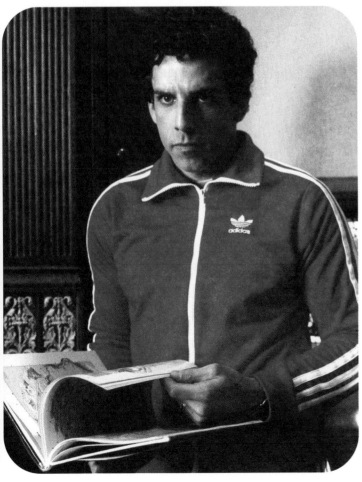

he would himself describe it as one of the tours de force of his career. "*He's not particularly subtle*," Wes Anderson commented. "*He likes the big effect, the very dramatic camera move, the very theatrical device. I love that!*" From the master, Wes Anderson inherited a taste for lengthy, linear tracking shots, preferably in geographically complicated settings, the use of wide-angle lenses; he also has a certain affinity for shots so formally audacious that they always underline the sovereign presence of the director, so often concealed in the camera's shadow.

With *The Royal Tenenbaums*, Wes Anderson in turn paints a grand family fresco, the first act of which continues to resonate with *The Magnificent Ambersons*. Yet, the disenchantment that pervades Orson Welles' film, the melancholy of an old world that is on the verge of slipping into oblivion, is echoed just as powerfully in *The Grand Budapest Hotel*, where the splendors of yesteryear are already but a distant memory. "There aren't any times but new times," Eugene Morgan warned in *The Magnificent Ambersons*, well aware of how dangerous it is to live among the ruins of the past. Wes Anderson's movies are always pervaded by this nostalgic feeling, this sense of the impermanence of things that we thought would be eternal, and even the high walls of Grand Budapest are unable to protect M. Gustave's world from the cruel ravages of time. *Sic transit gloria*—thus passes glory. Such is Wes Anderson's motto, proclaimed by Max Fischer in *Rushmore*, and a sentence that could well have stood engraved on the frontispiece of the Amberson's proud home. ⚷

The Hole by Jacques Becker
A Secret Passage to Wes Anderson

1960.
When *The Hole*, Jacques Becker's new movie based on the novel by José Giovanni, was released in French movie theaters, it was preceded by a wash of laudatory reviews and received the unconditional support of one François Truffaut, who considered Jacques Becker as a true "auteur." In fact, it was on the occasion of the release of Becker's film *Ali Baba and the Forty Thieves*, a colossal filmic device created for the French actor Fernandel, that the star director of the "Nouvelle Vague" (the French New Wave movement) coined the term "Politique des auteurs," recognizing, even within this commissioned movie, *"la patte Becker"*[1] (the Becker touch). However, despite this remarkable support, *The Hole* was a huge flop in movie theaters nationwide, and French audiences shunned the filmmaker's latest work. However, Jacques Becker was unaffected by this, and with good reason: the director, exhausted by the extreme conditions that prevailed during the movie's shooting, passed away before it was released, just a few weeks after completing the editing. Exhausted, he finally laid down his arms on February 21, 1960. Becker would never present his masterpiece.

In a prison cell at the La Santé penitentiary, five inmates are hatching a grand plan to regain their freedom. A testament movie, *The Hole* is a tale of escape, friendship, humanity and weakness. One can wonder why Wes Anderson was so strongly attracted to this movie, despite its undeniable narrative and visual qualities, to the extent that he selected it and recommended it to his team on the set of *The French Dispatch*. Visually, *The Hole* is, in many ways, the exact antithesis of Wes Anderson's cinema: bare and dry as a desert in summer, devoid of music, tending toward the rawest expression of naturalism, the movie goes straight to the point, with no bells nor whistles. One can

1. François Truffaut, "*Ali Baba* et la 'politique des auteurs'," *Cahiers du Cinéma*, February 1955.

perceive it as a gesture of friendship from the director toward his cinema family, a desire and an urge to share this cinematic masterpiece, which he may believe has slipped under most of his team's radar.

It cannot be denied that Becker's movie has already left its mark on Wes Anderson's cinema, And one needs to go all the way back to *The Grand Budapest Hotel* to perceive its influence. First, there is a scene where one of the guards cuts up, shreds and crushes just about everything contained in the parcels sent to the prisoners from the outside world. The jailers are looking for hacksaws, box cutters, sharpened blades—in short, any tool that is undesirable within the walls of a prison populated by hardened criminals and other rough characters. The same scene can be found in Jacques Becker's classic movie; here, however, no pastry from Mendl's bakery can move the guard enough to convince him to hold back his vengeful hand. No parcel escapes his extreme vigilance. With the precision of a jackhammer, the uniformed man clearly maliciously enjoys destroying the rare food items brought in from the outside world, as actor Marc Michel looks on in disappointment. Yet, in this scene, there is a need to describe the guard's gesture, to exhibit it, to film it in real time, with all its precision and its repetition: a quasi-documentary dimension of Jacques Becker's cinema.

Another scene, this time emblematic of the French director's works, undoubtedly attracted the full attention of the Texan director. One by one, the inmates strike the floor of their cell with heavy blows, breaking it, digging into it, piercing it meticulously, stone by stone. And it is perhaps here, beyond the discrete nods, that lies the real and true connection between Jacques Becker and Wes Anderson—the need to create their movie in the same way that one might sculpt and build an object from scratch, one day after another. We are all well acquainted with the American director's taste for detail, his almost obsessive precision, his cardboard sets, models, puppets (whether human or otherwise)—in short, anything that

Wes Anderson and his team can shape with their hands, like craftsmen would. Here, one recognizes Jacques Becker's characters who, throughout the film, will have to work like craftsmen to dig a hole until they are able to escape. Indeed, Jacques Becker examines every single gesture of this escape with a magnifying glass—from the scene where

his characters make a pocket periscope from a toothbrush and a tiny piece of a mirror to the sequence shot marked by the deafening, repetitive sound of iron bars striking a floor that is too hard, leaving viewers feeling every bit as exhausted as the protagonists.

Above and beyond his love of France and its cinema, Wes Anderson undoubtedly recognizes in Jacques Becker's movie the work of another dedicated filmmaker who, just like him, was keen to pay tribute to "specialists" of all kinds—whether burglars, killers or humble plumbers. And perhaps Wes Anderson will not have remained insensitive to Jean-Pierre Melville's statement at the film's release: "*How many pages would I need to enumerate the marvels contained within this masterpiece, this film that I consider—and here, I am very carefully weighing my words—to be the greatest French film of all time?*"[2] Nothing less. ⚷

2. Jean-Pierre Melville, "Le plus grand film français," *Cahiers du Cinéma*, May 1960.

The Graduate by Mike Nichols

Learning to Run

In the corridors of the airport, Benjamin allows himself to be carried along by the moving sidewalk's mechanical movement, with a deadened look on his face, while the camera follows his stationary run. Only the motion of the airport's walls passing by and the procession of hurried travelers betray this immobile movement. With its cult

his first major role. Freshly graduated from a prominent business school, Benjamin returns to his parents' home to enjoy a little calm before taking the big leap into an adult life—a prospect that he is hardly enthralled about. In their affluent Los Angeles suburb, the Braddocks organize a small reception in his honor, in the company of neighbors

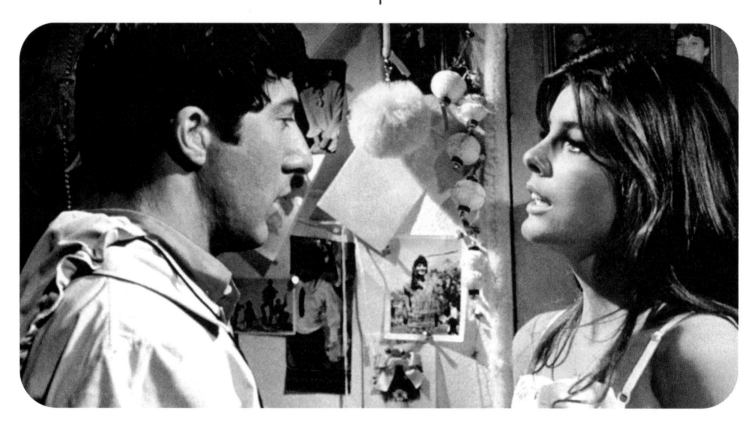

motion soundtrack, which featured *Sound of Silence* by Simon & Garfunkel, *The Graduate* immediately begins to paint the portrait of a character that is going through the motions—the only unmoving feature in a moving world, swept along on a trajectory that he has not chosen.

Released in American movie theaters in 1967, Mike Nichols' *The Graduate* follows the journey (or rather, the wanderings) of young Benjamin Braddock, played by Dustin Hoffman in

and friends who predict that he will have "*a great future in plastics.*" Adrift and listless, Benjamin indulges in an affair with Mrs. Robinson, a married woman who sets her heart on him. However, everything falls apart when the young man falls in love with Elaine, the Robinson couple's daughter. A beautiful movie about the passage to adulthood, with all its burdens and doubts, rebellions and raging depression, *The Graduate* echoes in many ways throughout Wes Anderson's works. *Rushmore*, in particular,

pays an affectionate tribute to its predecessor by adopting a number of its visual and thematic motifs and establishing its protagonist, Max, as the heir to Benjamin Braddock.

A coming-of-age comedy, *Rushmore* features the bewildered character of Max Fischer who, in turn, falls under the spell of an older woman. Where Mike Nichols' love triangle was completed by the arrival of Elaine, *Rushmore* insinuates an unlikely third party in the person of Herman Blume—Max's mentor and friend, and a family man at the end of his tether, caught in the throes of a deep depression. How can one fail to recognize, in Blume's character—a sullen middle-

private schools, upper-class suburbs and professional successes devoid of ideals that are celebrated with a drink by the pool—the perfect symbol of success. *Rushmore* also paints a small social, bustling portrait of America, as the movie explores the relationship between family and social determinism, but also the panic fear of failure and the even more deep-rooted fear of the future.

Rushmore is every bit as obsessed with aquariums and swimming pools as its predecessor. This homage hardly comes as a surprise: indeed, nothing better than water can sum up the state of torpor in which the heroes of *Rushmore* or *The Graduate* sometimes

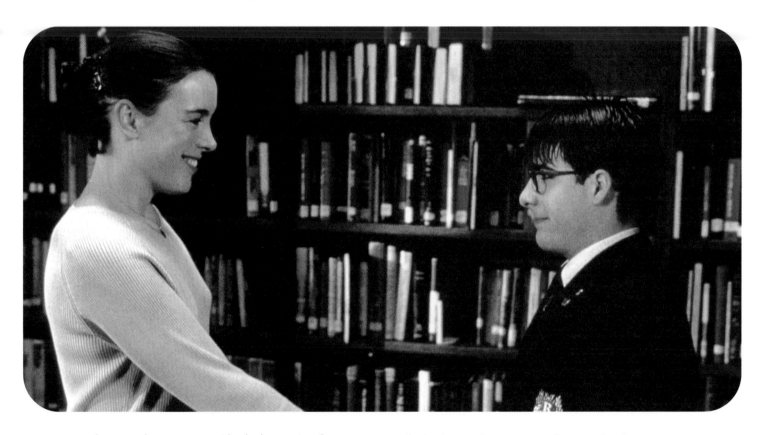

aged man who runs a thriving steel company, and lives in a pleasant villa with a swimming pool—a glimpse of the gentrified future so fiercely dreaded by Benjamin Braddock in *The Graduate*?
Herman Blume could indeed embody the existence that awaits our young graduate at the end of the moving sidewalk. In Mike Nichols's movie, which is often perceived as a portent of the counter-culture, American society is depicted as sclerotic, consumed by its preoccupation with performance and materialism, with its

find themselves. In the pool where he seeks refuge, Benjamin Braddock takes it easy, his limbs leaden, succumbing to the gentle movement of the water, cut off from the world and the noises outside, or lets himself drift aimlessly, under the sun, to his father's great displeasure. *"Ben—what are you doing?"* his father asks. *"Well, I would say that I'm just drifting—here, in the pool,"* Benjamin replies placidly. Just as, earlier in the movie, Benjamin allowed himself to be carried along by the

gentle motion of the airport's moving sidewalk, he succumbs to the indulgent flow of the water, which gently drags him to the bottom or allows him to peacefully float on the surface. From one depression to another, the link connecting both becomes even clearer when Herman Blume, played by Bill Murray, tries to escape his own pool party. He dives into the chlorinated waters before letting himself sink, curled up, into the pool's depths. For Matt Zoller Seitz, in *The Wes Anderson Collection*, one could even perceive this as a ripple effect of *The Graduate*, this time seen from the point of view of the cheated husband, as Mrs. Blume brazenly flirts with her young lover by the pool. Finally, The Kinks' song *Nothin' in the World Can Stop Me From Worryin' 'Bout That Girl*, to which the scene unfolds, echoes the melancholy of Simon & Garfunkel's music, recalling the montage sequence depicting Benjamin's depression to the sound of the tracks *Sound of Silence* and *April Come She Will*. Water, whether filling the tiled pools or the aquariums that our characters appear to tirelessly gaze at, is the metaphor

for this subdued depression that engulfs everything around it.

However, Max Fischer is not cut from the same cloth as Benjamin, and to counter the danger of an existential void, he wholeheartedly embraces a fantasized life, even if it means staging his own existence, as in one of his plays: he improvises himself as a doctor's son, a man of the theater, a brilliant student or an irresistible seducer. And so, reality is filtered through the veil of his desires, to the point of confusing viewers, who will struggle to comprehend whether Max is an absolute genius or rather one of those magnificent losers scattered throughout Wes Anderson's filmography. While Max takes refuge in fantasy, Benjamin seeks solace refuge in total inertia. After leaving school, he finds himself haggardly searching for a meaning to give to his existence, or at least, for a way out of the existence that is being prepared for him. And if he indeed finds this way out at the end of the movie (and nothing is more uncertain), it will only be by disobeying his parents and forsaking social shackles, finally setting his character in motion.

In their romantic aspirations, too, Max and Benjamin also collide with adult life for the first time, as they date older, more experienced women. Benjamin Braddock thus experiences his first love affair with the enterprising Mrs. Robinson, whose frank and direct approach to sexuality could unsettle, or even scare off the young man. Wes Anderson's portrayal of Miss Cross is more forgiving and gentler, as it is once again the innocent projection of Max's own sensitivities. Finally, frustrated by the boy's intrusive feelings, she loses her temper and bluntly expresses her adult sexuality, forcefully undermining Max's romantic image of her. The desacralization of both women's sexuality clashes with Max and Benjamin's adolescent ideals, confronting them with the cold realities experienced by grown-ups. In *The Graduate*, as in *Rushmore*, our young heroes awaken to the adult world and its disillusions.

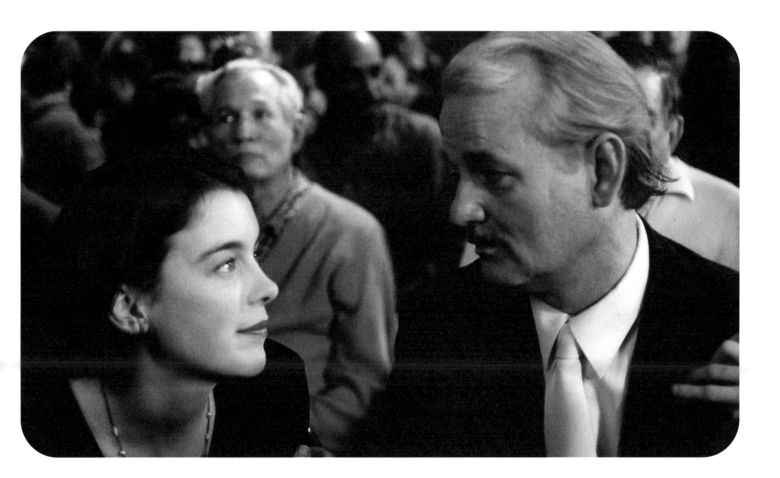

In *The Graduate*'s mythical final scene, Benjamin overcomes his immobility and sets off in pursuit of Elaine, wrenching her free from her marriage, giving in to a sudden life drive. *The Graduate* could be the tale of how a boy, trapped on a moving sidewalk, learns how to run. However, at the back of the bus that drives the protagonists away from their lives, something seems hollow. Instead of de rigueur happy ending, the shot continues strangely, leading viewers to question their uncertain future. And indeed, a manifestation of doubt soon appears on the lovers' euphoric faces. Their facial expressions become darker, and their embarrassed gazes no longer dare to meet. In an instant, Benjamin reverts to the absent gaze that he had at the start of the movie, just as the theme song, *Sound of Silence*, plays again. One cannot escape oneself, Mike Nichols seems to whisper. In *Rushmore*, the final evening following the triumph of Max Fischer's play bears a strong resemblance to one of the fantasies that dominate the movie. This happy ending is tinged with a hint of ambiguity, however, and one cannot help but wonder just how

much fantasy Max is injecting into the scene, considering to how often the young man's reality is contaminated by his desires. As in most of Wes Anderson's movies, Rushmore touches on obsessions so deeply rooted within us that they sometimes take over from reality to the point of isolating the films' characters or making them lose sight of everything that is essential. However, if the closing scene of *The Graduate* warns us against these desires, which are quickly overcome by reality, the ending scene of *Rushmore* may be different, rather encouraging us to pursue our passions and nurture desires that will, in turn, transcend reality. While *Rushmore* never ceases to recall *The Graduate*, the movie has the same pure, hopeful heart as his hero, and there is every reason for us to believe in its happy ending. ⚷

Apocalypse Now
by Francis Ford Coppola
At the Heart of Chaos

"We were in the jungle. There were too many of us. We had access to too much money, too much equipment, and little by little, we went insane." —Francis Ford Coppola. Press conference, Cannes, 1979.

The tale is famous. It was on the Croisette, in May 1979, that Francis Ford Coppola presented his latest effort. However, the word *effort* is far too weak to describe the hell that descended upon the crew as they filmed Coppola's ultimate masterpiece, *Apocalypse Now*. Indeed, before him, another sacred monster had already tried his hand at adapting Joseph Conrad's novel *Heart of Darkness*. Orson Welles himself had attempted to turn the novel into his very first

feature film; however, he was met with reluctance from the studios. Staging *Heart of Darkness* also meant taking on one of history's greatest directors. Many years later, Coppola, buoyed by the immense success of *The Godfather*, and now living in a twenty-two-room home, was determined to take up the challenge of a novel that was presumed to be impossible to adapt. He entrusted John Milius with the screenplay, considered casting Harvey Keitel in the lead role and immediately imagined Marlon Brando as the Prince of Darkness. In February 1976, he left to shoot his movie in the Philippines, taking with him his wife, Eleanor, and their three children, Gian-Carlo, Roman and Sofia,

who was aged just four at the time. However, nothing had prepared the director and his team for the profound chaos that would engulf the production of *Apocalypse Now*. While they were initially relatively mild, filming conditions soon deteriorated, until a typhoon devastated the location, obliging the entire cast to return home for several months. However, Coppola refused to give up and, after mortgaging his house and just about everything else he owned, pumped in millions of dollars to bring his vision, his nightmare, to the screen. After only a few weeks of filming, at the drop of a hat, Harvey Keitel was dismissed and replaced by Martin Sheen. Filming was falling further and

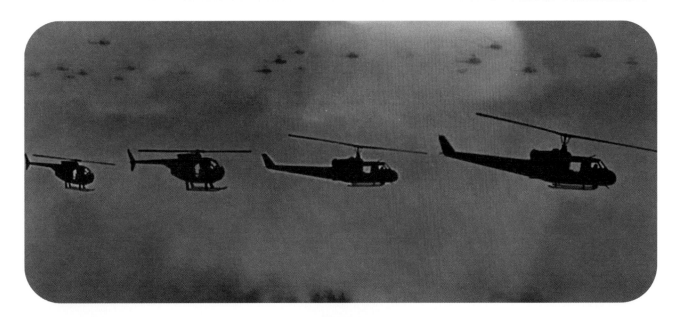

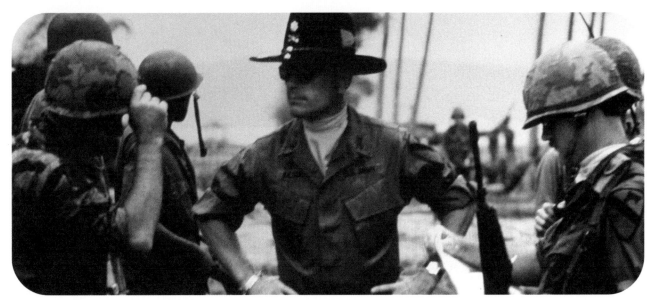

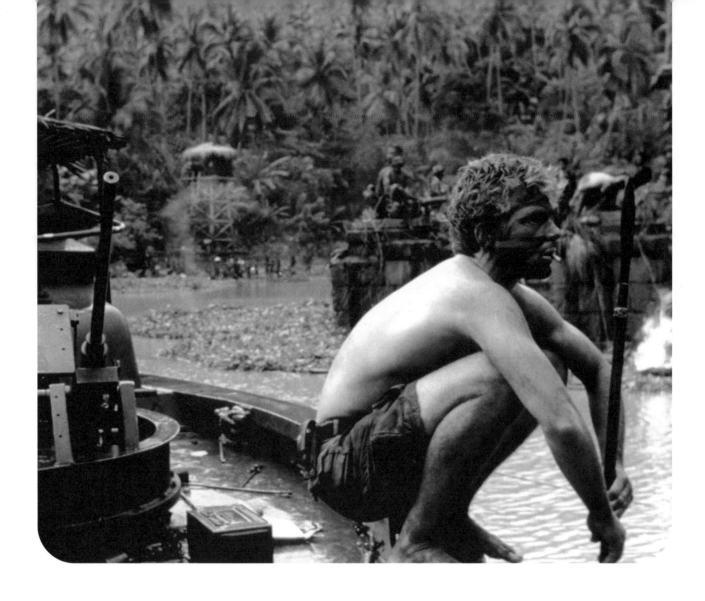

further behind schedule. Martin Sheen also pushed himself to his limits, and, in a famous scene where he goes off the rails after drinking every single of drop of alcohol that he can find in his hotel room, he slashes his hand striking a mirror and breaks down in tears. Coppola, camera in hand, drove the actor to the ragged edge of his abilities by evoking intimate memories, such as his home and his wife. According to Eleanor Coppola, who meticulously documented the hellish filming shoot in *Hearts of Darkness: A Filmmaker's Apocalypse*, Francis Ford Coppola himself was teetering on the brink of madness.

America had never seemed so far away, both for the filmmaker and his crew. Minds and bodies were tested, and Martin Sheen, at the end of his tether, suffered a heart attack. No one could tell whether the film would ever be completed, and Coppola himself was convinced that he was heading for

disaster. Then, Marlon Brando arrived… however, not without threatening to leave the project while also pocketing the million-dollar advance from the three-million-dollar salary that he was due to receive for three weeks of filming. Gone was the Greek god of Brando's glory days; the man who landed in the Philippines was a veritable ogre. The actor weighed over 220 pounds, and had promised Coppola that he would lose weight before his arrival. He had also promised to read Joseph Conrad's novel, but did not read a single line of it. In fact, he hadn't even learned his lines. The rest became legendary. Brando launched into Dantean, improvised monologues, disclosing his darkest thoughts to the camera. The film entered a whole other dimension.

With two Academy Awards and a Palme d'Or, *Apocalypse Now* remains, to this day, the greatest war movie ever. Even Stanley Kubrick's *Full Metal*

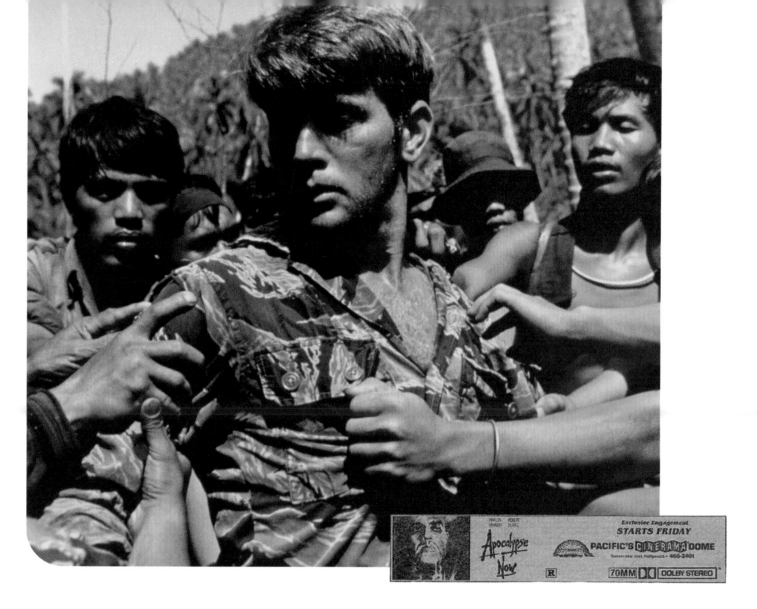

Jacket failed to claim its throne.
Colonel Kurtz sits on it for all
eternity, and the film is regularly
cited by movie enthusiasts worldwide
as a monument to the seventh art. And
yet, Wes Anderson, seemingly so far
removed from this universe and this
hellish creative process, explicitly
quotes scenes from the movie. He pays
tribute to it, in his own manner, by
recreating the movie in a theater play
in *Rushmore*, where Jason Schwartzman
enters the stage in the guise of a
knockoff Martin Sheen. Wes Anderson
cobbles together his own pocket
Apocalypse Now, made of cardboard and
foam, featuring real, yet harmless
explosions: a children's version of
Francis Ford Coppola's inferno, an
end-of-year show for all manner of
movie enthusiasts. It is interesting
to compare the ways in which the
Italian-American colossus and the
Texan filmmaker approach the making of
a movie. While the former pushed the
boundaries to the point of unleashing

chaos, the latter feels the need to
control every single facet of his film,
from the preparation of the set to the
actual shooting of the movie. Their
methods and attitudes differ radically,
yet they work toward one same goal:
to prepare everything, using colossal
and seemingly unlimited resources, in
order to fulfill their most absolute
creative vision. In both his gigantic
ambitions and his extreme commitment,
Wes Anderson may not be so far removed
from Francis Ford Coppola; however,
his films are radically opposed to
those of the director of *Apocalypse
Now*. Time would bring Wes Anderson
and Francis Ford Coppola even closer
together, as the director's loyal co-
writer and close friend is none other
than Roman Coppola, Francis's son. The
circle is complete, and Wes Anderson
can finally sit down at Francis Ford
Coppola's table to enjoy his famous
pasta and, of course, to discuss
movies. ⚷

Cartoons by Chuck Jones
Flattening the World

Fig. 58

THE GREATER ROADRUNNER (GEOCOCCYX CALIFORNIANUS)

The scene is a deserted horizon, toward which a dusty road winds. Under a blazing sun, a handful solitary cacti and high ocher cliffs stand out against a turquoise sky. This familiar setting, a true *Americana* fantasy, is that of the famous *Road Runner and Wile E. Coyote*. It was in 1949, in the episode "*Fast and Furryous*," that Wile E. Coyote and the Road Runner made their appearance on television screens. Barely out of the imagination of one Chuck Jones, the scrawny coyote and his feathered foe play an eternal game of cat-and-mouse across the American desert. However, this arid landscape, all blue sky and red earth, could just as easily

describe the setting for *Asteroid City*, the Texan director's eleventh film.

Wes Anderson's cinema unquestionably features an increasingly cartoonish dimension. Indeed, the director, who has never paid much attention to naturalism, appears to be "flattening" his mise en scène even further. Nothing could be more metatextual since most of the action takes place on a theater stage. Among the criticisms leveled at Anderson, the most hackneyed is that his cinema is a frozen art, devoid of any form of vital impetus, capable of turning the most talented actors into disembodied puppets. If one is to believe this

accusation, his movies offer little more than a succession of scenes reduced to mere vignettes, played out at breakneck speed to create the illusion of life; a device reminiscent of the flip books that Anthony, in *Bottle Rocket*, enjoyed seeing come to life between his fingers. Yet what could be more vibrant than the art of the moving image? "*Animation isn't the illusion of life; it is life,*"[1] Chuck Jones observed.

While in *Asteroid City*, Wes Anderson does not return to the world of animation, he does, however, borrow its formidable simplicity, the effectiveness of gags and broadly sketched characters. The filmmaker has sometimes been compared to another key Texan figure, animation giant Tex Avery. Here, the reference to legendary cartoonist Chuck Jones is impossible to ignore. A true pillar of traditional American animation, Chuck Jones is the creator (or co-creator) of the genre's most iconic characters. The Warner Bros. bestiary, which he endeavored to populate with *Looney Tunes* and *Merrie Melodies*, contains such famous characters as Bugs Bunny, Daffy Duck, Elmer Fudd, Porky Pig, Pepé le Pew and Marvin the Martian. Over the course of a career spanning six decades and including more than three hundred cartoons, Chuck Jones left an indelible mark on the history of animation and on the collective

imagination of several generations of viewers.

Asteroid City is a film packed with cinematic references: Midge Campbell recalls both Marilyn Monroe and Kim Novak, Augie Steenbeck owes a great deal to one Stanley Kubrick, and visual inspirations abound, from *Bad Day at Black Rock* by John Sturges and *Encounters of the Third Kind* by Steven Spielberg. But the way that Wes Anderson invokes Chuck Jones's work, this time, is a straightforward homage. There are, of course, the landscapes, straight out of a *Road Runner and Wile E. Coyote* background, set in the middle of a cardboard desert depicting the south-western expanses of America. Even the abandoned footbridge, a stretch of road that ends abruptly above the town, evokes the cartoon's most famous gag, without even needing to actually use it: as Coyote prepares to fall from a ravine, he remains suspended in the void, long enough to turn a stunned gaze to the camera, before gravity catches up with him. Gravity is indeed both Woodrow's and Chuck Jones' preferred law of physics. In fact, Wes Anderson's movie briefly mentions a coyote that was run over on the outskirts of the town. According to a freckled boy who seems a little too enthusiastic about witnessing the event, the unfortunate coyote was "*run over by a fourteen-wheeler, and*

1. Chuck Jones, *Chuck Amuck: The Life and Times of Animated Cartoonist*, Farrar, Straus & Giroux, 1999.

it left him flat as a pancake," which immediately evokes images of Wile E. Coyote lying flat on the ground after one of his many falls, much to the delight of the children. However, the most explicit tribute is, of course, this wandering bird, a species that goes by the delicate name of Greater Roadrunner, which is none other than the feathered beast that inspired the cartoon character. This roadrunner graces spectators with an enthusiastic *"beep-beep"* here and there.

While there are no red dynamite sticks in sight here, there is a nuclear warhead that could indeed be stamped "ACME Corporation," the company from whom Coyote consistently orders an arsenal of weaponry that consistently turns against him. Even the mushroom clouds in the distance have a decidedly cartoonish quality. As for our space cadets and other stargazers, their wacky inventions (which include a jetpack, a death ray and a device for projecting an American flag onto the Moon) seem to have come right from the spaceship belonging to one Marvin the Martian—a character who enjoys nothing more than planting his flag on foreign planets. When the real alien makes his appearance, his rubber-like skin, his calm demeanor and his large, expressive white eyes are indeed reminiscent of Marvin, even though the comparison ends there (there is indeed no centurion's skirt in sight). In any case, this extraterrestrial borrows a certain comic timing from Chuck Jones's universe, cartoon-

like movements that actually remind us directly of the burlesque cinema genre. Chuck Jones and Wes Anderson indeed revere the same masters of slapstick comedy, such as Charlie Chaplin and Buster Keaton. This mysterious alien is finally the missing link between Jeff Goldblum and Bugs Bunny—one we needed without actually being aware of it.

Asteroid City is, without a doubt, Anderson's most "Looney Tunes-like" movie, which he appears to paint on a two-dimensional canvas. The movie's economy of movement is typical of old-school hand-crafted animation, with its immobile backgrounds, while each of the protagonists' gestures and movements are drawn with great effort. In animation movies, environments are rendered on painted backgrounds, over which the celluloid characters slide to produce the illusion of tracking shots. Here, even Anderson's customary lateral tracking shots, which he particularly uses to film walking characters, take on a cartoon-like quality. His meticulous control of the setting, where every cactus and every prop is carefully imagined, designed and arranged, has nothing to envy the world of animation. Since experimenting with stop-motion, Anderson has acquired a taste for a "hand-crafted" approach, which even his live-action works now seem to hold as a cardinal rule.

However, the sympathetic reference to American cartoons should not obscure our characters' existential questions, which are anything but two-dimensional. Indeed, at its core, the movie addresses xenophobia and the fear of foreigners, the abyssal emptiness left by grief, the dramatization of human passions and the very meaning of life. The highly disturbing irruption of an alien, like some cosmic anomaly, calls all certainties into question. *"The world will never be the same! What happens next? Nobody knows! Will he visit us again? […] What's out there? Something! The meaning of life? Maybe there is one!"* the young Woodrow ponders. How do you live in a world where so many answers are lacking?

This is the banal and all-consuming question that occupies our characters: that of the meaning of existence. It's the same question that torments actor Jones Hall when he suddenly exits the play, between two lines, to consult the director. "*Am I doing him right?*" he asks, looking confused. "*Do I just keep doing it?—Yes!—Without knowing anything?—Yes!—Isn't there supposed to be some kind of answer? Out there in the cosmic wilderness?*" the actor insists. "*I still don't understand the play,*" he finally answers, at a loss. "*It doesn't matter,*" the director replies. "*Just keep telling the story. You're doing him right.*"

To believe that Wes Anderson's flattened worlds are devoid of the sensitivity and complexity of the world is to believe that artifice is the enemy of emotion, when in fact it is sometimes its greatest revealer. It is perhaps one of the great aims of cartoons, theater, cinema, literature and musicals: to shrink the mysteries of this world to a reduced, intelligible version. As Shakespeare wrote in *Macbeth*, life "*is a tale […] full of sound and fury, signifying nothing.*" Flattening the world, for Chuck Jones as for Wes Anderson, means showing it in a simpler, more condensed form, in a representation that is easier to grasp than the great maelstrom filled with sound and fury that the real, outdoor world offers. Who can still blame Wes Anderson for wanting to contain the world in the palm of his hand? 🔑

ASTEROID CITY 950855

TABLE	NO. PERSONS	WAITER	AMOUNT OF CHECK

THE NINE COMMANDMENTS OF WILE E. COYOTE AND THE ROAD RUNNER BY CHUCK JONES

TABLE	NO. PERSONS	WAITER	CHECK NO.
			950855

Rule #1	The Road Runner cannot harm Wile E. Coyote, except by going "beep-beep."
Rule #2	No outside force can harm Wile E. Coyote—only his own ineptitude or the failure of ACME products.
Rule #3	The Coyote could stop at any moment… if he wasn't a fanatic. ("*Fanaticism consists in redoubling your effort when you have forgotten your aim.*" George Santayana.)
Rule #4	No dialogue, except "beep-beep."
Rule #5	The Road Runner must stay on the road (otherwise he logically cannot be called a "Road Runner").
Rule #6	All action must to be confined to the natural environment of the two characters: the desert of the American Southwest.
Rule #7	All materials, tools, weapons or mechanical conveniences must be obtained from ACME Corporation.
Rule #8	Whenever possible, gravity should be Wile E. Coyote's greatest enemy.
Rule #9	The Coyote is always more humiliated than hurt by his failures.

TAX		
STYLE xx	Thank You -- Call Again	

IX

THE CABINET OF TRAVEL SOUVENIRS

Little Italian villages nestled within their ramparts, sheltered from the passage of time. Locomotives barreling across India towards the Himalayan highlands. Kingdoms sunken in the depths of the ocean, and misty peaks in the Sudetenwaltz Alps. Like all great travelers, Wes Anderson brings back all sorts of souvenirs from his adventures, whether real or fantasized, which are preserved here, in our Imaginary Museum. In this room, which resembles a cabinet of curiosities, you will find a miniature train decorated with painted elephants, crumpled old issues of the Trans-Alpine Yodel, unreliable New York bus timetables, and a bestiary filled with aquatic creatures still unknown to the scientific world. When Wes Anderson isn't actually traveling from one end of the world to the other alongside his cinema family, he cannot refrain from inventing uncharted territories. These imaginary countries feature so many details and so many parallel stories that they truly deserve that we settle down there for a little while. Indeed, film after film, Wes Anderson's cinema reveals itself to be a perfectly expanding universe. From his native state of Texas, the director extends his worlds to include avenues, cities and entire countries, to the point of drawing the possibility of distant galaxies. One cannot help but dream of an adaptation by Wes Anderson of Jules Verne's novel *Around the World in Eighty Days*, featuring Bill Murray and Jason Schwartzman as a duo, speeding along the bumpy roads of his imagination. If you happen to run into our favorite director, please pass on the idea to him!

Monsieur Miroslav Soukup
Chef adjoint de la Division internationale
Ministère des Postes

PRAHA
Tjeckoslovakien

省エネルギー切手

FIRST DAY OF ISSUE

Printed
matter
Via Air Mail

Mr. Jaroslav Zemek
U stadionu
537 01 Chrudim III/721
Czechoslovakia

Souvenirs From India
The Odyssey on Railroad Tracks

It is a remote, exotic and mystical location, filled with man-eating tigers, necklaces of Indian roses, vibrantly colored trains, where blue and saffron yellow collide joyously… It is a mysterious representation of India that the Whitman brothers see flashing past them, at full speed, from the window of their railroad car compartment. Our journey begins at the railroad station, amid the hustle and bustle of the city, and will lead us to sacred temples, arid deserts and the Himalayan highlands.

In *The Darjeeling Limited*, Wes Anderson takes us on a road movie set on railroad tracks. It is this beautiful blue train, adorned with painted elephants, that lends its name to the director's fifth film. You will be welcomed aboard its comfortable cars with a glass of fresh lemonade and a bag of savory snacks, a mixture containing almonds and cashew nuts. The itinerary is plotted in millimetric detail, printed and laminated, with precise instructions for our journey: arrival at Shivapur railroad station (9 a.m.), a visit of the Temple of One Thousand Bulls (9:15 a.m.), a stroll around the Kaka market square (10:30 a.m.), before boarding the train which is already heading for its next stop. Our destination is, of course, the town of Darjeeling, located in the north of the state of Bengal, where lush tea plantations spread out over the foothills of the Himalayas.

For centuries, India has fed the Western imagination with fantasies of horizons unknown. These oriental dreams, fueled by literature and, more broadly, by fiction, sometimes collide with the harshness of reality. This,

francis whitman industries

TRAVEL ITINERARY 2-13-07

6.30a	Wake up - Francis Whitman (FW)
6.35a	Shower - FW
6.45a	Wake up - Jack Whitman (JW)
6.50a	Shower - JW
7a	Wake up - Peter Whitman (PW)
7.05a	Shower - PW
7.20a	Breakfast in Dining Car
8a	Quiet Time
9a	Train Arrives @ Shivapur Junction
9.15a	Visit Temple of 1000 Bulls
10.30a	Shopping in Kaka Market
12.30p	Lunch @ Tripathi Guest House
2p	Board Darjeeling Ltd. @ Shivapur In.
2.15p	Darjeeling Ltd. Depart for Premgarth
2.20p	More Quiet Time
3.45p	Tea (Chai) in Lounge

This, at least, will be Francis Whitman's experience, who believed that he was purchasing an authentic spiritual rebirth for the price of a train ticket. In the sleeper car where they are crammed, numbing their minds with painkillers and cough syrup, Francis, Peter and Jack fail to find the peace of mind that they were hoping for. The Whitman brothers' spiritual quest quickly veers off course, like the train itself, which takes a wrong turn and finds itself lost in the middle of the desert. A few unfortunate incidents later (including a venomous snake, a scuffle and some Indian pepper spray), our three brothers find themselves abandoned at the side of the road, burdened with a printer, a laminating machine and eleven suitcases. And it is here, off the beaten track, that the real adventure begins.

At the crossroads of many inspirations, India appears to the director as the ideal backdrop for his great journey. This fascination began with a childhood memory of his: "*The way I became interested in India in the first place was my oldest friend is from what was Madras. So I grew up and I met him when I was 8 in Texas. […] I have memories from stories he told me from when I was a kid that were so alien to me.*"[1] The works of Bengali filmmaker Satyajit Ray and a screening of the film *The River* by Jean Renoir won Wes Anderson over. The fictional journey then doubles as a real journey. To better immerse himself in the writing of his film's screenplay, the director set off on a pilgrimage of his own, accompanied by two accomplices: his co-writers Roman Coppola and Jason Schwartzman (who are also cousins). Writing began in Paris and continued across India for five weeks. As surrogate brothers, akin to the Whitman siblings, the three men discovered the country and filled the script with both imaginary twists and real-life anecdotes. Like their characters, they traveled to sacred temples and embraced the philosophy of "*saying yes to everything,*"[2] and traveled with a printer that would eventually be blown up by a minor issue with an adapter.

Unlike the Whitman brothers, however, they formally denied adopting a deadly desert snake. A year later, these adoptive brothers met up again on the set, for an almost five-month-long immersion. After extensive field research, the film was mainly shot in the desert lands of Rajasthan, the land of kings, filled with palaces. Departing the city of Jodhpur, *The Darjeeling Limited* winds its way through the Thar Desert, on the Pakistani border. Finally, the convent where Patricia Whitman withdrew from the world is actually located in Udaipur, in a former royal hunting lodge that once belonged to one of the Rajput era sovereigns; a remote and dramatic setting that owes much to Powell and Pressburger's film, *Black Narcissus*, in which nuns settle in a strange Himalayan palace.

1. Steve Weintraub, "*Wes Anderson & Roman Coppola Interview,*" Collider, 7 October 2007.
2. Michael Guillen, "*Interview With Wes Anderson, Jason Schwartzman & Roman Coppola,*" Screen Anarchy, 10 October 2007.

However, as the saying goes, what matters most is not the destination, but the journey itself. And so, it was the idea of the train that first occurred to the director. "*I'd always wanted to make a movie on a train because I like the idea of a moving location. It goes forward as the story goes forward,*"[3] Wes Anderson explained. From this perspective, train travel has always held a certain fascination for the seventh art form. Whether the train is the symbol of a galloping Industrial Revolution in Western movies, a barely concealed sexual metaphor in *North By Northwest*, a place of confinement and mystery in *Murder on the Orient Express* or the scene of a heartbreaking farewell in *The Umbrellas of Cherbourg*, trains and cinema have traveled a long way together since the arrival of a train was first filmed at the La Ciotat railroad station. From the Lumière brothers to Alfred Hitchcock and Yasujirō Ozu, trains have always been favored by filmmakers. With Wes Anderson, this means of transport reveals all its comic potential, due to the cramped cabins—during a clumsy fight scene, for instance. It also underlines, with a pinch of humor, a symbolic reading of the "path of life," with its tracks, its starting points, its stages and its switch points. Lastly, it illustrates the claustrophobic, confined and cramped conditions in which the Whitman brothers live, so incompatible with the great adventure that they aspire to live.

After taking us into the belly of the *Belafonte*, with *The Darjeeling Limited*, the director imagines a vehicle that matches the landscape outside. The vehicle is a purpose-built, fully functional train: a veritable miniature studio that the director intends to put on the rails. Indeed, Wes Anderson was determined to shoot his movie on board a moving train, on a working railroad line. From the logistics perspective, the idea was calamitous, but the filmmaker was adamant that his train would run. Of course, he would need to move mountains of bureaucracy, make arrangements with the railroad company, work around train timetables, deal with delays and power outages… For the technical team, also, shooting in such a cramped set involved a considerable amount of acrobatic gymnastics, both when setting up the lights and moving the camera around the space. However, as Wes Anderson's faithful director of photography, Robert Yeoman, explains: "*Wes felt that a moving train imparts an energy to the shot that cannot be faked,*"[4] Both inside and out, *The Darjeeling Limited* is crafted down to the last detail. From the platform, passengers can admire the fabulous fresco, hand-painted by local artisans. Inside, the cabins are decorated in a dazzling shade of blue, combining Art Deco touches with Rajasthan-style fabrics. Among the small accessories that furnish the car, nothing is left to chance, from embroidered pajamas to

3. *The Darjeeling Limited*, press kit, Fox Searchlight Pictures, 2007.
4. *Ibid.*

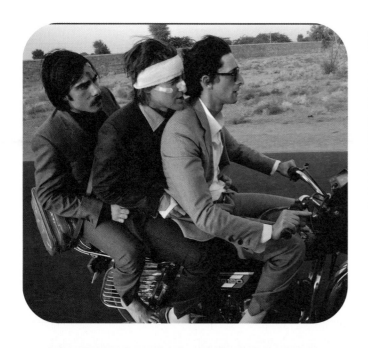

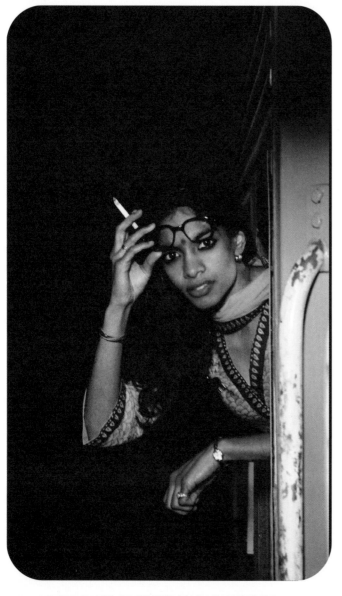

coffee mugs adorned with elephants. The train is not a faithful reproduction, but a creation in its own right; a skillful blend of influences and discoveries found here and there, over the course of many hours of research. Wes Anderson and his chief set designer, Mark Friedberg, explore the nation's rich railroad history; a country crisscrossed by an immense railroad network, one of the most extensive in the world. Soon, a composite vehicle emerged, at the crossroads of the East and the West, inspired by Indian trains and other mythical trains such as the *Orient Express* or the *20th Century Limited*, the New York night train, a steel heavyweight long considered to be the largest train in the world. However, *The Darjeeling Limited* is also a close cousin of the Toy Train, that cute little blue steam train, a true collector's item, which tackles the steep slopes of the Himalayas all the way to the town of Darjeeling; A picturesque, toy-like train that looks like something straight out of Wes Anderson's world. In 2021, in fact, a train will very literally be born of the filmmaker's imagination, who was commissioned to design a carriage for the luxurious *Belmond British Pullman*. The resulting compartment, filled with marquetry and emerald green motifs, underscores the masterly precision with which Wes Anderson treats each of his sets, both in the city and on stage; yet another way of crossing the thin line between reality and fiction. Like all the countries that he visits, Wes Anderson's depiction of India is a picture-book country. This dreamlike India, caught up in a deluge of colors, featuring wild horizons and gods that the people fervently prayed to, never offers more than a *perspective* of India (in fact, the filmmaker only ever offers a *perspective* of France or a *perspective* of New York). Wes Anderson's portrait of India may only be a mirage, a little play of shadows… However, it gradually imposes itself on the film, the characters and even the film crew. When the Whitmans believe that they're opening themselves up to an *experience*

of India, India overwhelms them and sweeps them away in its torrents (a well-known syndrome, peculiar to that country). On this shoot that took place at the end of the world, all would also have to learn to leave things to chance, to make room for mistakes and for the unexpected—in short, to let India be India. "*India gets under your skin*," the filmmaker states. "*India influenced the form as well as the content of our movie. Our policy was not to control what we find there, but to look and see what we could discover. […] India became the subject matter.*"[5] 🔑➞

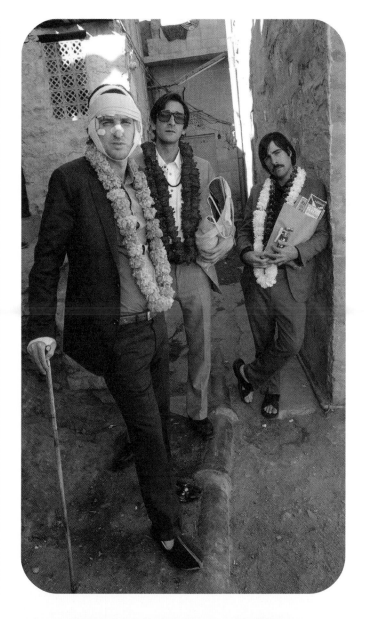

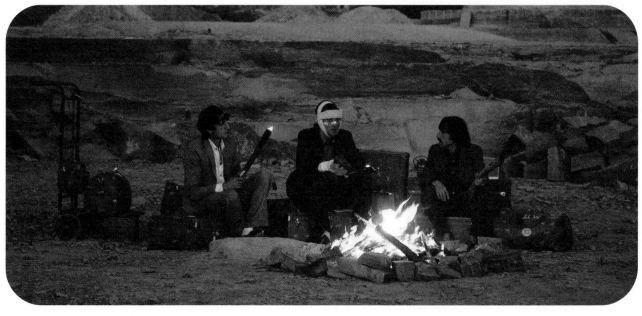

5. Karin Badt, "*A Conversation With Director Wes Anderson*," *Huffington Post*, 26 September 2007.

Souvenirs From Italy
La Dolce Vita

The formidable travel itinerary that Wes Anderson's filmography embodies naturally features a stopover in Italy. While the stopover will be short, it will lead us to the very heart of the country, far from the eternal city of Rome and the canals of Venice, where gondolas laze, for an evening whose memory will long be cherished.

It is a night of celebrations at Castello Cavalcanti. On the evening of September 1955, the impressive Molte Miglia (which could be translated as "many miles") motor race passed through the ancient walls of this small, medieval Italian village. The entire village (meaning some thirty people, at the most) appears to have gathered at the charming *caffè* located on the central square; Many old-timers, and a few children are present. A *mamma* lights a cigarette, while others knit; hunters straight out of Francis Ford Coppola's movie *The Godfather*, with their game still in hand, are cutting a rug. A little further, four *zio* (grandfathers), with their berets firmly in place, are playing cards—probably a game of *scopa*, with its characteristic drawings printed on the cards. Even the priest and some of the nuns have taken front-row seats, holding little flags in their hands. The café's pretty waitress, leaning against the counter, seems bored out of her mind (her father certainly isn't far away). Bales of hay line the road, while a handful of goats wander around.

Anyone who has ever set foot in the heartland of Italy knows that even a modest event is indeed an event, while so many evenings seem to blur the line between tranquility and boredom.

The cars race by. The photographer from a sports newspaper, probably from a big city, captures this fleeting moment on film. Once the high-speed cars have disappeared into the distance, he gets on a BMW motorbike and takes off. And that's that. The villagers wave their flags in the silent night, cheering the pilots on, while the cars' engines are now only

a hum in the distance. The locals are out celebrating, but the party is somewhat lonely, When all of a sudden, one last driver hurtles into the town and, losing control of his vehicle, crashes into the stone walls. His name is Jed Cavalcanti, a young American pilot who, on this memorable evening, will discover that he is the village's prodigal son and will meet his ancestors. That's all it will take for him to miss the last bus that would have allowed him to leave the village. Instead, he will order a plate of spaghetti from the pretty waitress, and will sit at the old-timers' table to remain longer in this picturesque village that seems to speak to his heart.

In the small village of Castello Cavalcanti, sheltered behind its fortifications, time passes with the slowness characteristic of the Old World. Nothing had prepared the charming little town for such a surge of high-speed action. On this September evening, the modern world makes a sudden and somewhat disappointing irruption, and these few racing cars hurtle off into the night, without so much as a glance for the village's friendly committee. That's all it takes for us to read, from this anecdote, a eulogy of slowness. For Wes Anderson, a filmmaker smitten by nostalgia, Castello Cavalcanti could well be a haven, too isolated, too far removed from the world to really feel its turmoil. And in just over seven minutes, he sums up an evening in the heartland of Italy. A game of *scopa*, a handful of old-timers, some *mamma* putting the world (or rather, the village) in order, a young crowd smoking cigarettes, a child playing with a car, chickens, goats and a generous plate of spaghetti. The filmmaker offers us his vision of Italy, a postcard in which we too would love to remain stranded for a night—until the next espresso served on the café's terrace, with the latest *gazette* and a delicious cornetto, still piping hot from the oven. In a few words, la dolce vita. ⚷

Souvenirs From the Former Republic of Zubrowka

Paradise Lost

"**A**t the easternmost border of *the European continent. The former Republic of Zubrowka. Once the seat of an empire.*" These are the words that welcome us to this small country that was once the heart of *Mitteleuropa*. While we are hardly familiar with this state, with its uncertain topography and blurred unclear borders, the Imaginary Museum has gathered a few souvenirs, trinkets and relics in order to preserve, within these walls, a little of what the humble and proud Zubrowkan spirit once was.

A journey through the imaginary Republic of Zubrowka, in its heyday, would be inconceivable without a stopover in the town of Lutz. From here, travelers can climb aboard a train that travels through the barley fields to the charming spa town of Nebelsbad, at the feet of the Sudetenwaltz Alps. It is here, overlooking Nebelsbad, that the marvelous Grand Budapest Hotel is located. This first view of the building, set against the misty, snow-capped mountains that surround it, is somewhat reminiscent of Thomas Mann's novel *The Magic Mountain*. One can also recognize the paintings of German artist Caspar David Friedrich, featuring Alpine landscapes bathed in mist. To reach the hotel, however, travelers are encouraged to save

their soles and, instead, board the little funicular—a most adorable vehicle adorned with the crowned initials "GB," which stand for "Grand Budapest". It also reminds us of some of its European cousins, such as the Budavári Sikló, the funicular that connects the Hungarian capital to Buda Castle, perched atop its hill. After ascending the steep slope, visitors finally arrive at the hotel's heavy doors, where a *bellhop* awaits them with a most serious expression.

If the hotel that travelers are faced with resembles a gigantic pastry shop, it is indeed because it is also, quite precisely, a mille-feuille of influences and cross-references. "*I liked the idea of drawing on a lot of heterogeneous elements, and combining them to produce the appearance of an object based purely on fantasy and fiction, just as I did with my literary sources,*" Wes Anderson explains. "*The film's hotel, for instance, is inspired by around twenty different establishments, which I have taken an interest in through photographs, books or films, retaining only minute details of each.*"[1] To bring this golden age to life, Wes Anderson and his co-writer, Hugo Guinness, set off in search of the most sumptuous buildings in Bavaria, Austria and the Czech Republic, feeding this European reverie with a thousand fragments. The formidable

1. Julien Gester, "Wes Anderson : la précision du style l'emporte toujours," *Libération*, 25 February, 2014.

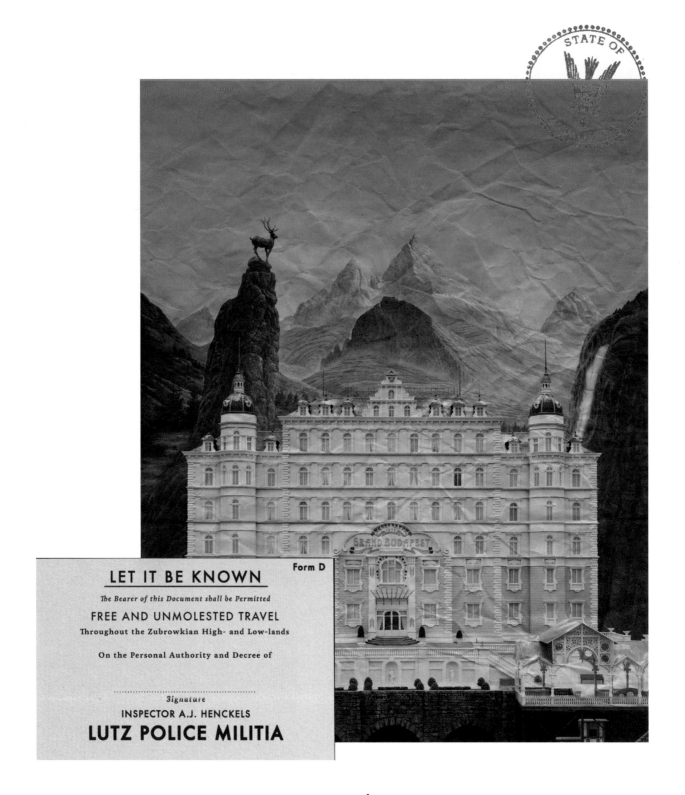

LET IT BE KNOWN Form D

The Bearer of this Document shall be Permitted

FREE AND UNMOLESTED TRAVEL

Throughout the Zubrowkian High- and Low-lands

On the Personal Authority and Decree of

..
Signature
INSPECTOR A.J. HENCKELS

LUTZ POLICE MILITIA

model of the Grand Budapest Hotel's façade, far from being a replica of the Bristol Hotel or the Grandhotel Pupp in Carlsbad, is in fact a reminiscence of these establishments, a distant and romantic echo. This is why, by virtue of this infinite movement that intertwines reality and fiction, we can legitimately be seized, here and there in Europe, by the persistent impression of having suddenly stumbled into a Wes Anderson movie. As for the pure sugar interior of The Grand

Budapest, it could no doubt have been designed and prepared like a huge *pièce montée*, level by level, in one of those bare studios where entire universes are sometimes constructed. Yet, it was in the small Saxon town of Görlitz that Wes Anderson and his head set designer, Adam Stockhausen, found a former department store. The Görlitzer Warenhaus, untouched by time and history, would be transformed into a hotel lobby featuring scarlet carpets and dazzling chandeliers.

196

It is here, in this glorious lobby, that travelers patiently wait for the key to the Prince Heinrich suite (room 133), unless it is no longer available, in which case the Kaiser Frederich suite (room 142) will do just fine. Comfortably seated in the depths of a soft armchair, visitors have plenty of time to peruse the latest edition of the *Trans-Alpine*

misplaced, on our library shelves) stated in *The World of Yesterday*: "*It remains an irrefragable law of history that contemporaries are denied a recognition of the beginnings of the great movements which determine their times.*"[2] And so, in the Grand Budapest, everyone goes about their business, unwilling to acknowledge the great movement that is shaping

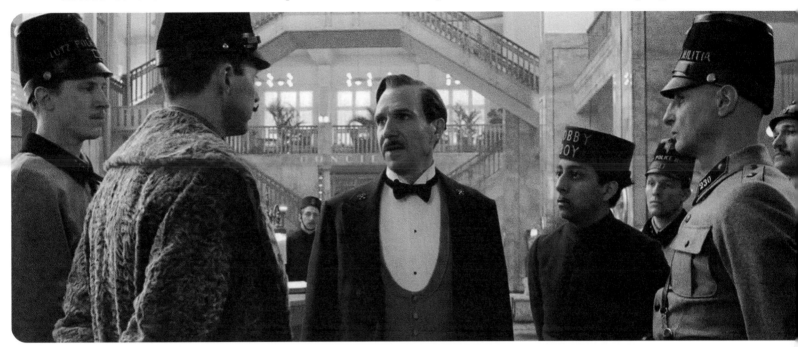

Yodel, to gauge the pulse of the small country that welcomes them. The *Trans-Alpine Yodel* is released, not once, but twice a day, which says a lot about the liveliness of Zubrowkan life. And if, on the morning of October 19, 1932, the traveler had indulged in a copy of the morning edition of the *Trans-Alpine Yodel* (at the very reasonable price of half a *Klubeck*, the national Zubrowkan currency), they would have been seized by the alarming news of the day. Printed in black letters on pink paper, the headlines proclaimed the possibility of a war. Yet, unaware of the conflict's imminence (even though tanks were currently stationed at the country's borders), Zubrowkan high society is rather more concerned (as a comical camera movement indicates) with the death of the Dowager Countess, Madame Céline Villeneuve Desgoffe und Taxis, reported in a rather graphic manner. But, as the writer Stefan Zweig (whose works are very present, albeit

their era: the slow, inexorable pace of history on the march.

In the end, little is known about this political backdrop, other than that the calm heralds the storm. The film seems to amalgamate the two world wars, and the rise of fascism unfurls under the seal of twin letters, "ZZ," reminiscent of the *Schutzstaffel*, better known by its initials "SS." And so, at the crack of dawn, the stunned traveler can watch the Zig-Zag Brigade burst in, turning the hotel into its headquarters. The division will leave behind a sad legacy indeed, as well as a few customized Martini spoons and ping-pong tables bearing the party logo. The filmmaker paints a mediocre portrait of this brigade, devoid of ideals; it is a portrait of evil diluted in the collective, where barbarity can reside in the ordinary and the trivial, echoing a referential read for Wes Anderson, *Eichmann in Jerusalem: A Report on the Banality of Evil*, in which Hannah Arendt

2. Stefan Zweig, *The World of Yesterday, Memoirs of a European*, 1943.

197

develops the chilling concept of the "*banality of evil.*" Indeed, while *The Grand Budapest Hotel* enjoys twisting history, it is no less attentive to its testimonies.

From the outset, the film turns the *former* Republic of Zubrowka into a nostalgic evocation of a world that we know to be already doomed by the course of history. And from 1968 onwards, travelers still wishing to stay at the Grand Budapest would be greeted by a faded décor. The hotel of yesteryear, an architectural bonbonnière painted in delicate shades of pink, has been replaced by a brutalist and sadly functional façade. Even the beloved little funicular seems to have lost its luster. This melancholic vision hangs like a shadow over the Grand Budapest Hotel. And while Zero Moustafa's moving narrative attempts to restore it to its former glory and revive its tarnished colors, the faded image of the hotel, which is doomed to destruction, lingers in the viewer's mind. "*It was an enchanting, old ruin—but I never managed to see it again,*" the writer and narrator regretfully states. Many years later, in Lutz's old cemetery, girded with red brick walls, the spectator knows that the Grand Budapest of his dreams is no more. Our imaginary travelers, however, can still pay tribute to the elderly writer, whose statue stands in the heart of the cemetery, by hanging a hotel key against the stone base. As for the Grand Budapest, what remains of its former glory lies between the pages of a candy-pink book, where one can still travel by thought and, once again, board the cute little funicular that runs down the hill. ⚷

ZIG - ZAG
ZZ
DIVISION

Souvenirs From Ennui-sur-Blasé

Time Machine

Of all the places that Wes Anderson has turned into movie sets, Ennui-sur-Blasé is undoubtedly the one teeming with the greatest amount of details: for the viewer's curious eye, it is both an enchantment and a challenge. And if *The Grand Budapest Hotel* has often been compared to an imposing, pastel-colored pastry, *The French Dispatch* is unquestionably a Sunday meal in the purest French tradition: excessive, but comforting.

A fantasy of a Paris gone by (if it ever existed), Ennui-sur-Blasé is packed with so many secrets, so many graphic details, visual elements and accessories that it would be impossible to list them all here. A filmmaker of overabundance, Wes Anderson reveals, movie after movie, an insatiable appetite for detail. However, the director is unwilling to simply set a picturesque scene and leave it at that. On the contrary, every minute object, every fragment of the set seems to be part of a larger story, an extended universe that is only waiting for the observant viewer to unfold. And so, Ennui-sur-Blasé is an old town, steeped in heritage, which was once a cluster of tradesmen's villages. If you only imagine all the stories that haunt the town's streets (and Wes Anderson's imagination), your head will begin to spin. Even the tiny, wacky newsvendor facing the pharmacist's displays an incalculable number of publications. Just take a look…
But it was Herbsaint Sazerac, in his article entitled "The Cycling Reporter" (in the "Local Color section), on pages 3 and 4 of

The French Dispatch, who best described Ennui-sur-Blasé. Perched on his bicycle, wearing his habitual beret, with a small clipboard steno pad firmly mounted on the bike's headlight, the journalist is an ideal guide for anyone wishing to get lost in this curious little town. So, let us get on our bikes and follow Herbsaint Sazerac on his French safari, discovering its *menagerie*, as the editor likes to call it.

Sazerac warns us: after a long Sunday of rest, the city of Ennui *rises suddenly on a Monday.* Indeed, the entire town seems to have gathered at precisely the same time. A stream of water even surges from the sewers, gathering the remainders of the weekend, at this crucial moment, as if all the city's alarm clocks and other timepieces had synchronized. Even the baker (located at the end of rue Sante, number 12, under the "Pains grillés" sign that adorns the

building's façade), who had no doubt been up for some time already, appears to have been waiting for this exact instant to come out of his store, raise the iron curtain and offer his bread, brioches and croissants, still warm from the oven. A dog runs across the street, another one barks, a lady dusts a carpet in her window, a man lights a pipe, while others sit on crates for a chat, work on a blade, or simply read the Monday morning paper. Is Ennui-sur-Blasé a town that exists solely in a theater play or a movie, patiently waiting for the curtain to rise or for the director's "Action!" call to suddenly come to life?
 Or is it simply too firmly rooted in its habits? The town, which is clearly insistent on preserving its daily routine, has nevertheless changed a great deal over the years, and only the names of the districts remain unchanged, as the journalist reminds us, perched on his orange bicycle. Let us follow the guide, however.

"*Through the time machine of poetic license, let us take a sightseeing tour. A day in Ennui over the course of 250 years*," says Sazerac, leading us through a maze of cobbled streets. There is the Bootblack District, where the dirty streets full of young children with shoeshine kits have given way to a clean shoe repair shop and the pretty façade of the Hôtel de Chaussures. The establishment offers hot and cold water, breakfast, rooms to rent of all sizes and for all the family, ample payment facilities, café-bar, central heating, lower

prices… In a nutshell: all the modern amenities. What a fine promise for lost tourists. Parked right next to the entrance, the pretty egg-yellow Citroën, symbol of the flourishing French industry, completes this charming portrait for all those nostalgic of the utterly Godardian depiction of France in the fifties and sixties. Quick-eyed viewers may even notice that the children and their toolkits have been replaced by an automatic, coin-operated shoeshine machine, available to everyone. Another perk of modernity. The Bricklayer's quarter, on the other hand, has completely disappeared. It is now home to the nightclub La Brique Rouge and its neon sign in the same color.

Here, only the cobblestones have stood the test of time and city policies. The Butcher's Arcade has become the entrance to the aptly named metro station: Abattoir. The dangling carcasses and sharp blades have been replaced by a very young ticket inspector who, confined to his little

booth, and far removed from the surly faces of the butchers, seems to have escaped from a François Truffaut movie. And as far as the Pick-pocket Cul-de-Sac is concerned, the atmosphere remains the same. It is still as seedy as ever, sardine-packed with scoundrels and punks of all kinds, with switchblades and brass knuckles in their pockets. Only the outfits have changed, with leather jackets replacing blazers and berets. Here again, attentive spectators will notice that walls covered in graffiti have replaced the laundry items that used to hang from the windows, proof that over the years, the town's inhabitants have definitively deserted this underworld alleyway. Finally, commenting on the passage of time, Herbsaint Sazerac tells us that the beautiful food market, which was built under a vast glass and cast-iron canopy, has been demolished, and will soon be replaced by a multi-story shopping center and parking structure. We will leave it to each and every one to judge this kind of transformation of the city; in this case, opinions are divided.

We now enter the metro and take our seats in a second-class car, while the train is already traveling through Marville station (after Abattoir station, on the Flop Quarter line). "*Like any living city,*" the reporter warns us, "*Like every living city, Ennui supports a menagerie of vermin and scavengers.*" Rats literally infest Ennui-sur Blasé's basements, while cats have colonized its sloping zinc roofs, and eels peacefully swarm in its shallow drainage canals. A host of fauna that lives with the inhabitants, for better or for worse. We have now arrived in the Flop Quarter, home to broke students and the Café Sans Blague, the headquarters of the protest movement, where music, laughter and impassioned discussions can be heard echoing in the distance. All this lively activity provides a stark contrast with the area that awaits us further on, the Hovel District. The juxtaposition hits the nail on the head. We have now reached Rue des Feutriers, served by a bus route, where the passionate former students who have failed end up as penniless old people.

And because Ennui-sur-Blasé has
all the makings of a modern city,
traffic never ceases. It is a mixed
blessing, the town guide admits. At
rush hour, it is a constant flow of
noisy, backfiring, honking, sputtering
cars, emitting "*toxic fumes and
filthy exhaust pollution,*" not to
mention reckless drivers and serious
accidents. Pedestrians and cyclists
beware! Finally, as night falls, the
honest shopkeepers, who have gone to
rest after a hard day's work, are
replaced by a completely different
fauna. A fascinating motley crew of
prostitutes and gigolos occupies the
district's pavements, And the effluvium
of debauchery rises from streets and
cul-de-sacs.

And here ends this brief guided
tour of the "real" Ennui-sur-Blasé,
however, not before counting the
number of bodies pulled from the Blasé
river every week (8.25), and passing
by the town's prison and public
urinals. Isn't it almost too seedy,
the editor-in-chief worries? We are
already back at *The French Dispatch*,
and the narrative once again becomes
part of the narrative. Whether seedy
or charming, Herbsaint's article
is, like Wes Anderson's filmography,
dominated by this concern for the

passage of time, against which we can
do nothing. Of course, the little
Ennui-sur-Blasé of yesteryear is no
more. However, writing once again
appears to be the only way to access
these worlds fallen into oblivion, as
it was for *The Grand Budapest Hotel*.
The tales of the past, embedded in the
tales of the present, are, like the
poetic license used by the reporter:
a "time machine."

To conclude, let us quote Herbsaint
Sazerac once more: "*What sounds
will punctuate the night, and what
mysteries will they foretell? Perhaps
the doubtful old maxim speaks true:
all grand beauties withhold their
deepest secrets.*" This is how life is
in Ennui-sur-Blasé, even around the
town's public urinals. ⚷

Souvenirs From the Island of New Penzance
The Robinsonade

It is a tiny, remote island, located off the coast of New England. At the very edge of the New Penzance coastline, on the shore, stands the Bishops' red and white house. At its summit, perched like a bird on its observatory, Suzy scans the horizon with an impatient gaze. We are at Summer's End, one of the island's northernmost points, which shares its name with this red wooden building, girded by tidy white fences, resembling a doll's house. Right from the film's introduction, the melancholic name Summer's End tells the tale of the bitterness peculiar to childhood that pervades *Moonrise Kingdom:* the end of the summer holidays, the fading sun, the nostalgia of afternoons spent playing games. It is here, at the end of summer, as childhood is already spilling over into adolescent turmoil, that Suzy waits for Sam's last letter. Before docking on these rocky shores, our humble narrator, Bob Balaban, who is also this small island community's librarian of record, dispenses some essential information about the location's topography. New Penzance is a small island, 16 miles long, on the far edge of the Black Beacon Strait. Its lands, planted with centuries-old pines and maples, are mostly uninhabited, with the exception of a few solitary trappers. The Chickchaw territory, named after the island's ancient native tribe, is now fully signposted and provides a pleasant, if ambitious, walking trail. The island is devoid of paved roads, but covered by miles of narrow, winding paths. Mail arrives on the island by small plane, and a ferry runs twice a day from Stone Cove Bay. The inhabitants of New Penzance lead a peaceful life, far from the hustle and bustle of the world, and have all the necessary amenities at their disposal—from the library to the church, right down to the tiny police station, neatly perched at the end of the jetty.

depict this imaginary island, Wes Anderson and his team opted for the miles of Rhode Island coastline, with its steep ravines, rolling fields, rocky coves, beaches and forests. Among the many filming locations are Narragansett Bay, Camp Yawgoog, Newport's historic Trinity Church and Conanicut Island Light—a former lighthouse that, for a time, became Suzy Bishop's home.

In days gone by, New Penzance was undoubtedly a key stopover on the maritime route to the New World. On this island, bathed in an imaginary world forged by pioneers, our runaways follow the harvest trail of the Chickchaw tribe as if they were traveling back in time, determined to escape civilization and to settle on their beach at the end of the world. It is the pursuit of an ideal, the quest for a lost paradise, that leads our young heroes to this isolated cove. With fierce cries, they claim their territory, like explorers reaching the threshold of the New World. Sam and Suzy are engulfed in a joyous illusion, that of finally being beyond the reach of adults, on an island that belongs to them alone, and building a simpler, more innocent world—a sanctuary for their love. In fact, every feature of the little island of New Penzance invites us to live a Robinsonade. A novelistic subgenre that flourished under the patronage of *Robinson Crusoe*, the Robinsonade is related to the adventure novel. Since Daniel Defoe's work was published in 1719, many shipwrecked sailors have found themselves stranded on mysterious islands. The Robinsonade is a godsend for these heroes, who have returned to the genesis of everything, ready to build a new civilization and thus, correct the mistakes of the past. Indeed, the Robinsonade is first and foremost a philosophical and social fable: it tells the tale of humanity, sent back to the dawn of the world and driven to construct a new destiny. The Robinsonade soon reached the shores of children's literature, maybe spurred on by the enthusiasm of the French writer Jean-Jacques Rousseau, who, in *Emile, or Treatise on Education,* considered it to embody the most successful

treatise on "natural education." Children themselves sometimes become the heroes of these Robinsonades. After Mary and Robert, the budding explorers in *In Search of the Castaways* (1868), Jules Vernes abandoned an entire troupe of children on a Pacific island in *Two Years' Vacation* (1888). With its outbursts of passion and its ruthless little scouts, however, *Moonrise Kingdom* undoubtedly owes a great deal to William Golding's *Lord of the Flies* (1954, also adapted on the silver screen in 1963). In this novel, a group of shipwrecked children organize themselves into a violent tribal society, while Sam and Suzy's adolescent emotions may well remind us of those of Emmeline and Richard, survivors of a shipwreck in *The Blue Lagoon*, which was turned into a movie in 1980.

For Sam and Suzy, however, who also want to recreate the world in their own image, the Robinsonade will be

short-lived; indeed, anyone attempting to flee on an island runs the serious risk of being caught up. When the adults find them in the morning, the sky, as if it were attuned to their moods, darkens and becomes charged with electricity. Two days later, a deluge falls on the island and all its inhabitants. This storm, with all its Shakespearean and biblical connotations, is the harbinger of a greater peril, that of the loss of innocence. Indeed, *Moonrise Kingdom* is not the sunny film that it appears to be. In this respect, its title says a lot about its characters lunar and dreamy mindset. This name, although never uttered on screen, refers to the cove where Sam and Suzy set up camp. On the maps, the beach is technically called "Mile 3.25 Tidal Inlet"; for them, however, it's a secret kingdom, whose name they spell out with white stones, lined up on the sand. Thus christened, the cove becomes a magical place that feels like something out

of one of Suzy's favorite fantasy novels, like an enclave of imagination in a world that is threatening to grow dark. It's an exile into happy innocence for a day and a night, a final parenthesis before adulthood. "*C'est le temps de l'amour, le temps des copains et de l'aventure,*" (It's a time for love, a time for friends and adventure), Françoise Hardy sings on the blue record player— a chorus that was never better illustrated than at the end of this summer of 1965. ⚷

Souvenirs From New York

Once Upon a Time, There Was a City…

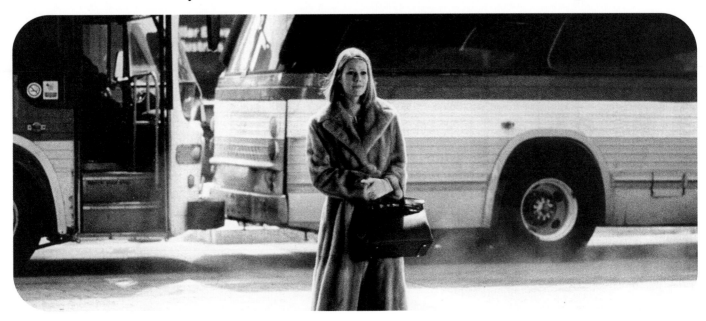

It is, without a doubt, the most cinematic city of all. From romantic walks at the foot of Queensboro Bridge in Manhattan to the wastelands where the Jets and Sharks pull knives in *West Side Story*, New York is a city that is inhabited, maybe even haunted by an entire cinematic imagination. It's not unusual, as one saunters through the city's streets, to recall a mythical scene, from Audrey Hepburn's graceful silhouette on Fifth Avenue to Travis Bickle's nocturnal troubles in *Taxi Driver*. And yet, anyone who has ever explored the Big Apple may well find themselves rather disorientated by the curious picture painted by Wes Anderson.

From an aesthetic perspective, *The Royal Tenenbaums* heralds the emergence of a number of the artist's obsessions that were already asserted with gentleness in *Rushmore*, while *Bottle Rocket*, a more carefree film, appears to float, much like its heroes, like a flag in the wind. This third feature film confirms Wes Anderson's mannerism, which has evolved into a style—a whimsical, old-fashioned aesthetic that will soon become unmistakable. To give the Tenenbaums a world to match this ultra-stylized production, Anderson initially planned to shoot the entire film in a studio, with the aim of giving free rein to his creativity. In the end, however, New York came out on top—or rather, a certain idea of New York, a fantasy city where invented avenues and fictitious bus routes meet in an imaginary district.

Far from taking stock of the city as a tourist destination, Wes Anderson has instead drawn up an imaginary map of it. Here, there are no long shots designed to enable viewers to find their bearings with a glance at the Statue of Liberty, the Empire State Building or the Brooklyn Bridge. If none of the city's major landmarks are present in *The Royal Tenenbaums*, it is because the story takes place in a city of New York that does not speak its name. *"Though we never call it New York in the film, I was looking for a certain feeling of living in New York, not the real New York, more a New York of the imagination,"*[1] Anderson explains. Wes Anderson strives to retain the romantic soul and literary fantasy that surround The City That Never Sleeps, while also blurring the lines.

1. *The Royal Tenenbaums*, press kit, Touchstone Pictures, 2001.

This parallel New York is a setting that presents a precise, if somewhat mysterious, geography. In these so-called New York neighborhoods, populated by battered gypsy cabs, Wes Anderson multiplies fictitious landmarks. From the Tenenbaums' home, he leads us to Lindbergh Palace (actually the prestigious Waldorf-Astoria), to 2100 North Thirteen Avenue, not forgetting a visit to the Public Archives and the Eagle Island residence, where the Tenenbaum family spend their summer weeks. To connect these locations, Wes Anderson imagines a vast selection of public transport (the scene of Margaux's love affair), ranging from the Green Line Bus to the 375th Street Y line, via the 22nd Avenue Express or the Irving Island Ferry. Even the house at 111 Archer Avenue, a large New York building, broken up and cut up to the extreme like a theater set, becomes reminiscent of a doll's house. "*Since the people in the story are to some degree made up from literary associations and characters from other films, they all sort of live in an alternate reality, and that led us to creating an entire world in which the sense of reality is intensified and embellished,*"[2] Anderson states. While the characters are sketched out in broad strokes, with their uniforms and idiosyncrasies, the world that they inhabit is consistent to the extreme; indeed, Wes Anderson's genius lies in the details.

In the real New York, visitors won't happen upon any rattling gypsy cabs, nor will they find a neighborhood called Mockingbird Heights. And yet, while Anderson strips the city of all its identifiable features, in the middle of these anomalies, comical details and imaginary addresses, he succeeds in painting a portrait of a New York that is strangely familiar. What the filmmaker is attempting to preserve, above all, is a mythical interpretation of New York, pieced together from literary references. For the Texan director, *The Royal Tenenbaums* is a movie about New York—not from the perspective of someone who has walked its streets all their life, but from that of someone who has experienced it primarily through the prism of fantasy. "*It is much more of a dream idea,*"[3] he explains.

In this obsessively fabricated geography, Anderson borrows from a vast mythology inspired by New York. This is indeed the romantic vision that a foreign traveler would have of New York; that of someone for whom the city, before they have tamed it, remains imbued with fiction, and who recreates this mythical location in an affectionate and dissolute way. This melancholic relationship with the city is also the driving force behind the film. This is the gift that cinema consistently gives New York: celebrating it for what it is, as much as for what fiction has turned it into. These representations are so convincing, so tenacious in the collective imagination, that they contaminate reality. What city, better than New York, where reality and myth become one, could fulfill Wes Anderson's desire to interweave reality and fiction? ⚷

2. Ibid. • 3. Ibid.

Souvenirs From the Oceans
Bric-a-brac Under the Sea

Not content with scouring the surface of the globe, from Paris to New York, via imaginary nations whose secret borders only he knows, Wes Anderson dives deep into the bowels of the Earth, discovering buried worlds in *The Fantastic Mr. Fox*, or the underwater kingdoms of *The Life Aquatic*. As we know, these depths hold no secrets for the filmmaker—at least, not those explored by the oceanographer and documentarian Steve Zissou. A true voyage into the depths of the sea, *The Life Aquatic* is an aptly named film, and soon reveals some of the extraordinary fauna that inhabits these reefs. Amid seaweed stirred by currents and multicolored coral, species previously unknown to scientists emerge. From the Obyamywe Peninsula to the Pescespada

Island observatory, via the Lurisia Archipelago, the mysterious waters teem with astonishing life aquatic: killer whales, albino dolphins, gum-colored fluorescent snappers, rainbow seahorses, killer eels, sugar crabs, rhinestone bluefins, electric jellyfish (unless they are stinging Viet-Cong man-of-wars) washed up on the beach, forming a slimy tide—and lastly, the fearsome jaguar shark, prince of the oceans.

Of course, Wes Anderson draws most of this bestiary from his fertile imagination. There is no doubt, however, that ancient fantasies are resurfacing here, splashing the screen with a myriad of colors— those of the director's childhood hero, Jacques Cousteau. The captain's

influence goes back even further than *The Life Aquatic*. In *Bottle Rocket*, Cousteau appeared as a portrait on the wall, then again in *Rushmore*, this time through a symbolic book, *Driving for Sunken Treasure*. However, nothing captures the childhood wonderment of Captain Cousteau's documentaries better than these few "fabricated" scenes in *The Life Aquatic*, which immerse us in this televisual nostalgia. To achieve this, Wes Anderson uses two tools: an old-fashioned soundtrack, in which flutes play alongside synthesizers producing artificial notes that accompany the film's adventurers, and the stop-motion technique. A few years before embarking on the great animated adventure of *The Fantastic Mr. Fox*, Wes Anderson tried his hand at this technique which, thanks to the genius of Willis H. O'Brien and

Ray Harryhausen, brought to life prehistoric creatures in *The Lost World* (1925) by Arthur Conan Doyle and skeletons in *Jason and the Argonauts* (1963), and was also used in *The 7th Voyage of Sinbad* (1958). For this first experimentation with animation in his movies, Anderson called on Henry Selick, the undisputed star of this technique, to whom we owe (even more than we owe it to Tim Burton) the masterpiece that is *The Nightmare Before Christmas*.

Wes Anderson is perfectly aware of the qualities offered by computer-generated images when it comes to simulating reality, but he chooses to leave the confounding realism of digital effects to his peers. Going against industry standards, he prefers the authenticity of stop motion (what could be more real, after all, than figurines that

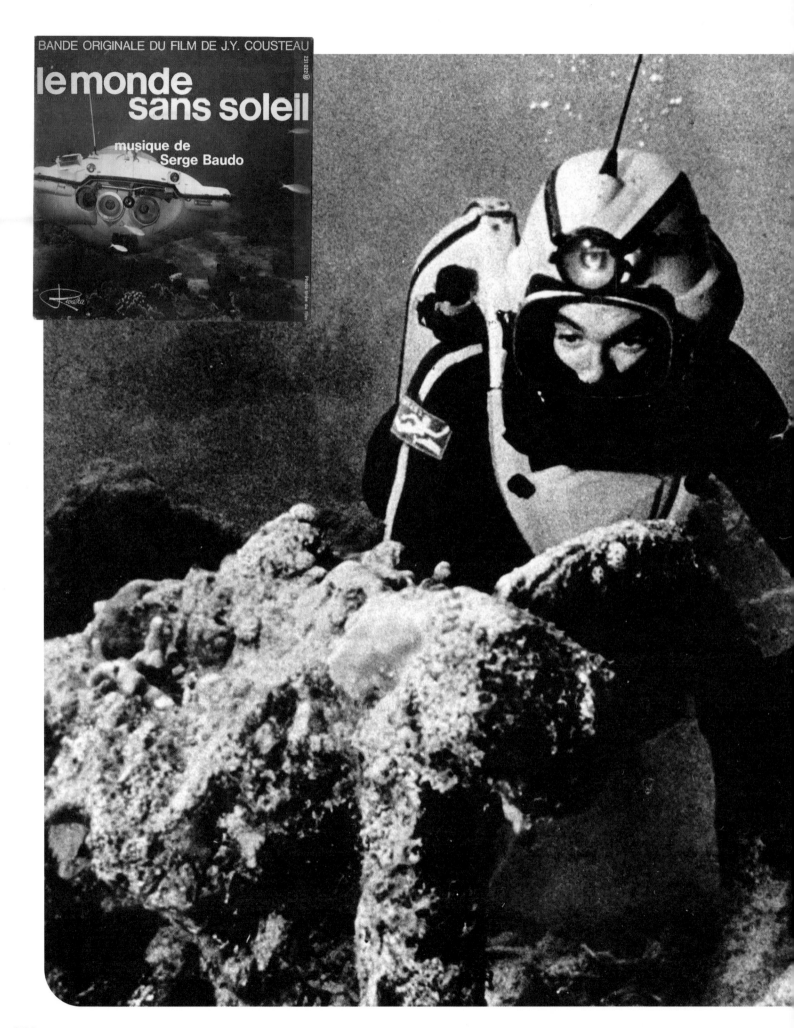

BANDE ORIGINALE DU FILM DE J.Y. COUSTEAU

le monde sans soleil

musique de Serge Baudo

you can actually touch with your finger?) to the distant realism of computer animation. "*And it's not like I love stop-motion because I think it's this great way to make you think these things are really alive. It's more that I think it's such a magical way to make it seem as though these things are really alive,*"[1] the filmmaker states. For the director, it's a new declaration of faith; the faith that he places in the omnipotence of suspension of disbelief.

Stop-motion has the power to appeal to our childhood imagination, much like the toys and puppets that we used to animate for hours in our bedrooms, on a rug that became a world in itself, an ocean to explore, a planet to conquer. Even the submarine *Deep Search* looks more like a bath toy than a submersible designed for oceanographic research. Returning to the very source of animation, this technique *manufactures*, in *The Life Aquatic*, the nostalgia of a world we have never known and will never know. It is a secret universe, hidden in the depths of the water, from which a sea monster could suddenly emerge, whether a giant squid attacking the *Nautilus* or a jaguar shark of gigantic proportions. This aquatic kingdom, straight out of a children's book, has a repertoire that is every bit as mysterious as it is infinite. These underwater scenes are like so many pages that we love to turn in the evening, before turning off the light, hoping in our dreams to climb back aboard the little yellow submarine.

1. Matt Zoller Seitz, *The Wes Anderson Collection*, Abrams, 2013.

X

THE MUSEUM SHOP

A filmmaker by the name of Orson Welles once said that "*a movie in production is the greatest train set a boy could ever have.*" This metaphor has a particular resonance in Wes Anderson's films. Indeed, his movies are filled with multicolored trains, miniature railroads, manor houses that resemble dolls' houses and submarines that need to be rewound once one has found the key. This quote also summarizes his goldsmith-like precision, his absolute mastery of the worlds that he sets in motion and his immense faith in the power of imagination. And yet, behind this demiurgic control, Wes Anderson's little electric train runs on nostalgia; nostalgia for childhood, for its innocence, for the desire to escape the adult world, which is too unpredictable, too complicated, too disorderly. Nostalgia, too, because sooner or later, we have to accept that we need to put the train set away and live amid the chaos outside. Wes Anderson readily grants this miniature quality to the worlds he imagines; yet, from one film to another, these universes expand to form streets, cities, continents and galaxies. It is a vast world indeed, albeit a miniature one, And only someone who had slightly lost touch with the child that they once were would consider refusing to get on board this electric train.

Your stroll through Andersonian lands is coming to an end. After following the scents coming from the kitchens, brushing against the velvet fabrics of the cloakroom,

walking past the projection room's vast screens, crossing an auditorium where music is playing at maximum volume, leafing through a few well-worn volumes stored on the library's shelves, and perhaps finding your way to the secret room, you have now reached the end of your visit; an ending that is every bit as imaginary as the exhibition that you just visited. It is a journey that you can prolong for as long as you wish, and as far as you can. Indeed, Wes Anderson's work cannot be contained within these few pages. His universe is too expansive, his palette is too rich, his gallery of characters is too vast, and the details are almost infinite. From now on, it is up to you to create your own Imaginary Museum, and to journal within it your references, your favorite objects and your keenest observations. Above all, this book is but a humble invitation to continue your adventure, to expand this Imaginary Museum, again and again, armed with a notebook and a pencil (this is how we imagine you here). And if you don't have those items to hand, please feel free to saunter through the museum shop, where you will find some delightful stationery direct from the craftsmen of Lutz, in the Republic of Zubrowka.

P.S. Before you leave, we strongly recommend that you stop off at the café opposite the museum, Au Bon Beurre. Show your admission ticket, and you will receive a three-dollar discount on the dish of the day.

© Prestel Verlag, Munich · London · New York, 2024
A member of Penguin Random House Verlagsgruppe GmbH
Neumarkter Strasse 28 · 81673 Munich

Originally published in the French language under the title: *Le musée imaginaire de Wes Anderson*
© 2023, Éditions Gründ, an imprint of Édi8, Paris

Cover: ©American Empirical Pictures - Moonrise - Collection Christophel

Library of Congress Control Number is available; a CIP catalogue record for this book is available from the British Library.

Editorial direction: Claudia Schönecker
Project management: Veronika Brandt
Translation: David Rocher
Copyediting: John Stilwell
Typesetting: Weiß-Freiburg GmbH
Production management: Corinna Pickart
Printing and binding: TOPPAN Printing Co., Ltd.

Penguin Random House Verlagsgruppe FSC® N001967

Printed in China

ISBN 978-3-7913-9341-4

www.prestel.com

ACKNOWLEDGMENTS FROM THE AUTHORS

Many thanks to Luc-Édouard Gonot for his trust, and of course to Wes Anderson as well all his characters for the inspiration.

Johan warmly thanks Roman Coppola, Valentin Altersitz, Roger Do Minh, and dedicates this book to his daughter, Valentina, in memory of the Sunday afternoon film clubs.

Camille thanks Claire Baldairon for the illustrations that punctuate these pages, and her mother for making her Breton house a true writer's residence. She dedicates this book to the memory of her uncle, Laurent, hoping that he would have enjoyed the journey.

THANK YOU FOR YOUR VISIT.

足摺国定公園
ASHIZURI QUASI NATIONAL PARK

SHIGETOSHI
2266 SHINO
SHINJUKU

Mr.Capt. Carl W.Ehlerding
Fahrhof uber Rotenburg (Han)
West Germany

TOSASHIMIZU
KOCHI
-1.Ⅷ.60 8-12
JAPAN

35. 8. 1
高知
土佐清水

SECTION PHILATÉLIQUE
DU COMITÉ D'ENTREPRISE
DE LA Cⁱᵉ AIR FRANCE

СР
-5-86 8:15
МОСКВА

JAPAN STAMP
BUREAU

省エネルギー

SHIP'S MAIL — Posted at sea

M.S. ANDERS MÆRSK
RØMØ
OXIT
BRT: 33401
WK: 35104

HANS CHR. DYRHAUGE

Thor Dyrhauge
Falkevænget2
DK - 5610 Assens
DENMARK

KOBE PORT
12.Ⅱ.86 8-12
JAPAN

PAQUEBOT

藝術寫真版

伊吹山雄姿

伊吹山頂
3.7.15

CARTE POSTALE